How Digital Photography Works

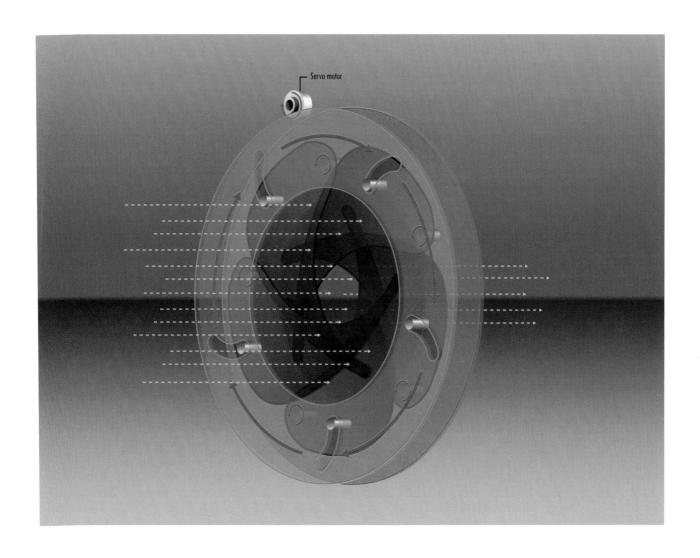

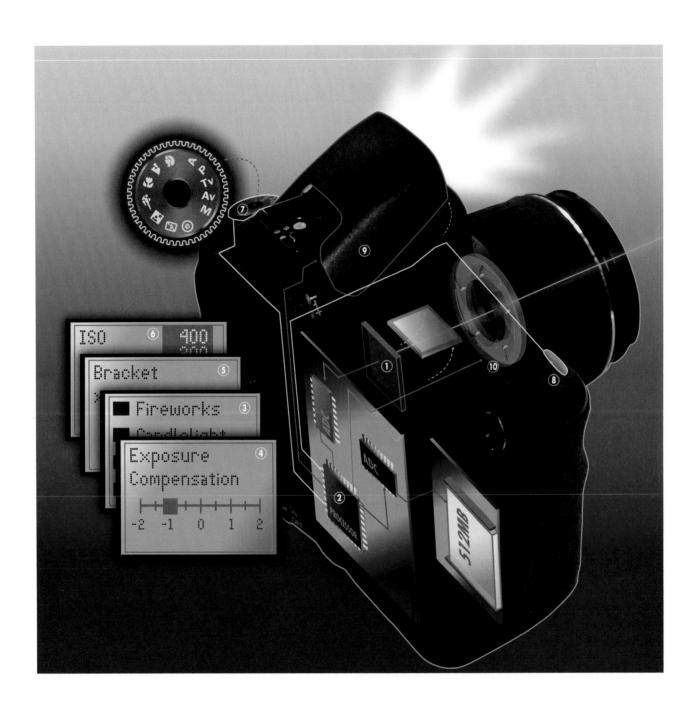

How Digital Photography Works

Ron White

Illustrated by Timothy Edward Downs

How Digital Photography Works

Copyright © 2006 by Ron White

All rights reserved. No part of this book shall be reproduced, stored in a retrieval system, or transmitted by any means, electronic, mechanical, photocopying, recording, or otherwise, without written permission from the publisher. No patent liability is assumed with respect to the use of the information contained herein. Although every precaution has been taken in the preparation of this book, the publisher and author assume no responsibility for errors or omissions. Nor is any liability assumed for damages resulting from the use of the information contained herein.

International Standard Book Number: 0-7897-3309-9 Library of Congress Catalog Card Number: 2004116489

Printed in the United States of America

First Printing: September 2005

08 07 06 05

4 3 2 1

Trademarks

All terms mentioned in this book that are known to be trademarks or service marks have been appropriately capitalized. Que Publishing cannot attest to the accuracy of this information. Use of a term in this book should not be regarded as affecting the validity of any trademark or service mark.

Warning and Disclaimer

Every effort has been made to make this book as complete and as accurate as possible, but no warranty or fitness is implied. The information provided is on an "as is" basis. The author, illustrator, and publisher shall have neither liability nor responsibility to any person or entity with respect to any loss or damages arising from the information contained in this book.

Bulk Sales

Que Publishing offers excellent discounts on this book when ordered in quantity for bulk purchases or special sales. For more information, please contact

U.S. Corporate and Government Sales 1-800-382-3419

corpsales@pearsontechgroup.com

For sales outside the United States, please contact

International Sales

international@pearsoned.com

Greg Wiegand Associate Publisher **Executive Editor** Rick Kughen Todd Brakke **Development Editor** Managing Editor Charlotte Clapp Tonya Simpson **Project Editor** Megan Wade **Production Editor** Indexer Agron Black Proofreader Melinda Gutowski Technical Editor Jay Townsend Publishing Coordinator Sharry Lee Gregory

Book Designer Anne Jones

Page Layout Susan Geiselman and TNT Design

Graphics Tim Downs
Reviewers John Freeland

Mark Edward Soper Jay Townsend

For Sue, without whom this book and the best things in life would be impossible, Ron

For Olivia and Marco, my daily inspiration, Tim

Part 1 Getting to Know		How New Technology Creates a Standard for Digital Cameras	56
Digital Cameras	2	How Digital Cameras Cure the Shakes	58
Chapter 1	,	Electronic Image Stabilization	60
The Workings of a Digital Camera	6	Vari-Angle Prism System	61
Gathering the Light Crafting Light into an Image	8 10	Piezoelectric Supersonic Linear Actuator Stabilization	62
Storing the Image	12	Chapter 4 How Digital Cameras Capture Light	64
Part 2 How Digital Cameras Capture		How a Diaphragm Controls Light	66
lmages .	14	How the Shutter Slices Time	68
Chapter 2		How Cameras Measure Light	70
How Lenses Work	18	How Light Meters View the World	72
How a Lens Bends Light	20	How Digicams Juggle Exposure and Creativity	74
How a Lens Focuses an Image How Active Autofocus Makes Pictures Sharp	22 28	How Exposure Systems Balance Aperture and Shutter	76
How Passive Autofocus Sees Sharp and Fuzzy	30	How Digital Photographers Remain Masters of Their Domains	78
How a High-tech Motor Moves the Lens How the Eye Controls Autofocus	32 34	How Digital Cameras Create a Whiter Shade of White	80
		How Photos Make Noise	82
Chapter 3 How Digital Images Trick the Eye	36	How Histograms Run the Gamut	84
How Viewfinders Frame Your Pictures	38	Chapter 5	
How Lenses See Far and Wide	40	How Light Becomes Data	86
How Digital Lenses Manipulate Space	42	How Film Photography Captures an Image	88
How Zoom Lenses Zoom	44	How a Microchip Catches a Picture	90
How Digital Zoom Fakes It	46	How Image Sensors Differ	92
How We Perceive Detail	48	How the Foveon Image Sensor Stacks It On	94
How Perception Creates Depth of Field	50	How an Image Becomes Data	96
How Photographers Control Depth of Field	52	How Algorithms Smooth Out a Picture's Rough Spots	98
How Digital Tech Changes the Way Lenses Work	54	How Big Photos Fit in Small Chips	100

136

140

142

144

146

148

150

152

154

156

164

Part 4 How Digital

Darkroom Works Print-making Works 102 Chapter 6 Chapter 9 How Software Manipulates Pixels 106 How Computers and Printers Create Photographs How Software Changes Photos by the 108 Numbers How an LCD Screen Displays Your Photo How Software Focuses Pictures After How Colors Are Created They're Taken 110 How Calibration Keeps Your Colors How Blurred Becomes Better 112 Your Colors How Software Changes Exposure After Chapter 10 the Shot 114 How Printers Deliver Photo-quality How Software Corrects Bad Lighting 116 **Prints** How Bigger Photos Preserve Little Details 118 How a Printer Rains Ink to Create a Picture How a Digital Darkroom Makes Good How Inkiets and Inks Differ 120 Photos Better How a Dye Sub Photo Printer Works Chapter 7 How Digital Retouching Restores Glossary 122 Heirloom Photographs How Software Removes Dust and Scratches 124 Index How the Digital Darkroom Rescues Damaged Heirlooms 126 How Software Brings Pictures Back to Life 128 Chapter 8 How the Digital Darkroom Makes

130

132

134

Part 3 How the Digital

Good Photos into Great Fantasies

How Digital Photos Make Fun of You

How to Make a Red Rose Blue

About the Author

Ron White is the author of the award-winning, decade-long best-seller How Computers Work and a dozen other books on digital photography, computers, and underground music. He has been a photojournalist for three decades, both shooting photos and writing for some of the best-known publications in the United States. He gained attention early in his career by leaving the water running in the darkroom at the San Antonio Light, flooding the publisher's office. He has since acquired drier recognition as a newspaper and magazine executive and as an award-winning writer and publication designer. He has been recognized by the National Endowment for the Humanities and the Robert F. Kennedy Awards for his criticism and investigative reporting and by the National Magazine Awards for his self-effacing humor as a feature writer and columnist at PC Computing. He has been a host on NPR's Beyond Computing and a frequent guest on television and radio to explain new technology. Currently, he is working on The Daily Digital Digest, a newsletter and Internet blog to expand on the information found in his books. Tim Downs and Ron White have worked together on editorial and advertising technical guides for more than 10 years. Ron lives with his wife, Sue, in San Antonio. He can be reached at ron@ronwhite.com.

About the Illustrator

Timothy Edward Downs is an award-winning magazine designer, a photographer, and the illustrator of the New York Times Best Seller *How Computers Work*. He has directed and designed several national consumer business, technology, and lifestyle magazines, always infusing a sense of "How it Works" into every project. By tapping his vast computer system and process knowledge, Tim has developed the richly illustrative style that is unique to the *How It Works* series. In *How Digital Photography Works*, Tim has further blurred the lines between informational illustration and photography.

Acknowledgments

WRITING this book was my own exploration into many areas about which I was so unfamiliar that I didn't know how much I didn't know about them until they raised their obscure, obtuse, and unfathomable faces, from which dripped entangled equations and a new vocabulary with terms such as Airy discs and circles of confusion. What I saw originally as a three-month or four-month project when I started grew by leaps of weeks and bounds of months. While I spent time assimilating optics, one of the strangest sciences I've encountered, a lot of people waited with patience—most of the time, anyway—and encouragement. To them, I owe such tremendous debts of gratitude that I never will be able to repay them adequately. But for now, here's a down payment of thanks to Tim Downs, whose artistry explodes into a new universe with every book we do; my editors at Que, Rick Kughen, Greg Wiegand, and Todd Brakke; technical editor Jay Townsend; and my agent, Claudette Moore.

I'm enormously grateful to John Rizzo for pitching in and writing most of the material in the software section. For sharing their knowledge, research, and photography, I'm grateful to outdoor photographer Ed Knepley, Sabine Süsstrunk of the Swiss Federal Institute of Technology Lausanne, David Alleysson of Universite Pierre-Mendes France, Ron Kimmel of Technion Israel Institute of Technology, as well as Alan Schietzsch of interpolateTHIS.com for sharing their insights and photos regarding the fine art of demosaicing, or demosaication, or...whatever. I couldn't have done this without the help, information, and equipment loans from Steven Rosenbaum of S.I.R. Marketing Communication for Konica-Minolta, Andy LaGuardia and Craig Andrews of Fujifilm, Eric Zarakov of Foveon, and Tom Crawford of the Photo Marketing Association International.

There are others I'm afraid I've overlooked. One technician at Colorvision was enormously helpful for me understanding color calibration, but I can't for the life of me find his name in my notes.

It's a cliché for authors to thank their spouses for their patience, encouragement, inspiration, and for not running off with someone who spends way less time in front of a keyboard. The thing about clichés, though, is they're often based on truth. I could not have done this without my wife, Sue. She was encouraging, patient, angry, forgiving, insistent, comforting, and a great editor and advisor. Writing a book is not easy, and without someone like Sue, I'm not sure it's even worthwhile.

-Ron White

San Antonio, 2005

We Want to Hear from You!

AS the reader of this book, you are our most important critic and commentator. We value your opinion and want to know what we're doing right, what we could do better, what areas you'd like to see us publish in, and any other words of wisdom you're willing to pass our way.

As an associate publisher for Que Publishing, I welcome your comments. You can email or write me directly to let me know what you did or didn't like about this book—as well as what we can do to make our books better.

Please note that I cannot help you with technical problems related to the topic of this book. We do have a User Services group, however, where I will forward specific technical questions related to the book.

When you write, please be sure to include this book's title and author as well as your name, email address, and phone number. I will carefully review your comments and share them with the author and editors who worked on the book.

Email:

feedback@quepublishing.com

Mail:

Greg Wiegand

Associate Publisher Que Publishing 800 East 96th Street

Indianapolis, IN 46240 USA

For more information about this book or another Que title, visit our website at www. quepublishing.com. Type the ISBN (excluding hyphens) or the title of a book in the Search field to find the page you're looking for.

Introduction

It's weird that photographers spend years, or even a whole lifetime, trying to capture moments that added together, don't even amount to a couple of hours.

—James Lalropui Keivom

If I could tell the story in words, I wouldn't need to lug around a camera.

—Lewis Hine

WHEN you talk about the quality of a photograph—how good a picture is—what are you talking about? One obvious meaning is creative quality, the photographer's choice of subject matter, the light falling on the subject, and how the photographer frames the picture so that the arrangement of objects in the photo—the picture's composition—all add up to the effect the photographer wants the picture to have when someone else looks at it.

In this book, however, when we discuss *quality*, it means something less esoteric. We're talking about the technical quality of the picture. Here *quality* refers to the sharpness of an image, how well the exposure settings capture the details that are in shadow and in bright light, and how accurate the photo's colors displayed on a computer monitor are to the colors in the original subject as well as how accurate a hard-copy print is to the colors on the monitor.

Actually, this book rarely speaks of quality at all. That's because it's possible to take good, even great, photos using a \$9.99 disposal camera. And it's even easier to take terrible, terrible photos using the most expensive, technically advanced photo system you can buy. One anonymous quotation I came across in my research says, "Buying a Nikon doesn't make you a photographer. It makes you a Nikon owner." I've tried to be nondenominational in this book and generally ignore camera makers' claims that their technology is better than their rivals' technology. There's no blueprint or schematic for creativity. Creativity, by definition, springs out of the originality of one person's mind. If you follow a scheme written in some book about creativity, you aren't creating. You're copying.

Some books and teachers can help you unleash the creativity you already have lurking in your mind. This book simply isn't one of them. And its artist and writer aren't trying to be one of those teachers. Instead, our goal is much simpler: to make you, as photographer, the master of your tools, whether camera, darkroom software, or printer. And to be the complete master of your tools, you must understand how they work, not use them by blindly following someone else's instructions.

With all tools, it's possible to misuse them. Ask anyone who has tried to use pliers to hammer a nail or a hammer to loosen a lid. If you understand how pliers and a hammer work, you're far less likely to push them beyond their capabilities. And if you know how your camera's lens, exposure meter, focusing mechanism, and the dozen or so other controls work, you'll have fewer bad photos—whether intended for the family album or a museum wall—that are ruined because of photographer error.

And speaking of error, if you find anything in this book that you disagree with, please drop be a line at ron@ronwhite.com. One of the things that continually amazed me is the extent to which photographers disagree with one another about the workings of this or that principle or tool. It's as if the science of optics is still up for grabs. I left out much of what could be said about photography because there is so much I could have said. If you think some omission is particularly egregious and you'd like to see it in a future edition, please let me know about that, too. And if you have any photos you're particularly proud of, send those along, too. They are finally what this is all about.

I plan to start a daily newsletter, "The Digital Daily Digest," covering photography, cameras, photo software, and assorted other topics that should interest professional and amateur photographers. There is so much email going on these days that this will be as brief a digest as possible of all the day's photography news, with links to the original stories for those with the time and interest to read more. If you'd like to subscribe—it's free—drop me a line at ron@ronwhite.com.

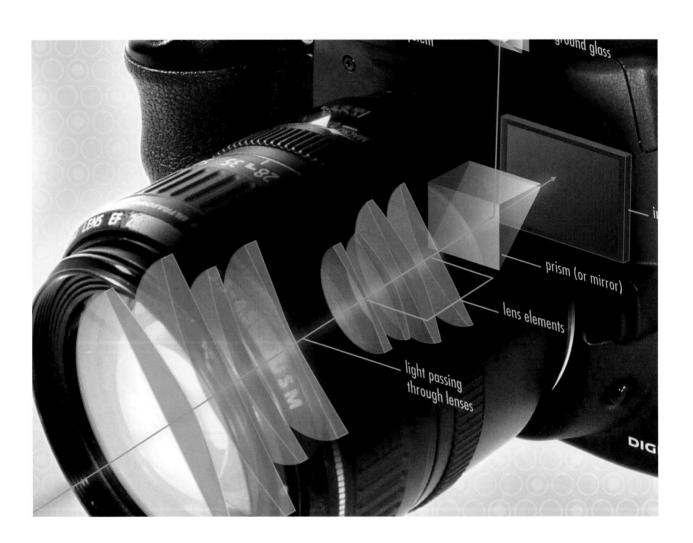

P A R T

Getting to Know Digital Cameras

CHAPTERS

CHAPTER 1 THE WORKINGS OF A DIGITAL CAMERA 6

"You push the button, we do the rest."

—George Eastman, 1888, pitching the first Kodak camera

PUT a digital camera next to a comparably priced camera that still uses film. What's the difference? Certainly it's not anything you can see: They both have a lens, some sort of viewfinder to peer through, and similar assortments of buttons and knobs.

The important difference between the two cameras is buried inside them. Take off the back of the film camera and you'll see a slot at one end where you insert your cassette of film and an empty spool on the other end to take up the roll of film as each frame is exposed. Between them is the shutter. When the camera back is closed, the film is held firmly against the frame around the shutter by a smooth flat surface called the *pressure plate*.

Take a digital camera and open the back—and you can't! There is no way to open it and see what's inside. That's what this book is for, to show you what you ordinarily can't see on your own. And what you'll see in this chapter is that all the apparatus inside a film camera—and the film itself—have been replaced by a **microchip** packed with microscopic electronic switches called **transistors**. This chip is similar to the microchips you've at least heard about in computers and wireless phones, and just about anything else these days that runs on electricity.

This particular type of microchip, as you'll see in more detail later in the book, is covered with a special type of transistor—millions of transistors, actually—that is sensitive to light and converts that light into electricity. The chip is called an **image sensor**, or an **imager**.

The image sensor's ability to translate different colors and intensities of light into constantly changing electrical currents is what accounts for the other important differences between digital and film cameras. The most obvious is that most digital cameras have an LCD screen on the back of them, like a tiny TV set, where the camera displays the scene to be shot or the photographs already stored in the camera. The LCD has its own array of transistors that do just the opposite of the imager's transistors: They convert electricity into light. (More about that, too, later on.)

If you inspect the two cameras closely enough, you might find some other differences. The digital camera might have, for example, a button or switch for something called **white balance**. It might have controls for onscreen menus, or for displaying information about a shot you've snapped, or a button with an icon of a trash can on it that's used for deleting files.

But that's about it. Those are all the differences you'll find by visually inspecting your digital camera—even if you tear it apart. With few exceptions, such as the aforementioned white balance, you use a digital camera just as you would a film camera.

But after you click the shutter, letting light fleetingly strike the image sensor, you've created not just one picture, but the possibility for scores of pictures. The future of that picture is limited only by your imagination. And as you'll see in Part 3, "How the Digital Darkroom Works," even your imagination can get a boost in digital photography.

CHAPTER

APICK

The Workings of a Digital Camera

AND there was, indeed, a time when it was just that simple. I recall my father's Kodak. It had a craftsmanship you don't see today. Not that it was built better than a top-of-the-line Nikon, Canon, or Konica Minolta. Those newer cameras communicate their sturdiness the moment you pick one up. Their precision is evident with each click of a dial or button, and you feel their dependability in the heft of a metal body, the sure movement of controls, and the quiet whisks and rumbles of the motors that go about their tasks without you.

But Daddy's Kodak was a lovely creation in its own right. There was a touch of the handmade in the leather bellows that grew out of the shallow box that held the camera safely when it wasn't being used. It had no motors. You cocked a spring manually to make the shutter snap open and close when you pressed a button at the end of a cable tethered to the lens.

The thing is, it took very decent photos. And it did so with few means to adjust exposure or focus—and with no opportunity at all to adjust settings we assume should be adjusted with today's cameras. There were no white balance controls, no bracketed shooting or exposure compensation, no depth of field to worry about, no flash or backlighting. You pretty much clicked the shutter and a week later picked up your photos from the drugstore.

Today's cameras, with all their automation and intelligence, are very easy to use. But you couldn't blame a novice if the sight of so many knobs and buttons makes him suddenly grow weak. It's not so bad if you take all the controls leisurely and a few at a time. That's what we'll do here to familiarize you with the lay of the land before you embark into the deeper territory of how digital photography works.

screen.

Gathering the Light

Here we're looking at two types of digital cameras. The small one is less expensive, so it doesn't have all the features found on the giant to its side. Both cameras, though, follow the same process when they capture a moment of time and space as millions of numbers that describe perfectly the shapes and colors that become a digital photo. Both cheap and expensive cameras start the process the same way—by gathering in light with all its shadows, colors, and intensities to channel the light to its digital metamorphosis. Here are the parts of a digital camera that kick off the show by latching onto the light.

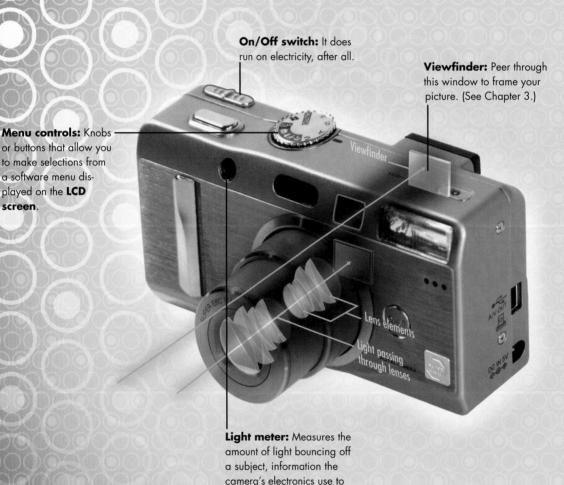

expose the picture correctly.

(See Chapter 4.)

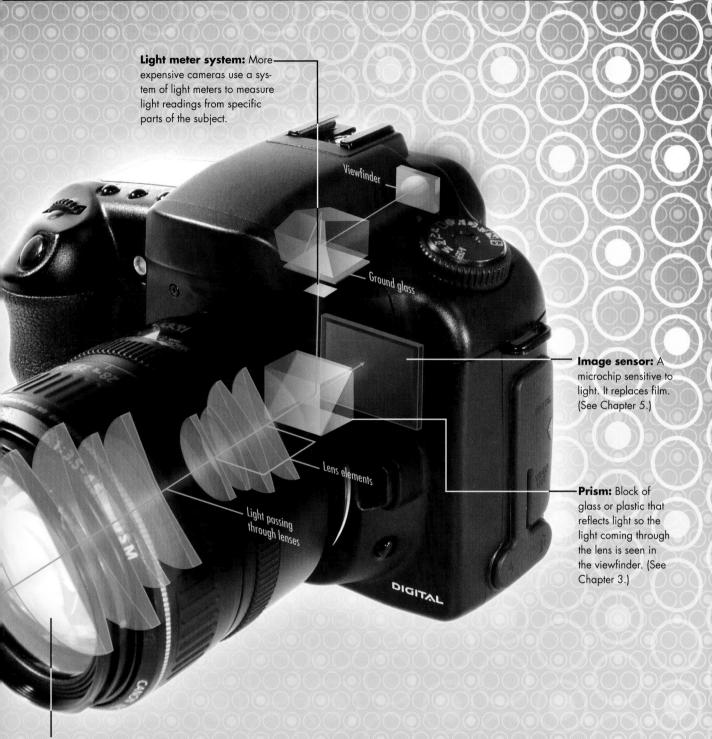

Lens: Collects light, passing it through a small opening to focus on a type of microchip called an **image sensor**. (See Chapter 2.)

Electronic circuitry: Like the motherboard in a computer, printed circuit boards send electrical signals scurrying from one part of the camera to another to control and synchronize the many functions of the camera.

Crafting Light into an Image

When light first strikes the lens, it is **incoherent** light, light that travels in all directions indiscriminately. The light might be no brighter than a shadow in a cave, or it might be the glare of the Sahara at noon. But that light is no more an image than mere noise is music. It's the role, mainly of two parts of a camera—the focus and exposure systems—to mold light into an image that captures and freezes one momentary slice of time and place. In the digital world, new tools let us refine the photograph even further, but the photography still starts with the tools that get the pictures into the camera in the first place.

Menu controls: Knobs or – buttons that allow you to make selections from a software menu displayed on the LCD screen.

Shutter button: A switch – that, when pressed, triggers an exposure by locking autofocus and autoexposure and opening the shutter. (See Chapter 4.)

White Balance button: Adjusts the camera so that, when the camera photographs a white object, it displays a "true" white regardless of how artificial lighting might introduce off-white hues. (See Chapter 4.)

LCD read-out window: Usually in combination with the digital control, this window tells you information such as the resolution, number of shots left, and battery power.

Infrared light source: The autofocus mechanism uses infrared rays that have bounced off the subject to determine the distance from the camera to the subject.

(See Chapter 2.)

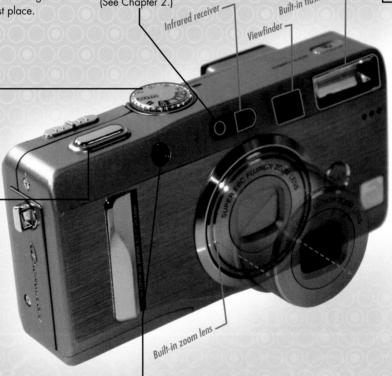

Light meter: A microchip that senses and measures the intensity of light striking it. (See Chapter 4.)

Rechargable Li-ion battery pack

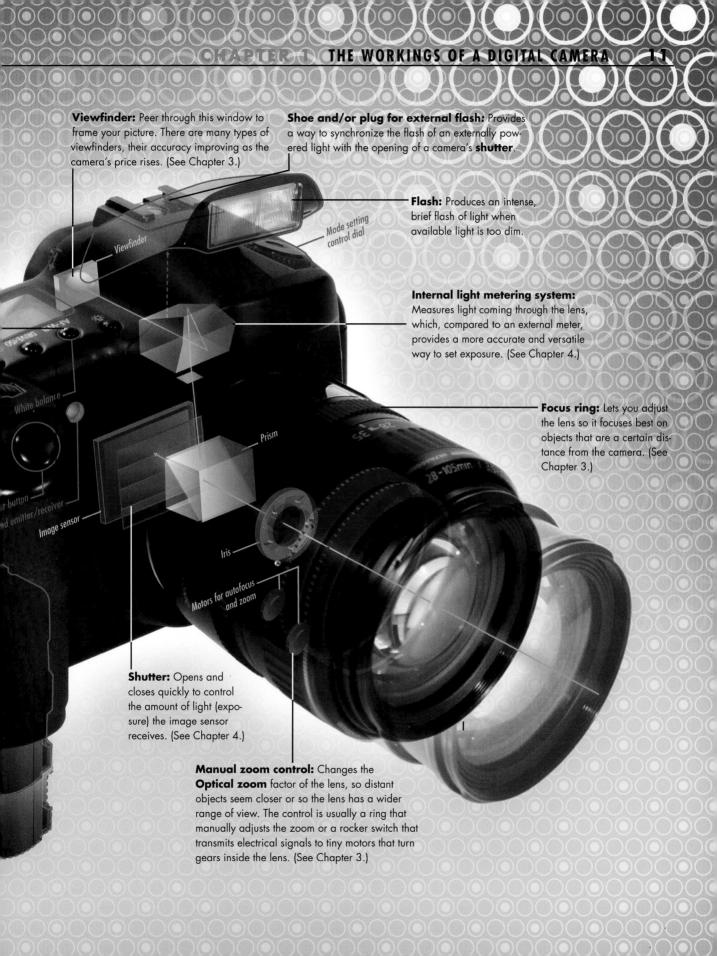

Storing the Image

After a camera has created an image from light, it has to put the image somewhere. Conventional cameras store images on film. Digital cameras store photographs in digital memory like a Word document or a database. Storage begins in your camera and continues to your personal computer.

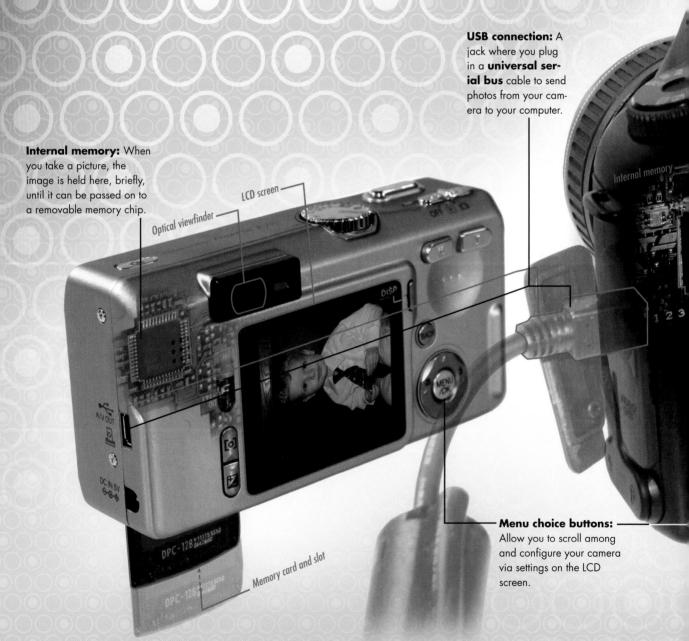

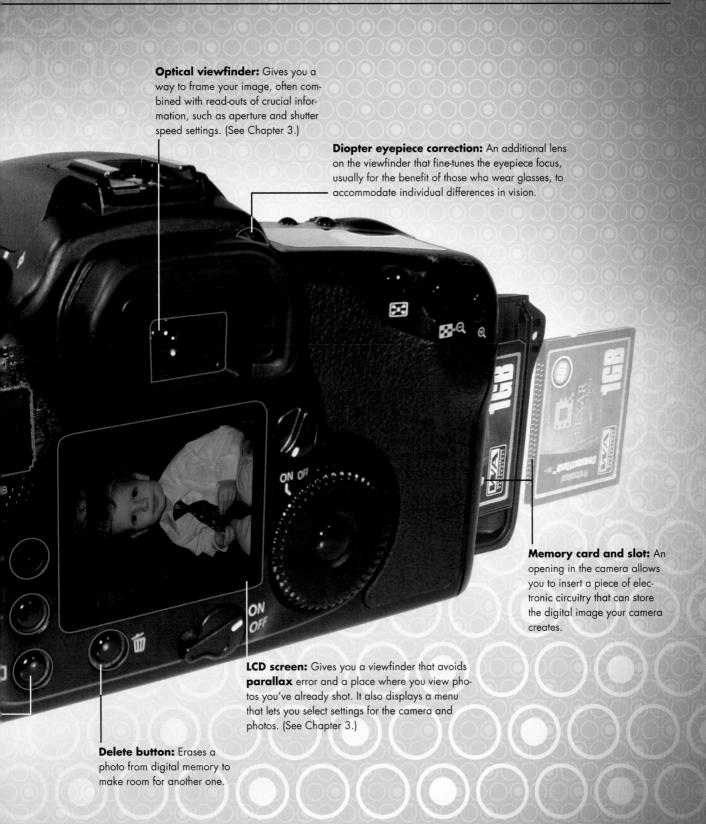

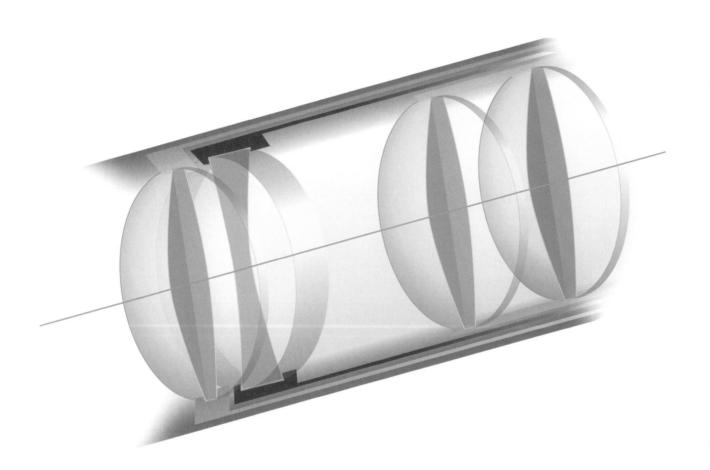

A R T

How Digital Cameras Capture Images

CHAPTERS

CHAPTER 2 HOW LENSES WORK 18

CHAPTER 3 HOW DIGITAL IMAGES TRICK THE EYE 36

CHAPTER 4 HOW DIGITAL CAMERAS CAPTURE LIGHT 64

CHAPTER 5 HOW LIGHT BECOMES DATA 86

"The camera is a remarkable instrument. Saturate yourself with your subject, and the camera will all but take you by the hand and point the way."

—Margaret Bourke White

IT'S possible to make a camera that has no lens. It's called a **pinhole** camera, and you can make one in just a few minutes. All it takes is a box with a tight-fitting lid that won't let light in. Punch a small hole—a pinhole made with a straight pin or needle—in the center of one side of the box. Because light enters the box through such a small opening, it does not spread out and become as diffused as does light that has unrestricted pathways. The result is a focused image striking the other side of the box. A pinhole camera is not only a fun project, but has been used by serious photographers to create excellent photographs. For more information, including how to build your own pinhole camera, check out Bob Miller's Light Walk at http://www.exploratorium.edu/light_walk.

Pinhole cameras aside, the lens is the most important part of a camera, digital or film. The image created on a sensor or film is only as good as the light focused on the sensor or film by the lens. In fact, the high cost of high-end cameras that professionals use is directly related to the quality of the lens in those cameras. The use of glass or plastic, how many pieces of plastic or glass make up the lens, and the precision with which its focusing and zooming mechanism works all determine the quality and price of a camera. In digital cameras, the sensitivity and size of the light sensor also contribute to the price, but a light sensor is a silicon chip, and we know that the prices of chips go down with mass manufacturing. However, high-quality lenses cannot be stamped out of a mold, and they will continue to be the most important and expensive part of a camera—digital or otherwise.

The most important function of the lens is to focus the light entering the camera so it creates a sharp, well-defined image on the film or sensor. The ways that lenses can focus that image made up by the light can vary widely. In general, you might focus the lens manually by turning a dial that fits around the lens. Or the lens might focus automatically by bouncing infrared light or sound waves off whatever you take a picture of. (This is true of film cameras too.) Or the lens might not change its focus at all. Cheap cameras—and there are cheap digital cameras and cheap film cameras—have lenses that more or less focus everything in front of the lens from a few feet out to infinity. (This is not as good a deal as it might seem at first glance.)

The lens brings the light into the camera, and other parts of the camera then turn that light into a picture. The **exposure** system creates a balance between the brightness of the light and the sensitivity of the film or image sensor. Again, digital cameras inherit the same mechanics used in film cameras. An **iris**, or **diaphragm**, made of overlapping pieces of metal opens and closes just like the iris in your eye. It determines how much light enters the camera and also influences the focusing of the image. A **shutter** then determines how long the light is allowed to strike the film or sensor, thus capturing an image.

How Lenses Work

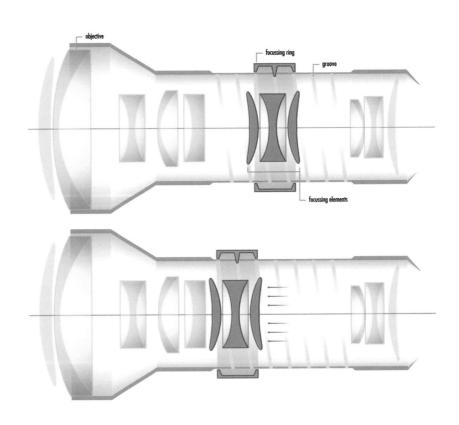

A lens can be made from a single piece of curved plastic or a complex system of crystal-clear disks of polished glass. When you pay a lot for a camera, film or digital, a big reason behind the price tag is the lens. A good lens delivers an image as sharp as an eagle's eyesight and is free of the distortions in color and shape that come with cheaper lenses.

The lens is the most important part of a camera. The image created on a sensor or film is only as good as the image created by light that the lens must focus. The use of glass or plastic, how many pieces of plastic or glass **elements** make up the lens, and the precision with which its focusing and zooming mechanisms work all determine the quality and price of a camera. Among digital cameras, the sensitivity and size of the light sensor also contribute heavily to the price, but a light sensor is a silicon chip, and we know that the prices of chips go down with mass manufacturing. But high-quality lenses cannot be stamped out of a mold, and they will continue to be the most expensive part of any good camera.

The most important function of the lens is to focus the light entering the camera so that it creates a sharp, well-defined image on the film or sensor. Control over that focus can involve turning a ring running around the barrel of the lens as you check the focus through the viewfinder. Or you might have nothing to do with it at all. The lens might focus automatically, or it might not change its focus at all. Cheap cameras—and there are cheap digital cameras and cheap film cameras—have fixed-focus lenses that bring into definition, more or less, everything in front of the lens from a few feet out to infinity. This is not as good a deal as it might seem at first glance. Everything is somewhat in focus, but nothing is sharply in focus. Plus, a good photographer doesn't always want everything to be focused. Blurred images have their place in photography, too.

After the lens puts the squeeze on light entering the camera, other parts of the camera manipulate the light further to turn it into an image with which the camera can work. The *exposure* system creates a balance between the brightness of the light and the sensitivity of the film or image sensor. Many digital cameras use precision mechanical devices inherited from film cameras to control exposure. A *diaphragm* determines how much light enters the camera—and also influences the focusing of the image.

A diaphragm is not the only device to control exposure. A *shutter* determines how long the light is allowed to strike the film or sensor. Traditionally, the shutter is a mechanical device. An *iris shutter* is made of overlapping pieces of metal arranged in a circle and forming a hole in the center. The metal pieces twist in unison to open or close the size of the opening, much like the iris and pupil in our eye. Other mechanical shutters consist of thin sheets of metal that cover the image sensor or film like a curtain.

The digital, microprocessor realm of photography, however, brings a new twist to the concept of a shutter. A few cameras simply turn on light-sensing transistors in the image sensor only long enough to absorb the right amount of light; then it switches them off. Nothing mechanical is involved. It's as if suddenly a window appears in a wall and then just as suddenly vanishes without a trace.

All that goes on in a camera before the image ever reaches the image sensor gives the photographer one of two grand opportunities for creativity. (The second is when an image reaches a digital darkroom, such as the one we'll use in Part 3.) *Photography* literally means "writing with light." As the light streams into the camera, the lens shapes it and the exposure system determines whether the light floods or trickles onto the digital canvas.

The digital camera takes photography to a magical realm, but as you'll learn from the illustrations in this chapter, some of a camera's oldest, nondigital components still pack some magic of their own.

How a Lens Bends Light

The lens performs multiple jobs when it comes to gathering the light that the camera then shapes into a photograph. The lens frames all the subject matter and determines how close or how far away they seem. The lens controls how much light passes through it, and which subjects are in focus. Framing with a viewfinder and the zoom controls still needs your aesthetic judgment. But with most digital cameras, the lens is happy to do all the focusing entirely on its own. Whether you focus the camera manually or let *autofocus* do the job, focusing works because of what happens when light passes through glass or plastic.

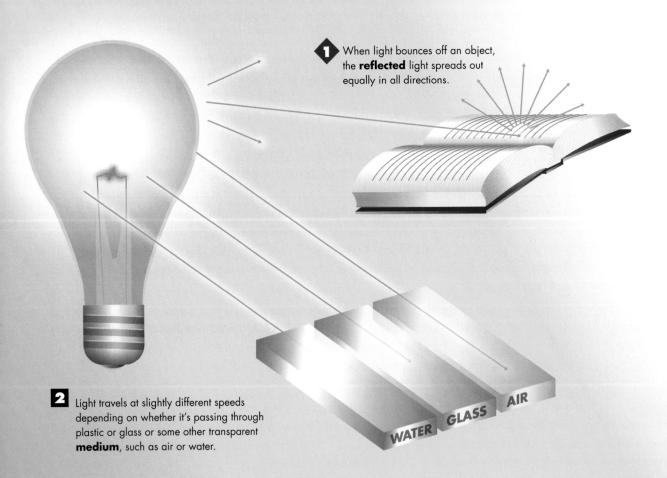

When a ray of light passes from the air into glass or plastic—the most common materials used for lenses—the light continues at a infinitesimally slower speed. It's like a speed limit enforced by the laws of nature.

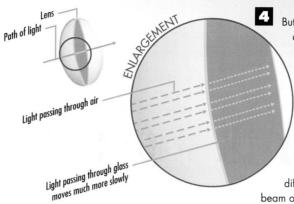

But if the ray of light is at an angle to the plane where air and glass meet, not all parts of the ray move at the same speed as they cross from air to glass.- The edge of a light beam that hits the glass first slows down while the opposite edge, still in the air, continues to move at a faster speed. The difference in speed results in the

beam of light traveling in a different direction. The effect is similar to a car that has its right wheels in sand and the left wheels on pavement. The right wheels spin without moving the car forward much. The left wheels, with more traction, push the car forward more than the opposite wheels, causing the car to skid to the right.

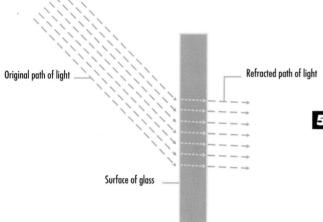

The process of bending light to travel in a new direction is called **refraction**. How much a substance causes light to bend, or **refract**, is called its **index of refraction**.

Refraction is the principle that allows a camera lens to create

a sharp, focused image.

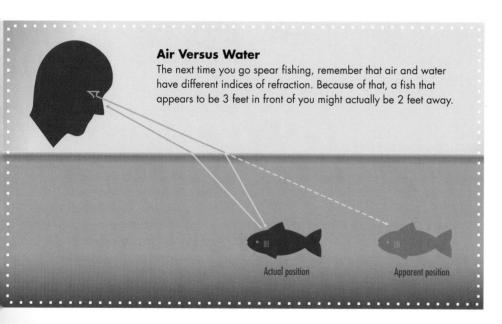

Left wheels continue to move forward while right wheels in sand fail to move

How a Lens Focuses an Image

You must remember boring, sunny summer days in your childhood when you took a magnifying glass outside looking for anything flammable. Having spied a dry leaf, you held your magnifying glass between the leaf and the summer sun. Moving the magnifying glass back and forth with the precision of a diamond cutter, you found the exact point where the magnifier's lens concentrated the sunlight to form an image of the sun on the hapless leaf. Within seconds, the concentrated rays of the sun caused a thin wisp of smoke to rise from the leaf. Then, suddenly, it burst into flame. You had just done the work involved in focusing a camera's lens, though with more dramatic results.

To create an image inside a camera, it's not enough that light bends when it goes through glass or plastic. A camera also needs the bending to apply to each and every beam of light that passes through the lens. And it needs the bends to be precise, yet different, for each separate light ray.

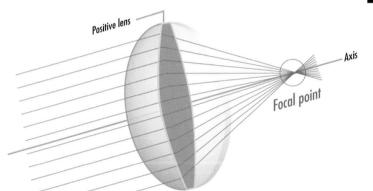

To make beams of light converge to a **focal point**—
like the hot spot on the leaf—the beams have to pass
through the glass at different angles from each other.
A **positive**, or **converging**, lens uses a smoothly
curved surface that bulges so it's thick in the middle
and thin at the edge, creating a **convex** surface.
One beam of light that passes dead-on through the
center, along the **axis** of the lens, doesn't bend
because it doesn't enter the lens at an angle.

All other rays of light traveling parallel to that center beam hit the surrounding curved surface at an angle and bend. The farther from the center that the light beams enter the lens, the more they are bent. A **positive lens** forces light rays to converge into a tighter pattern along the axis until they meet at a common focal point, where the energy in sunlight is concentrated enough to ignite a dry leaf. Positive lenses are also called **magnifying** lenses; they're used in reading glasses to magnify text.

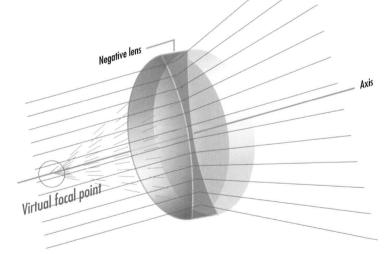

- A **negative**, or **diverging**, lens does just the opposite. It has *concave* surfaces that make the lenses thicker on the edges and thinner in the middle. Glasses for people who are nearsighted (who can't see distant objects well) use negative lenses.
- Light waves passing through a negative lens spread away from the lens's axis. The light waves don't meet, so there is no focal point that a leaf need fear. There is, however, a **virtual focal point** on the front side of the lens where the bent rays of light would meet if they were extended backward.

Focusing a clear image is a complex job that isn't done well by a single lens. Instead, most lenses consist of collections of different lenses grouped into **elements**. Together, they are able to focus objects at a multitude of distances from the lens with simple adjustments. Together, the elements determine the **focal length** of a lens. The focal length is the distance from the focal plane to the **rear nodal point** when the lens is focused at infinity. The rear nodal point isn't necessarily in the rear. In fact, it can be in front of the lens.

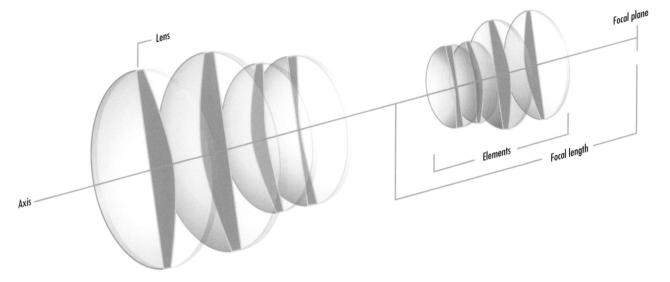

The Bend in the Rainbow

Not all colors of light bend at an angle when they pass through a lens. Different colors have different **wavelengths**, the distance between the high point of one wave in a beam of light to the high point in the next wave. That makes each color bend at a different angle, as shown in the drawing.

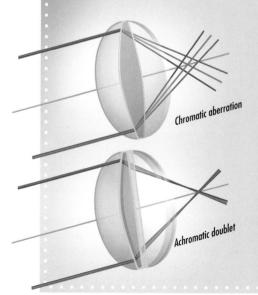

When light passes through raindrops, the drops act as lenses and break sky light into the colors of the spectrum. We call that a rainbow; when something similar happens in a camera, we call it chromatic aberration. In a photograph, it shows up as fringes or halos of color along the edges of objects in the picture, as in the photo shown here.

The aberration is prevented by an achromatic doublet, or achromat, a single lens made of two materials that are bonded together. Because each material has a different refractive index, their chromatic errors tend to cancel each other. The aberration is also corrected with image editing software, as was used on the second photo shown here.

Photos courtesy of Robert Tobler, who demonstrates the latter method at http://ray.cg.tuwien.ac.at/rft/Photography/TipsAndTricks/Aberration.

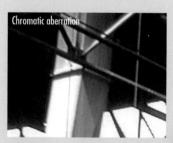

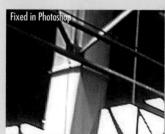

How a Lens Focuses an Image (Continued)

Let's go back to that childhood fascination with magnifying glasses that set the scene for the previous illustration. Take a closer look at the hot spot of light created by the magnifying glass. You'll see that the spot's actually a picture, a small image of the sun. Now, remember how you moved the magnifying glass back and forth until it was just the right distance to start a flame? You were focusing the picture the magnifier made on the leaf. In a camera, you have a lot of controls Image sensor

and sensors to help you focus, but basically you're still moving the lens back and forth.

At point A, the car absorbs all the light except orange rays. From that one point billions of rays of faintly orange light spread out in a constantly expanding sphere. The farther the light travels, the more it thins out. Without a lens, all but one ray of light spread out, away from point B. The only ray of light from point A that can wind up at point B on the surface of an image sensor, or film, is the one traveling in a straight line from A to B. By itself, that single point of light is too faint for the sensor to register significantly.

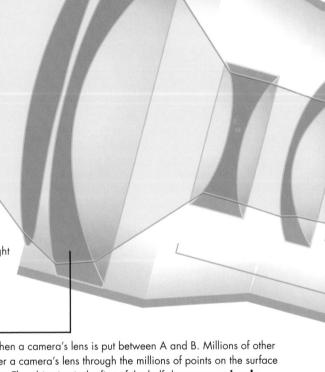

Objective

That changes when a camera's lens is put between A and B. Millions of other rays from A enter a camera's lens through the millions of points on the surface of the **objective**. The objective is the first of the half dozen or so **simple** lenses that make up the camera's compound lens. The simple, single lenses are distributed along the same line among separate groups called **elements**. The multiple lenses, which might mix positive and negative lenses, compensate for each other's defects in the way that two lenses fix chromatic aberration, which was shown in the previous illustration. Also, as you'll see, the compound lens design allows precise focusing and zooming.

Curves Ahead

There are two basic types of **simple lenses**: positive and negative. A **positive convex lens** causes parallel light rays entering one side of the lens to converge at a focal point on the other side. A **negative concave lens** causes parallel rays to emerge moving away from each other, as though they came from a common focal point on the other side of the lens.

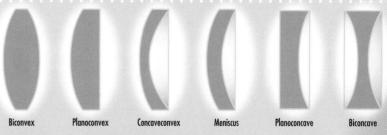

With these two basic shapes, optical engineers have engendered a variety of **multiple lenses**, which bond two simple lenses with a transparent glue. Simple and multiple lenses go into making **compound lenses**, which use different combinations of lenses to herd light rays into the corrals of film, eyes, and imaging sensors. Here are some variations on combinations of simple lenses, all of which can show up on the same camera.

The same process occurs for every point on the car that can be "seen" by the camera lens. For each point on the race car, there is a corresponding focal point for all those light rays that bounce off those points. All together, those focal points make up a **focal plane**. The plane is where you find the surface of a digital imager or a strip of film. Light that is focused on that plane produces a sharp, focused photo.

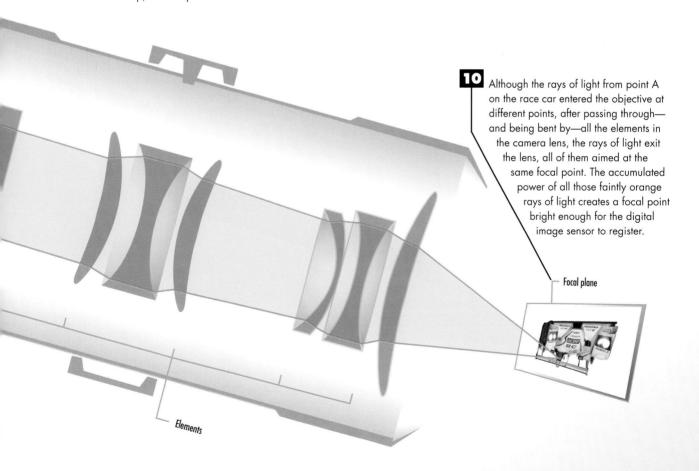

How a Lens Focuses an Image (Continued)

12 You can more easily understand focus if you see why some images are unfocused. Picture focused rays of light—the ones converging on a point of the focal plane—as a cone. If there's nothing at the focal plane to stop them, such as film or a digital image sensor, the light continues on to form another cone that's the mirror image of the first.

Rather than bring an object into focus by walking toward or away from it, the photographer turns a focus ring that runs around the barrel of the lens. (Virtually all digital cameras also provide autofocus, which adjusts the lens without the aid of the photographer. That's the subject of the next illustrations.)

Attached to the ring is a part of the lens's barrel with a spiral groove cut into it. As the groove turns with the focusing ring, it moves a pin from another part of the barrel. The groove-pin arrangement translates the focus ring's circular motion into linear motion.

That motion, in turn, moves the lens elements toward and away from one another. The different distances among them change the optical effect they have on each other and shift the paths that light beams take as they careen through the lenses. When the light rays reach the digital image sensor, the optical changes now bring to focus a part of the scene that's closer or farther away.

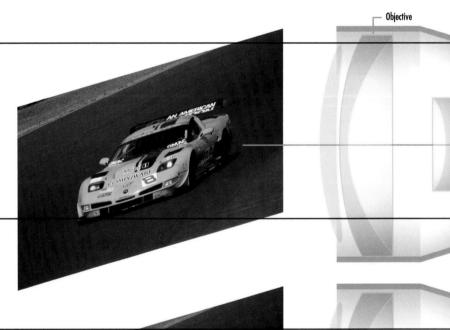

Focal plane

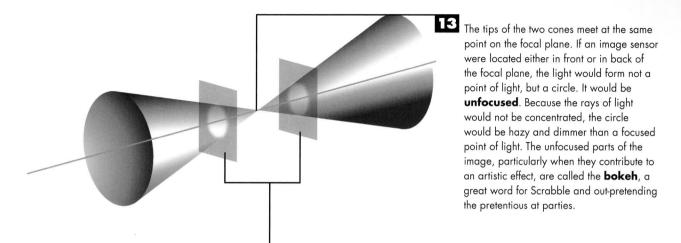

The location of a focal plane is partly the result of the optical characteristics of the lens and of the distance from the lens to the subject.

Objects at different distances, some too close to the lens and some too far away, will be out of focus.

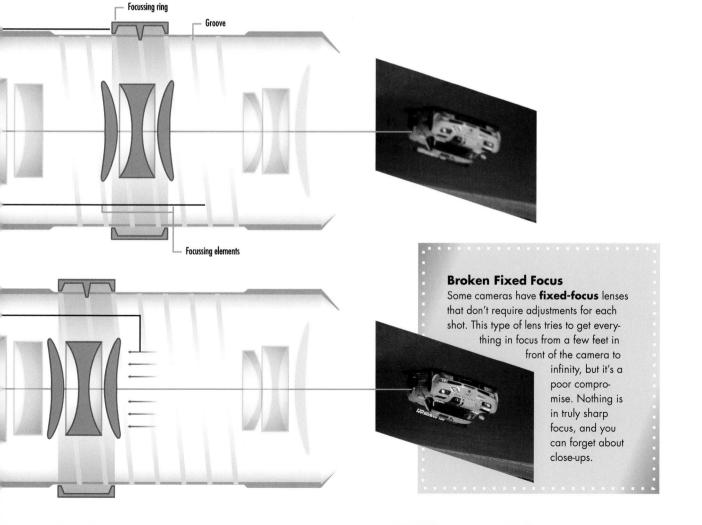

How Active Autofocus Makes Pictures Sharp

Photographers can't always rely on automatic focusing because it's subject to the vagaries of any mechanism that cannot see but pretends it can. For the most part, autofocus has all but eliminated pictures of relatives with fuzzy faces and blurred birthday bashes, and it's a must for action shots and subjects who won't stand still for a portrait. The implementations of autofocus are as diverse as the minds of the ingenious engineers who invent them.

We'll look here at two types of **active autofocus** found on less expensive cameras. One is akin to the echo technology of radar and sonar; the other is based on the triangulation used in rangefinders. Over the next few pages, we'll also take a look at passive autofocus designs and the motor that makes

Echo Active Autofocus

them all work.

When a photographer presses the shutter button, it sends a burst of electricity to a **trans-ducer** on the front of the camera. A device that changes one form of energy into another, the transducer generates volleys of infrared light toward the subject of the photograph.

When the infrared light bounces off the subject and returns to the transducer, it picks up each burst. The transducer turns the light energy into electrical currents that tell the camera's circuitry how long it took the infrared light to travel from the camera to the subiect and return.

The round-trip time for the light takes a little under 2 milliseconds for each foot from the camera to the subject.

The measurement of that time goes to a microprocessor that controls a small motor built into the lens housing.

The motor rotates to a position that's been calibrated to focus on an object at the distance determined by the infrared bounce.

This type of autofocus works with subjects no more than about 30 feet from the camera. With any subject farther than that, the returning light is too faint to register. In that situation, the camera sets the lens to **infinity**, which brings into focus any subject from 30 feet to the farthest star.

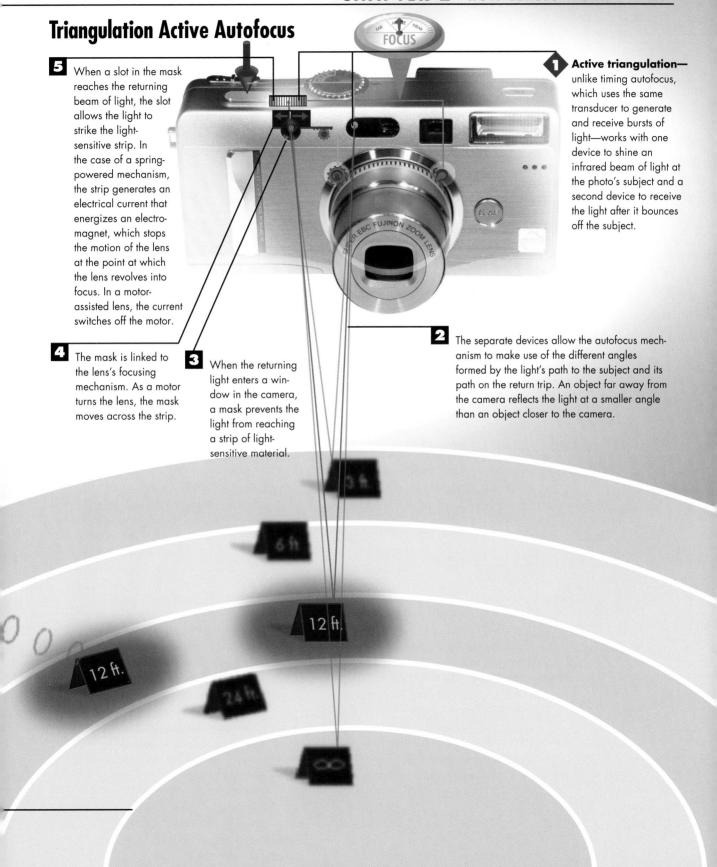

How Passive Autofocus Sees Sharp and Fuzzy

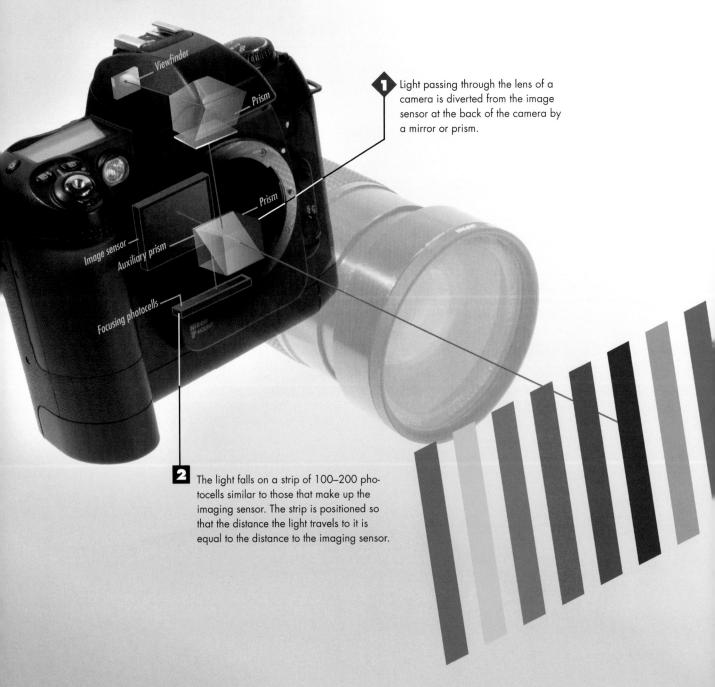

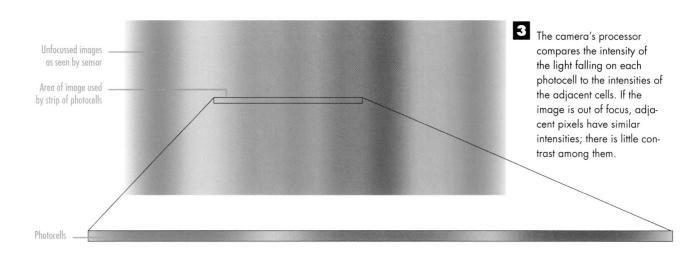

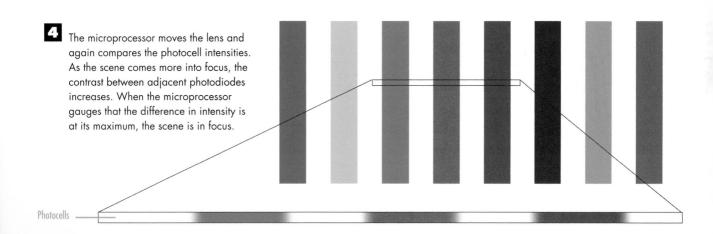

Autofocus Limitations

Both passive and active autofocus have advantages and disadvantages. Active focusing works at night and in dim lighting, but the infrared light can bounce off glass or mirrors, confusing the camera's processor. Using passive focusing, you aim through windows and there are no distance limitations beyond which it cannot work. But a blank wall or a scene devoid of straight edges, particularly vertical lines, throws passive autofocus for a loop.

To minimize the effects of shooting through glass, the photographer can put the lens directly on the glass. The infrared light passes through the glass. Any light that bounces back makes the trip too quickly for the camera to use its timing information.

With passive autofocus, turning the camera 90° can give the camera the perpendicular lines it needs. In scenes with little contrast, try focusing on an object elsewhere about the same distance away as your subject. Then keep the shutter button pressed down about halfway as you turn to frame your real subject. On some cameras, holding the button locks the focus until you press the button all the way to shoot your photo or until you release it.

Any automatic focusing camera must have a motor to move the lens elements to bring the subject into focus. That's not a simple task when you consider how much speed and precision the camera requires and how little space the lens provides to hide a motor. As with the autofocus mechanisms devised to measure the distance from camera to subject, camera makers have come up with several ingenious ways to slip motors into minuscule spaces. We'll look here at a motor designed by Canon that many other camera manufacturers have adapted: the **ultrasonic motor (USM)**.

The ultrasonic motor is built on a phenomenon called the **piezoelectric effect**. The effect turns up in certain substances, such as the ceramic **lead zirconium titanate (PZT)**. When an electrical voltage is applied to a strip of PZT, the ceramic expands in one direction and compresses in the other. If the voltage's **polarity**—the plus or minus charge—is reversed, the ceramic now compresses in the first direction and expands in the second.

To create a **piezo bender**, or **bimorph**, PZT is bonded to both sides of a thin strip of steel spring metal. A positive charge is applied to one side and a negative charge is applied to the other side. Now the only way the ceramic can expand or contract is to bend the metal strip. The negatively charged side bends out and the other, positively charged, side bends inward. If the charges are reversed, the bimorph bends the opposite way.

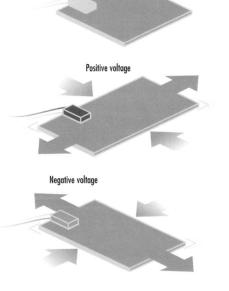

No charae

Piezo ceramic (PZT)

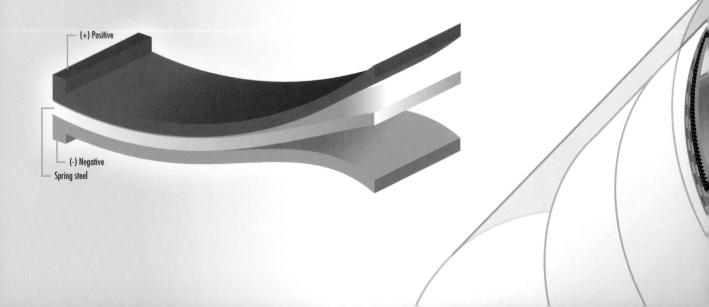

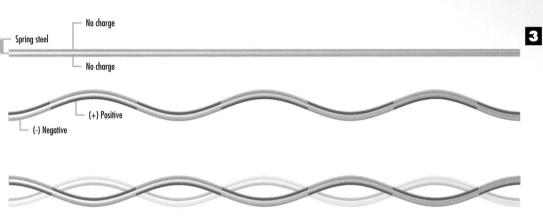

The next step in creating a piezo motor, or actuator, is to send opposite charges to alternating sections of the bender. The charge on one section makes the bender bow out at the same time the opposite charges going to the sections on either side make them curve inward.

By using an alternating current that switches its polarity several times a second, the bender seems to ripple as the adjacent sections bend first one way and then the other, looking like waves that have up-and-down motion but no lateral movement. The amplitude of the combined waves is only about 0.001 mm, but it's enough movement to power adjustments on even a weighty telephoto lens.

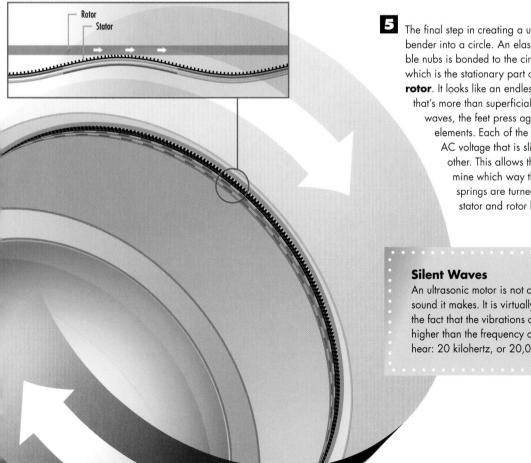

The final step in creating a ultrasonic motor is to mold the bender into a circle. An elastic material studded with flexible nubs is bonded to the circle's rim, creating a **stator**, which is the stationary part of a machine that moves a rotor. It looks like an endless caterpillar, a resemblance that's more than superficial. As the piezo strip makes waves, the feet press against the rotor, turning the lens elements. Each of the two layers of PZT has its own AC voltage that is slightly out of sync with the other. This allows the autofocus control to determine which way the rotor turns. When both springs are turned off, the friction between the stator and rotor holds the focus steady.

An ultrasonic motor is not called that because of the sound it makes. It is virtually silent. Ultrasonic refers to the fact that the vibrations of the piezo waves are higher than the frequency of sound waves humans can hear: 20 kilohertz, or 20,000 vibrations a second.

How the Eye Controls Autofocus

Few things are as easy as simply looking. You turn your eye, and everything else happens automatically. Muscles tug on the cornea to pull it into the proper shape to bring into focus whatever you're looking at. Other muscles contract or relax their holds on the iris so that the pupil shrinks in bright light or expands in dim

light so the light-sensitive cells lining the retina at the back of your eyeball see details without strain. If only other things, such as focusing a camera, were so easy. If the true object of your photo isn't dead-center in your viewfinder, most cameras—digital or film—require you to do a slight of hand with the shutter button, aiming at where you want it focused and then pressing the button halfway while you frame the picture for real. But some cameras, pioneered in the film days by Canon, have found a way to make focusing, literally, as simple as looking.

- Focus screen

When the photographer puts his eye to the viewfinder, he sees an image that has come through the camera lens and been reflected up to a focusing screen, a plate of glass that has been ground to have a rough surface on one side. The rough surface catches the light so it can be seen, like the image on a rear screen projection TV.

The photographer sees the image on the screen after it has passed through a prism, which flips the reversed image from the screen 180° so the photographer sees the image in its proper orientation.

7 From that comparison, the micro processor quickly determines what part of the image the photographer is looking at. It conveys that information to the camera's focusing mechanism, which is capable of evaluating up to 21 metering zones that are linked to 45 autofocus points that cover the whole frame of the picture. The signals tell the autofocus which of the zones to pay attention to, and the autofocus sends

signals accordingly to motors that adjust the lens to focus on

the target of the pho-

tographer's eye.

Dichroic mirror

Infrared LED

The sensor detects the image of the eyeball, iris, and pupil and sends information about the location of the eye's image on the sensor to a microprocessor.

Earlier, to calibrate the mechanism to the physiology of the picture taker's eye, the photographer had looked through the viewfinder in various directions. The processor stored the images that the eye's movement made on the processor during the calibration. Now it compares the new information from the sensor with the stored data.

The infrared light reflects off the eye. It passes, with no noticeable distortion, through a lens used to focus the photographer's vision on the reflected image from the ground glass. Then the infrared light reflects off a dichroic mirror set at an angle. A mirror has a thin coating of transparent metal oxides chosen, in this case, to reflect infrared light while letting visible light pass through the mirror.

The reflected light passes through a lens that focuses the image of the photographer's eye on a **complementary metal oxide semiconductor (CMOS)** autofocus sensor. This is an array of CMOS photodiodes that creates a current when they are stimulated by the infrared light.

Eyeball

At the same time an infrared **LED** (**light emitting diode**) shines light, invisible to the photographer, on his eye.

C H A P T E R

How Digital Images Trick the Eye

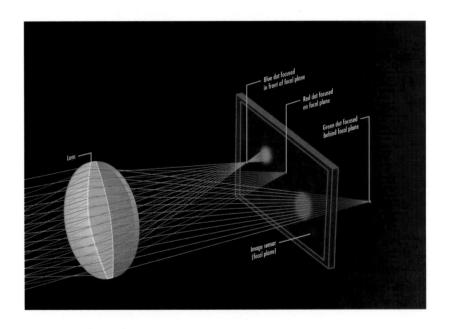

YOU'RE about to embark on a journey into the Twilight Zone of photography. It's a world halfway between the realities of physics and the perceptions of the human mind, between the harmonies of light and the vagaries of vision. It's a land inhabited by strange, only half-seen entities called Airy discs, living only a quantum leap away from perpetual circles of confusion. Optical physics is not frequent dinner conversation, with good reason. It borders on the most esoteric fields of scholarship without the wonder generated by the likes of black holes and quarks.

Ask half a dozen photographers to explain phenomena they live with every day—depth of field, perspective, foreshortening—and you're likely to get six different explanations of how it all works. You could, of course, disregard entirely the scholarly approach to this arcane knowledge, to understanding what your digital camera is doing when you shoot a picture, but you've gone this far. And if you dare to take those final steps, chances are your mind will hold together long enough to make the return trip. Chances are....

Just remember this as you proceed on your trip: Don't always believe everything you see.

How Viewfinders Frame Your Pictures

Using the viewfinder on a camera is so instinctive that we hardly give it a thought. It's literally point and shoot. Earlier photographers didn't have such an easy time of it. To see what their cameras saw, the photographers had to drape heavy black cloths over their cameras and their own heads. This was to shut out surrounding light so they could see the dim image the lens projected on a sheet of **ground glass** at the back of the bulky camera. The glass is etched so the light doesn't just pass through invisibly. The roughness makes the light's image visible the way dirty film on a windshield picks up the light from oncoming headlights. Ground glass is still used in cameras today, but you can leave the black cloth at home.

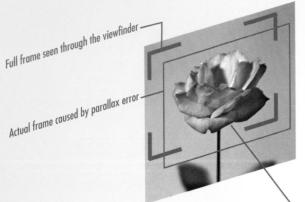

In less expensive cameras, the viewfinder is a simple hole through the camera's case with a plastic lens to make the scene framed in the camera approximate what the photograph will contain.

Because the viewfinder is not in a direct line with the camera's lens, the viewfinder actually frames a scene a bit to the left and above the photograph frame. The error is called **parallax**. The effect is more noticeable the closer the subject is to the camera.

The viewfinder compensates for parallax error by including lines along the upper and left sides of the frame to give the photographer a general idea of what parallax crops out of the picture.

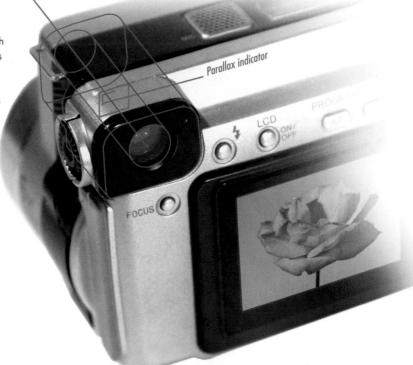

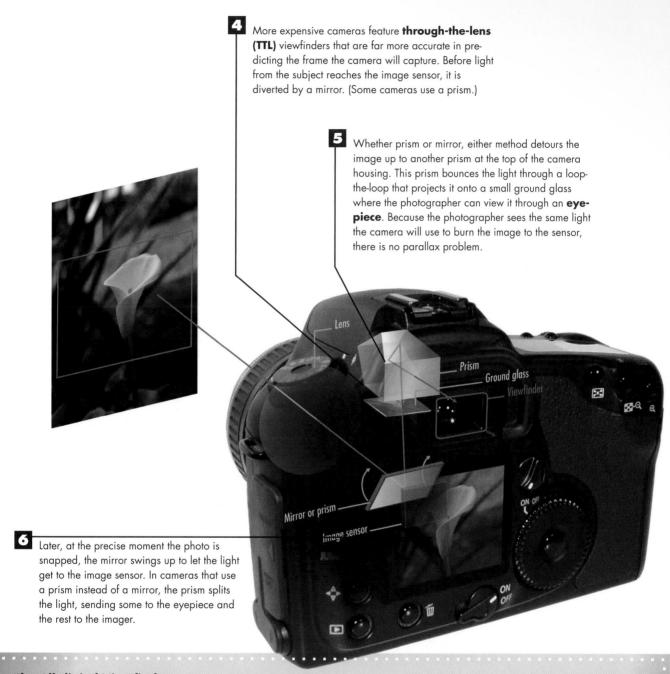

The All-digital Viewfinder

The **electronic viewfinder (EVF)** on a compact digital camera sits right in front of the eyepiece, where in a TTL camera you'd find the ground glass. It works like a TV screen receiving a live feed from the lens. Not to be confused with the large LCD screen on the back of most digital cameras—still another way to frame a snapshot—the EVF is about one half-inch diagonally; has some 200,000 pixels; and uses a small lens in front of it to magnify the image when seen through the eyepiece. Electronic and optical viewfinders have their pros and cons. TTL images are sharper and don't drain the battery. EVFs are quieter because there's no mirror to flip up, and some are mounted on a swivel so you can pull them away from the camera body to let you frame shots that otherwise might require you to lie on the ground to get the angle you want.

How Lenses See Far and Wide

The obvious jobs of telephoto and wide-angle lenses are that the telephoto lenses make things that are far away look close. Wide-angle lenses make things that are close look farther away, but they also stretch a photo to cover peripheral areas that would otherwise escape capture. But it's not as simple as that. Telephoto lenses don't exist simply so you won't have to walk closer to your subject, and wide-angle lenses aren't just for taking shots in small rooms where you can't step back any farther. Both types of lenses have serious effects on how sharp a scene is at different distances, and they're important tools to show what's important in a photograph. They can make subtle or exaggerated statements about what you're taking a picture of. Here's how they work.

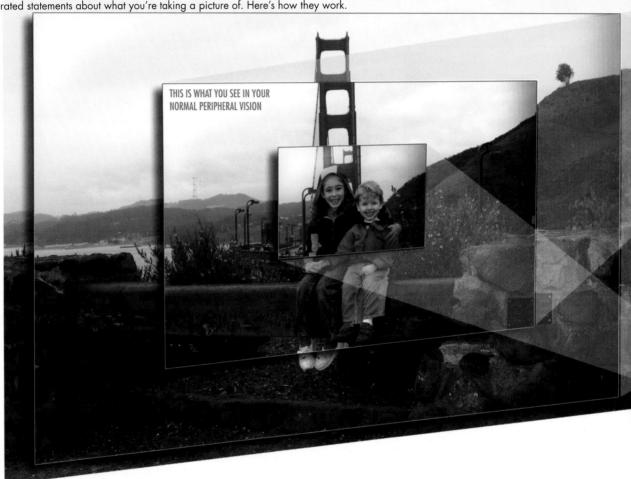

The images shown here are for photographs taken with different focal length lenses but at the same distance from the subject. They are also taken with digital cameras that have the same size image sensor. Toward the end of this chapter, you'll see the effect of changing distances and sensors.

The Normal Lens

In 35mm photography, a lens with a focal length of 50–55mm is considered normal. This is based on a rule of thumb that a normal lens's focal lenath is equal to the diagonal distance of the image formed on the film—or today, on the image sensor. For cameras with different image proportions, normal lenses have different focal lengths. For a camera using 2 1/4" square film, for example, the normal lens has a 75mm focal length. This is important in evaluating digital cameras, which have no standard image sensor size. (See "How Digital Tech Changes the Way Lenses Work," later in this chapter.)

When you look through the viewfinder of a camera with a normal lens, your subject looks about the same size, roughly, as it does to your naked eye. The lens elements are designed to focus the rays of light passing though them while still forcing them off their straightforward paths as little as possible.

28mm

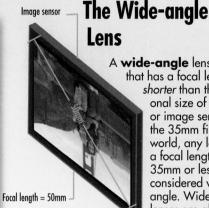

A wide-angle lens is one that has a focal length shorter than the diagonal size of the film or image sensor. In the 35mm film world, any lens with a focal length of 35mm or less is considered wideangle. Wide-angle lenses are also

called short lenses.

Looking though the viewfinder of a cam-

era equipped with a wide-angle lens shows you more than you would normally see with your peripheral vision if you simply Focal length = 28mm

stared straight ahead. It includes areas you would ordinarily have to turn your head to see. (The extreme is a lens with a focal length of 15mm or less. These are called **fisheye** lenses, so named because of their bulbous

shape that takes in a 180° angle of view essentially everything that's in front of the camera.) The design of a wideangle lens emphasizes converging positive elements that squeeze together the rays of light that pass through them. By the time the rays reach the image sensor, individual objects in the scene are small but a wider expanse now fits on the

sensor.

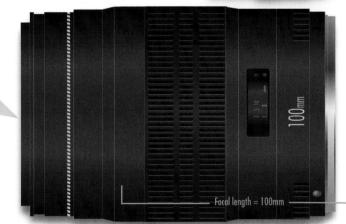

The Telephoto Lens

The **telephoto** lens has a focal length that is *longer* than that of the image sensor's diagonal. (They are also called *long* lenses.) In 35mm terms, telephoto lenses are those with focal lengths that are longer than 65mm, but for digital cameras the minimum focal length to be a telephoto shrinks to 50mm. It all depends on the size of the image sensor. A camera with an image sensor whose diagonal measure is half that of 35mm film requires only a 300mm lens to get the telephoto power of a 600mm lens on a film camera.

Not surprisingly, the design of a telephoto lens depends on lens elements that are the opposite of those in a wide-angle. They employ **negative**, or **diverging**, lenses that spread the light rays out of the center axis of the lens. The result is that the image that entered the lens covers a wider area by the time it reaches the image sensor. The sensor records a smaller center area of the total image with the effect that the area is enlarged in the photograph.

How Digital Lenses Manipulate Space

Telephoto and wide-angle lenses do more than change the size of your subject or the breadth of your image. They also change the relative sizes and relationships among individual objects in the photograph. A common misunderstanding is that lenses with different focal lengths change the perspective in photographs. For example, look at the three cubes shown here and guess which are representative of objects shot with a wide-angle, normal, or telephoto lens.

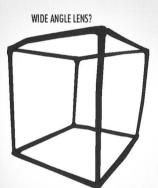

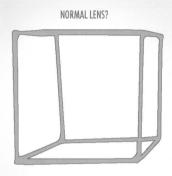

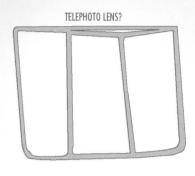

You probably guessed immediately that that was a trick question. The answer is that all the photos were shot with a digital camera using the same focal length. To be precise, they are all part of the same photo, as seen below.

What actually changes the perspective is the distance from the camera to the subject being photographed. The box nearest the camera was the most distorted: the box farthest from the camera appears to be more like a regular cube. What causes the distortion is perspective. Another of life's visual illusions that we've come to accept as reality, perspective compresses space in proportion to the distance from the observer to what's being observed. (If the objects being observed were small enough originally and are extremely far away, they disappear entirely at the appropriately named vanishing point, sort of an optical black hole except that it doesn't actually exist and objects don't really vanish.)

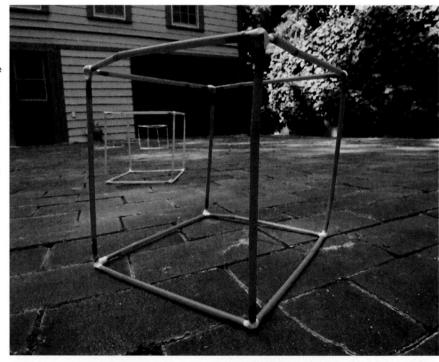

Perspective is not a factor of distance alone. The picture of the cubes was taken deliberately with an extreme wide-angle lens to exaggerate the perspective distortion. A normal or telephoto lens the same distance from the first box would not be able to capture the same distortion because its **angle of view** is not as wide as that of a wide-angle lens. In the example here of different angles of view for different focal lengths, keep in mind that these are for 35mm film cameras. As you'll see in a later chapter, the same focal length gets different results from different digital cameras. A wide-angle lens allows the photographer to get close enough to the front of the cube so that the far side of the cube is twice as far from the lens as the front of the cube. If the photographer stepped back 10 feet, the back of the cube would be only 0.06 times as distant from the camera compared to the cube's front.

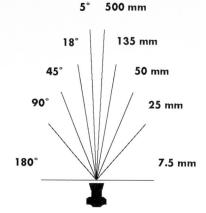

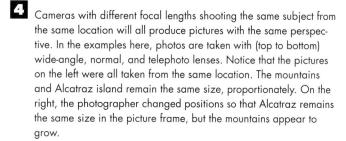

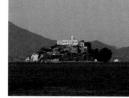

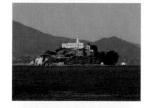

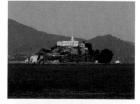

Lens Trickery in the Movies

Tricks using perspective are a staple in the movies. Anytime you see a car race or chase that involves cars weaving in and out at high speed, notice that you're looking at the race from behind or in front of the weaving cars, never from the side. The trick here is to use a long lens from far away. Perspective seems to compress the space between cars, so that whenever one car weaves in and out of traffic at breakneck speeds, it appears to be missing the other cars by inches, as demonstrated in the first photograph. If the chase were shot from the side—which it won't be—you'd see that in actuality, there are several car lengths between cars and the car doing all the weaving slips into places as easily as a supermodel trying on a fat lady's dress.

HEAD-ON VIEW

OFFSET VIEW

Negative element -

How Zoom Lenses Zoom

A single zoom lens lets photographers range through an infinite number of focal lengths from wide-angle through normal to telephoto. At first, the zoom lens was scorned by professional photographers because it lacked the image clarity of a fixed focal length lens. Not surprising. Zoom lenses have as many as 30 separate lens elements that move in complex patterns. Because advances in optics have improved the sharpness of zoom lenses today.

Front of lens

Path of light -

lens elements that move in complex patterns. Because advances in optics have improved the sharpness of zoom lenses today, zoom lenses are accepted by photo pros and are a standard fixture on most digital cameras. The dozens of designs for zooms are still complex, but the con-

cept for many boils down to the simplified zoom lenses we have here.

Light bouncing off the subject of your photo begins the journey to create a photograph when it enters the front

of your zoom lens.

Specifically, the light first passes through a part of the zoom called an **afo-cal** lens system. Afocal means what it sounds like: It has nothing to do with focusing the image. The afocal system con-

ments that are concerned only with the size of the image when it reaches the image sensor at the back of the camera. That size is a direct result of the posi-

sists of three lens ele-

tions of the three elements. Their positions come from the photographer operating the lens's zoom control. The afocal part of a zoom lens has two positive elements—the type that bends light rays outward to create a bigger image. Between those two is a negative element, which makes images smaller. The elements in this illustration are reduced to a single simple lens for each element.

The positive element closer to the camera end of the lens doesn't move. The other positive element (at the front of the lens), along with the negative element, moves in response to the photographer's use of the zoom control.

Telephoto positions

Zoom lens afocal system

Fixed-focus lens

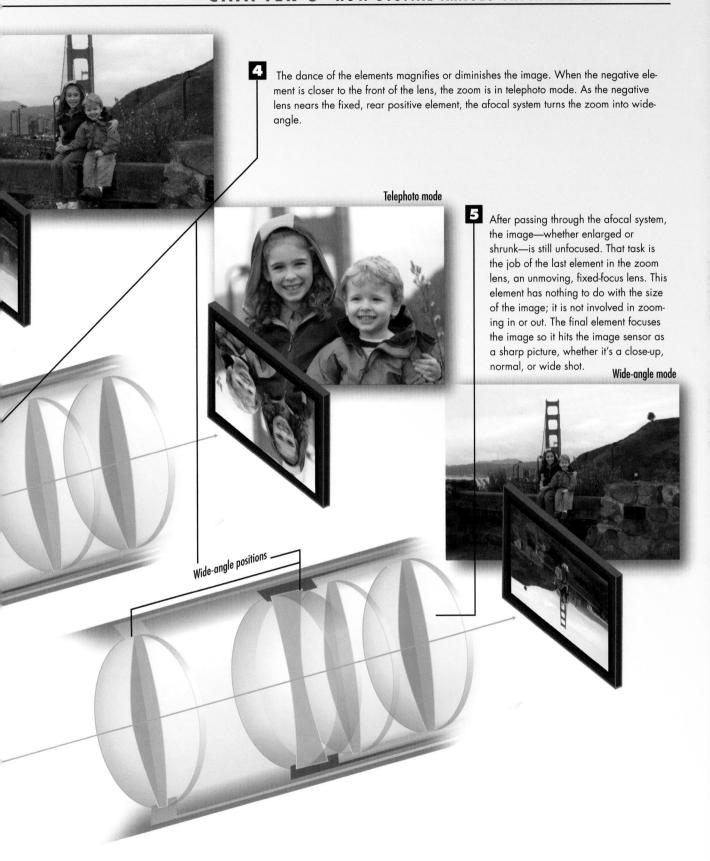

How Digital Zoom Fakes It

Most digital cameras give you both optical zoom and digital zoom. Optical zoom, as you saw in the previous illustration, uses the laws of optics to bend light so that a single lens takes on both the long-distance qualities of a telephoto lens and the expansive vision of a wide-angle lens. Digital zoom uses the blather of the marketing department to sell folks on the idea that they are getting more if their new camera has a 10X digital zoom. They aren't. In fact, a digital zoom only gives you educated guesses about what a picture would look like if it had been shot with a telephoto lens. Some guesses are pretty

good, but they're never as good as those from a true, optical zoom. All digital zooms can be created with more control and finesse after you transfer your shots to your computer. Here's how image editing software, either on-the-fly in your camera or on your PC, makes something out of nothing.

A digital zoom begins by concentrating on just the center portion of the image frame: the same portion that would have filled the viewfinder and the entire image using an optical zoom.

Software built in to a chip inside the camera expands the pixels that are in the area being zoomed so that the pixels fill the frame evenly. This leaves pixel areas that are blank surrounding pixels that contain fragments of the image.

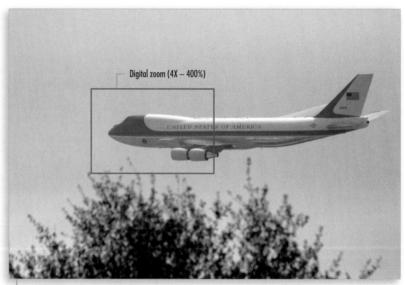

- Normal lens

Digital zoom (4X – 400%)

UNITED STAT

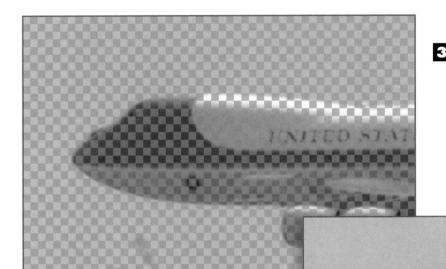

The software built in to the camera compares each blank pixel with the colored pixels nearest it. The software runs the adjacent-color values through a formula to determine which color the blank pixel area would most likely be if the picture were a true zoom.

The software fills the missing pixels with colors based on its educated guess to produce an approximation of what an optical zoom lens would have picked up.

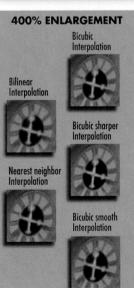

Spy in the Sky

In a common scene in movies and television, a blurry photograph is enlarged again and again until the identity of the enemy spy is revealed. That's fiction. In reality, only so much detail can be drawn from a picture if the visual information is not there to begin with. The formulas, or algorithms, used by a camera's digital zoom or by photo editing software vary in their complexity and the speed with which they can be computed. They also vary in the results they produce. Here are some comparisons between images shot with a lens zoom and the common types of software enlargements used for digital zooms.

How We Perceive Detail

In all the photographer talk about resolution, focus, and depth of field—which we'll get to after we lay a foundation of these pages—it's easy to lose sight of the ultimate restriction to how much detail you can see in a photo—the human eye. The biggest asset in seeing detail is imagination, the ability to make logical connections to fill in the details that are smaller than digital film can capture or photo printers can reproduce or the eye can discern. The tricks our perceptions pull on us are particularly important in digital photography because the technology squeezes the size of digital "film" to an area smaller, usually, than even the 35mm frame. That pushes the concepts of resolution and detail into even finer distinctions and even smaller realms. That's where human vision encounters the, no kidding, Airy discs and circles of confusion...strap yourselves in and keep your hands inside the cart at all times for this one

A point of light, like other points having no width or breadth, is an abstraction. The closest thing to a physical point of light is a spot of light called an **Airy disc** (after astronomer George Airy, who first noticed the phenomenon). An Airy disc is an artifact. It doesn't exist in nature, but instead is created by the interaction of light diffraction and human vision. What began as a point of light changes when it passes through air, a lens, and an aperture. (That includes the eye's lens and pupil. An Airy disc doesn't exist at all unless someone or something looks at it.)

Airy disc

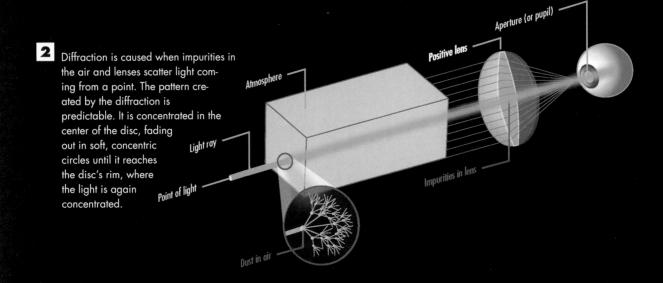

If you back away from any two objects, perspective makes them appear to move closer together. As two Airy discs approach each other, they reach a point where the distance between them is equal to half the radius of one of the discs, about 0.27 μ of their own diameter. This is called the Raleigh limit. (A good animation demonstrates this at www.smls03494.

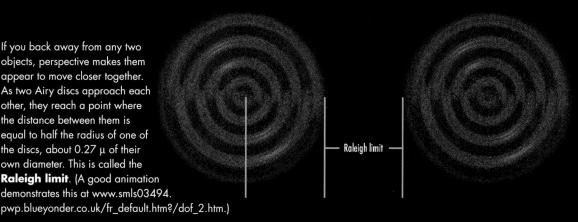

When objects cross the Raleigh limit, they can no longer be distinguished as separate objects. They lose visual information in the form of detail, but they might produce new, gestalt information. If you look closely at a brick wall, you'll see that it is made up of individual bricks with rough textures and a mixture of reds, all surrounded by mortar of a different color and texture.

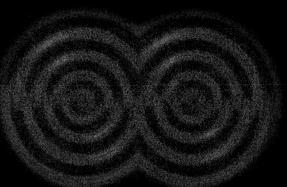

Back off from the wall and the points of light from the bricks cross the Raleigh limit, blending their visual information. First the wall's color becomes more uniform. Back off farther, and the individuality of the bricks blurs into one solid wall. Although you might lose visual information, such as the type of bricks used in the wall or even that it is made of bricks at all, you now know that the wall is of a two-story building, something that even a close knowledge of the parts of the wall couldn't tell you.

So What Do We Mean by Focus?

Based on the physics of Airy discs, lens makers have established a standard for measuring resolution based on pairs of black and white lines. This, of course, assumes ideal lighting conditions, 20/20 vision, the distance from an object to the eye, and various details concerning brightness and contrast. In photography, the assumptions also include how much a photo will be enlarged from a negative or digital image. Studies on human visual acuity indicate that the smallest feature an eye with 20/20 vision can distinguish is about one minute of an arc: 0.003" at a distance of 10". Optics, dealing as it does with human perception, is in many ways the most imprecise of the sciences that abound with measurements and complex math and formulas.

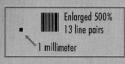

fuzzy < 30 microns < sharp

- The standard used by optical engineers, regardless of human acuity tests, is that 13 pairs of black and white lines per millimeter is the finest resolution that can be seen. More lines than that take the viewer into the gray Raleigh territory. That's equivalent to about 30 microns (.033mm).
- A point of light can undergo the Airy disc distortion and be enlarged in a photographic print, and as long as it does not exceed 30 micros, it will be perceived as still sharp. But if the point of light grows larger than that, it's considered blurry; the larger it gets, the blurrier it is. It is this visual definition of sharpness that we're looking for when we say a picture is in focus.

How Perception Creates Depth of Field

The very fact that you have to focus a camera implies that at some point things in front of the camera would be out of focus. In other words, focus must end somewhere. In fact, for the best of lenses there is only a single, spherical plane—one that surrounds the camera like a an invisible soap bubble—where any point in the photograph is as sharp as possible. Everything else in front of or behind that plane is out of focus. Then why don't more things in a photo look out of focus? Don't we even speak of depth of field as a range before and behind whatever we're focused on where other objects are also in focus? Well, yes, but you see, it's really just an illusion. It's a trick by an imperfect eye that makes the brain accept one standard of fuzziness as sharp focus and another degree of fuzziness as just fuzzy. Fortunately, it's an illusion that obeys some rules and that a photographer can control

- An object being photographed will be in focus when it lies on the plane of critical focus. It's actually a sphere, rather than a plane, at the center of which is the lens, but convention uses the term plane. The location of this plane or sphere is determined by the optics of the lens, the lens's focal length, and how the photographer has adjusted the lens's focus.
- Rays of light from a point on some object in that plane—the red point in our illustration—extend to all points on the front of the lens, which bends them to form a cone. At the tip of the cone, all the light rays converge on a single point at the focal plane of the camera. This is where the digital image sensor or film is mounted. (To make everything easier to understand, we've exaggerated the size of the digital sensor to something that resembles a drive-in movie screen.)

- Other points from objects in front of and behind the plane of critical focussuch as the green and blue pointsare also resolved by the lens to individual theoretical points. The only difference is that these focused points are not on the focal plane. The cones of light from these spots meet at focal points that fall either behind or in front of the focal plane. That plane, instead, is intersected by a section of the cones created by the light beams converging on their points. The digital sensor records not a point of light or even a least circle of confusion as occurs at the focal plane. Instead, the sensor records an everyday, common circle of confusion, what we would ordinarily call a blur The farther from the focal plane that the point is actually focused, the bigger the blurred circle.
- These circles of confusion, however, are often still so small that our eyes perceive them as a focused point. That's why an equal distance behind and in front of the plane of critical focus appears to also be in focus. This area is called the depth of field. The depth, or size, of the depth of field is determined by the focal length of the lens, the design of its optics, the size of the aperture (the opening light passes through when the shutter is snapped), and the distance from the lens to the critical focus plane. The size of the film or sensor compared to size of the print made from it is another set of factors in which subjective judgment, eyesight, and the distance from a print to someone looking at it all play a part.

6 As objects get farther from the critical plane, their smaller details are subsumed into overlapping Airy discs, losing individual identity. The process continues until even large objects that are far enough away from the critical plane fall below a threshold of focus that's acceptable to the human eye and perception. That's when we officially declare them to be "out of focus."

Calculating DoF

Depth of field (DOF) might seem like a topic for which a degree in higher math would be handy. Well, in this case, it would. But lacking the degree, you can take advantage of a couple of dozen calculators that will figure depth of field on your computer, handheld, or even without the advantages of electricity at all. The DOF Calculator, shown at the right, is a circular slide rule you can print and assemble that fits nicely on a lens cap. You'll find it and more calculators for DOF and other optic esoterica at http://www.dofmaster.com/, http://www.outsight.com/hyperfocal.html, http://www.betterphoto.com/forms/linkAll.asp?catlD=71, and http://www.tawbaware.com/maxlyons/calc.htm.

How Photographers Control Depth of Field

As tricky as **depth of field** can be as a concept, in practice it's an easily mastered beast and one that's high on any photographer's list of tools for emphasizing what's important in a photo. A shallow depth of field (DOF) allows the photographer to isolate crucial subject matter as the only thing well defined in a world of blurs. A deep depth of field is perfect for capturing landscapes, where everything is equally important. In between, depth of field can expand or shrink to make a person viewing the photo see what the photographer wants him to see. The tools needed to master DOF are common to all cameras: focal length, distance, and aperture. Digital cameras add one more element—the size of the imaging sensor, which we'll look at separately. It's important to note that the effect of any one of the tools on DOF does not necessarily hold if any of the other elements change.

Focal Length

DOF Rule 1: The longer the focal length of a lens, the shallower the depth of field will be. In a telephoto lens, the depth of field is shallower than in a wide-angle lens.

The line of dominoes here were photographed with a zoom lens on a Canon 10D, focused on the double-six tile at a distance of 20" using a focal length of 105mm. The aperture is set at f4.5. A point of light coming from the fourth domino with the double fives, winds up unfocused (outside the field of depth) because its Airy disc

Focal Length: 105 mm Distance: 20" Aperture: f4.5 Sutter speed 60

exceeds the size our eyes will accept as reasonably sharp. It has crossed the Raleigh limit to create a blur with the points neighboring it.

Nothing in this photo has changed except that the lens's focal length is now 35mm. Not only does the depth of field change, but so does the angle of view. You see more of the surroundings—only appropriate for a wide-angle lens.

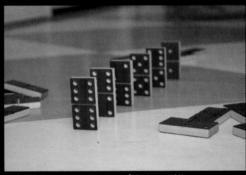

Focal Length: 35 mm Distance: 20" Aperture: f4.5 Sutter speed 60

Because the wide-angle photo encompasses a broader expanse, the apparent sizes of all objects must shrink so that they all fit into the frame. As a result, the same point of light in the first photo—the one from the red three-dot domino whose Airy disc grew beyond acceptable limits of sharpness—remains small enough to be part of the depth of field.

Distance

DOF Rule 2: The closer the camera is to its subject matter, the shallower the depth of field becomes, provided the focal length and aperture settings are unchanged.

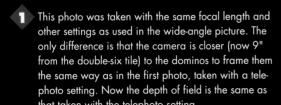

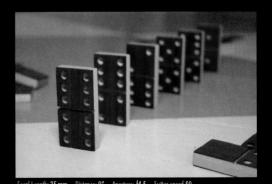

Aperture

DOF Rule 3: When the focal length and distance settings remain the same, the depth of field increases as the aperture opening (the diaphragm) becomes smaller.

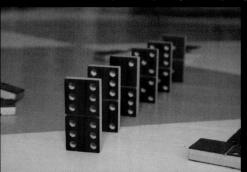

Focal Length: 55 mm Distance: 15" Aperture: f5.6 Sutter speed 60

With a wide iris, light from a point passes through at more angles and hits the image receiver—film or digital—over a wider area. The light rays are disorganized, making it more difficult for a lens to focus them.

These two photos were shot with the same focal length and the same distance from the camera to the dominoes. The shot on the left was taken with an f-stop of f5.6, and the photo on the right was shot with

a smaller aperture setting, f8, with a shutter speed of 4. The shutter speed has no effect on the depth of field. It changes here only to compensate for the smaller amount of light coming through the lens's iris at any given moment. The exposures are substantially equal, but the photo on the right, with the smaller aperture setting of f8, has a deeper depth of field. Why this happens is similar to why nearsighted people often squint: By narrowing the passageway through which light enters the iris in the eye (or the diaphragm in a lens), there is less scattering of the image's light.

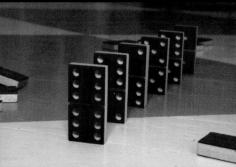

Focal Length: 55 mm Distance: 15" Aperture: f8 Sutter speed 4

With a narrow diaphragm, light is limited in the angles it can take on route to the image receiver. The lens has a much easier task focusing light rays that are already prearranged as they pass through the lens. This is the principle behind the pinhole camera, which can take photos that have remarkable sharpness and extensive depth of field despite having no lens.

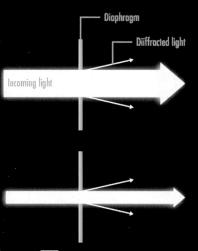

When the diaphragm is stopped down to its smallest openings, the percentage of diffracted light increases to the point that it degrades the sharpness of an image more than the added depth of field sharpens it.

When light passes near—within a few wave lengths of—any boundary, such as the diaphragm of a lens, it bends, which is an effect known as **diffraction**. With bigger diaphragm openings, the amount of light thrown off course by diffraction is a miniscule part of all the light passing through the lens.

Figuring the Hyperfocal

If you want to be ready to snap a photo quickly no matter how near or far the subject might be, turn off autofocus and keep your lens focused at the **hyperfocal distance**. If a lens focuses at infinity, the depth of field starts at somewhere in front of the lens and extends to infinity. The distance from the lens to the point where things start being in focus is the hyperfocal distance. Run some tests with your lens to find out where your hyperfocal point is. Focus at infinity and observe the distance at which things start getting fuzzy. If that distance is, say, 20 feet, that's your hyperfocal distance. If you set your lens to be focused on an object 20 feet away, everything from infinity to about half the distance from the lens to the hyperfocal point—in this case, about 10 feet—will be in focus. You'll have the most territory you can have in focus at the same time—the deepest depth of field. This makes for a better way to shoot landscapes than simply focusing on infinity. With hyperfocal focus, infinity is still in focus, but the depth of field captures more of the landscape nearer the camera. But note that the hyperfocal distance changes as you change aperture and lenses. Some of the calculators mentioned in the previous spread will figure your hyperfocal distance for you.

PART 2

How Digital Tech Changes the Way Lenses Work

So far, our look at how lenses work has applied to the traditional film camera as well as digital cameras. So much so, in fact, a reader might be tempted to believe there's no difference between film and digital cameras as far as optics go. But the differences are significant. They arise out of the nature of the electronic image sensor that replaces film. We'll be looking at the image sensor in microscopic detail in the next chapter, but while we're talking about lenses, let's look at how digital sensors transform the power of lenses while wreaking not inconsiderable confusion.

Most image sensors are significantly smaller than a 35mm frame of film. There is no standard for the size—or proportions—of the chips used to replace film. They vary from the size of a grain of rice to, on a few very expensive cameras, the size of 35mm or $2^{1}/_{4} \times 2^{1}/_{4}$ medium format film.

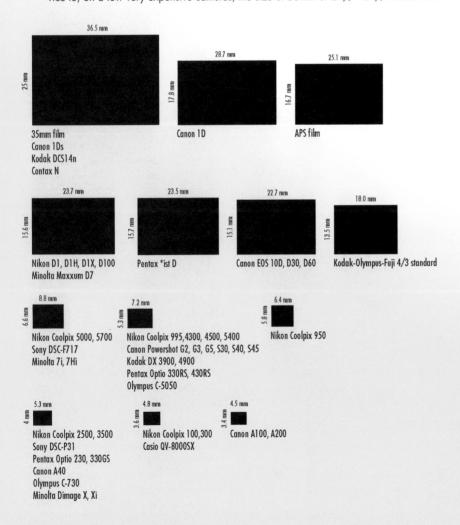

55

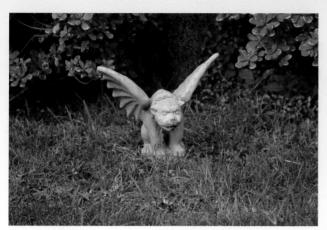

35mm FILM

2 The image circle that lenses cast on the sensors of two cameras are the same size and cover the same field of view-provided the lenses are set to the same focal length on both cameras. The picture on the left was taken with a traditional 35mm film Minolta Maxxum 7000 using a 100mm

lens. Like all 35mm film, the diagonal of the frame is 43.25mm.

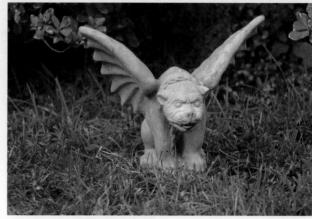

MINOLTA MAXXUM D7

The photo on the right was taken with a Minolta D7 digital using the same lens.

The Minolta has an image sensor with a diagonal of 28mm. On both cameras, the lens creates image circles of the same size. but the D7's digital image sensor takes in only a portion of the image circle while 35mm film takes in more. That's why the same focal length lens on the

digital camera becomes, in effect, a telephoto lens.

The difference in fields of view is the **digital multiplier**: the factor by which the focal length of the film camera's lens would have to increase to match the same field of view as the lens on a digital camera. If a digital camera has a multiplier of 1.5, a 100mm lens has the same telephoto powers as a 150mm lens on a standard 35mm camera.

5 The value of the multiplier is determined by the size of the image sensor. To determine the digital multiplier for a camera, divide 43.25mm—the diagonal distance of a 35mm film frame—by the diagonal size of the camera's image sensor. For the D7, that's $43.25 \div 28 = 1.54$.

43.25 Digital multiplier = Diagonal size of image sensor

The Upside-down Math of Digital

The effective focal length of a lens isn't the only thing affected by the sizes of digital image sensors. For example, using the Minolta D7 and a 35mm camera:

- The D7 has 1.5 times more depth of field than that found in a 35mm camera provided the cameras' distances from the subject matter are set up so that they have an equivalent field of view, which is the vertical and horizontal expanses that can be seen through the lens.
- The D7 has 1.5 less depth of field using the same lens that the 35mm image would have. Of course, the images would be different because the fields of view would be different.
- Take a picture of the same subject matter at the same distance using the same lens on a D7 and a 35mm camera. Then crop the 35mm image so you have the same field of view as in the uncropped D7 image. The depth of field of both will be identical.

How New Technology Creates a Standard for Digital Cameras

Because 35mm still cameras have dominated photography for nearly a century, the first digital cameras have been like Frankenstein's monster cobbled out of the stillbreathing 35mm standard. But the lens and camera bodies of the 35mm world are not a natural match for digital photography, where electronic image sensors only rarely have the same dimensions as a frame of 35mm film. It's as if, when 35mm film first came into vogue, photographers had kludged it into the then-prevalent 4" × 5" sheet film cameras. Now some digital camera makers, including Olympus, Kodak, Panasonic, and Fujifilm, want to avoid making digital photography a jury-rigged form of 35mm. To that end they proposed the Four Thirds, or 4/3, System standard. The standard includes lenses made to work specifically with image sensors rather than film and standardization of components for interchangeability among brands. Olympus has been the first to produce a 4/3 camera: the E-1. Reviews substantiate many of Olympus's claims for 4/3 technology, but whether it becomes a true standard depends as much on the marketplace as the optics lab.

One of the tenets of the 4/3 System standard is that light strikes film and a digital image sensor differently. With film, the **silver-halide** grains that capture the nuances of light and shadow are just below the surface of the emulsion layers holding them. They react equally to light from any direction, much like a sunbather standing in a window hoping to get a tan.

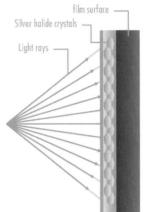

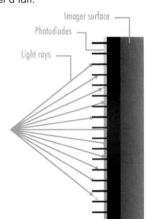

The light-sensitive pixels in a digital image sensor, on the other hand, are more like someone trying to get a tan by standing at a window. The pixels are located at the bottom of wells created by walls of electrodes and the grid that holds the pixels in their rigid pattern. The walls block light coming in at oblique angles, which becomes even more the case for pixels located toward the edges of the image, particularly with wide-angle lenses. The result can be a dim peripheral image with inaccurate color and poor resolution. Ideally, the pixels need to be exposed to light coming straight

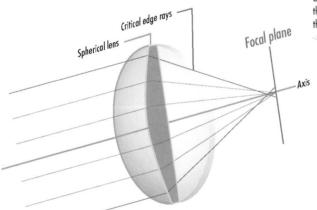

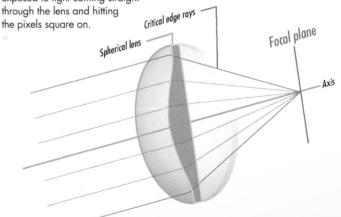

The 4/3 System standard has led to new lenses designed specifically for image sensors. The lenses use aspherical elements and extra-low dispersion glass (ED glass), which minimizes the separation of colors found in the chromatic aberration that plagues lenses. (Refer to "How a Lens Bends Light," in Chapter 2.) The continuously changing curvature in the aspherical lens that increases toward the lens's edge does a better job of gathering light from all parts of the lens to a single spot. While not achieving the ideal of organizing the light into parallel rays, the aspherical lens does bend the light so that it hits the pixels more directly.

Because the worst defects of ordinary lenses occur at the edges, the 4/3 System standard pushes those edges farther out, where they can do no harm. The 4/3 design requires that the diameter of the lens mount be about 50mm, roughly double the diagonal of the 33.87mm image circle. The more errant light rays from the perimeter of the lens fall harmlessly out of the image sensor's territory. The light that does hit the sensor comes more from the lens's center where light rays come closer to a path perpendicular to the sensor's surface. 4/3 also requires that the three-claw bayonet mount be standardized in fit and distance from the focal plane so that a lens from one brand of 4/3 System camera can be used with a different 4/3 System camera body.

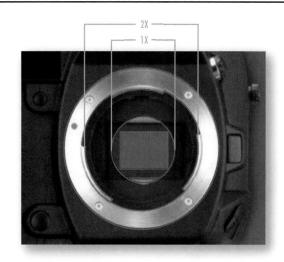

Because the 4/3 System lenses are designed specifically for digital cameras with sensors half the size of 35mm film, they have the benefit of producing the same field of view found in a film camera lens while using half the focal length. The 4/3 System lenses can be made shorter and lighter. Many of the lenses have their own microprocessor in addition to the three processors found in the camera body. The lens sends the information about itself through nine electrical contacts built in to the bayonet mount. The camera's processors and built-in software use that information to correct lens distortions, such as pin cushioning.

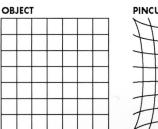

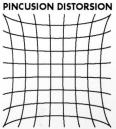

4/3 standardizes the diagonal size of the image sensor at 22.55mm so it fits within the image circle dictated by the standard. The Olympus E-1 sensor has proportions of 4:3, which makes it a little taller and not as wide as the 35 mm frame and covering about half the area. But 4:3 proportions are not required. A sensor can be any shape, including square, as long as it fits inside the image circle. There is no requirement as to the technology used in the sensor—it can be CCD, CMOS, or Foveon X3, all of which we'll examine in the next chapter.

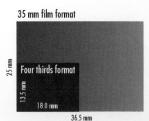

4/3 = what?

In the confusing tradition of aperture numbers, in which the bigger the number, the smaller the aperture opening, the nomenclature for different types of digital image sensors defies any comprehension. The 4/3 System standard is not a measurement—1 1/3—of the sensor or anything else you'll find on a 4/3 System camera. The same goes for other sensors, such as the 1.8, 2/3, and 1/2.5. Some experts claim the system refers to the aspect ratio of the sensors. That might hold true for 4/3, but it breaks down with other sensors. It's also suggested that the designations come from a system used in the movie industry to identify lenses and have no real meaning for the rest of us. Just accept it and don't ask questions.

How Digital Cameras Cure the Shakes

Next to the precision accuracy of a camera's focus and the native depth of field that is inherent and different in every lens and at every f-stop, there is a third factor that heavily influences the sharpness of a photo. Your hands.

A sharp image is the photographer's holy, and elusive, grail. You can be focused down to the breadth of an eyelash. You can have depth of field from sea to purple mountain majesties. But your hands, at their steadiest, still are wiggling 1-5 times a second, undermining your careful focusing. Even on a tripod, a gust of wind or a truck rumbling by is enough to ruin a photo. The slightest tremble, twitch, tic, or tremor makes a picture look as if it were taken during an earthquake. The light passing through the lens continues along a straight line, but the imaging sensor shifts and dodges the incoming light as if they were playing dodge ball. Instead of creating neat little points of color, the sensor records a blur. The longer the shutter time, the wider the blur.

The rule of thumb has been that, to avoid noticeable blurring, the shutter speed must be faster than 1/focal length. In 35mm terms, that means if you're using a normal lens of 50mm, you're going to get blurring with shutter speeds that photographers commonly resort to when they're using available light: 1/25 of a second, 1/30, 1/2, 1/60, or simply any shutter speed slower than 1/100 of a second. Screw on a telephoto lens, which exaggerates any movement, and you must use even faster shutters. Most digital cameras multiply the telephoto tremble. The average image sensor is smaller than a frame of 35mm film, but most pictures recorded to film and those captured by sensor wind up being printed the same size. But the digital photo has to be blown up more to match the size of a film-based picture. Any of the flaws in a

digital photo end up being bigger relative to the same flaws in a film print. A photo taken by a handheld camera, shooting at 1/60 of a second, is likely to turn out like the left photo on this page.

Several camera companies have come up with different technologies to clamp down on the shakes and turn

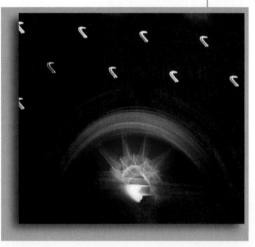

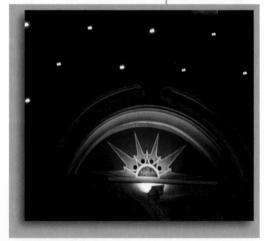

out photos that look more like the second shot, taken with Konica Minolta's ingenious antishake technology, which we'll look at on the following pages.

Camera makers have come up with several ways to stifle vibrations in both still cameras and camcorders. To be effective—which means reducing vibration so much that the photographer can use a shutter speed 2–3 stops slower—a VR (vibration reduction) system must counteract vertical vibration (pitch), side-to-side (yaw), and every direction in between. And it needs to make the correction within a few thou-

Here are two explanations of what happens when a camera is all shook up and four ways to calm the jitters.

How Vibration Creates Blurred Images

•

Normally, light rays from a scene being photographed pass through the object lens element at the front of the lens and stay true to lens's optical axis.

TO SUBJECT

When the lens moves, the beams of light pass through elements of the lens at the wrong points. More importantly, the image sensor moves out of position and the light is smeared across the surface of the sensor, blurring the subject. Preventing vibration and movement is virtually impossible. Any system that seeks to reduce blurs caused by camera movement must do something to put the light beams back on the right path before they hit the sensor. Electronic image stabilization, which we'll look at on the next page, is the one exception to this rule. It corrects the blur with software after it has

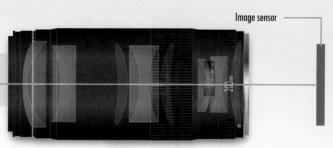

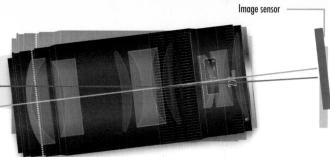

How Cameras Detect Movement

occurred.

Many antishake systems remain dormant until the photographer has the shutter button partially depressed. This is so the photographer can move the camera to frame a shot without having to fight the camera to position it. When the system is active and something jostles the camera, the movement is detected by two gyrosensors, which are gyroscopes attached to devices that measure motion. One gyrosensor is positioned to detect yaw, or horizontal movement. The other gyrosensor, mounted 90° away from the

ACCELLEROMETER

90° away from the first, reacts to **pitch**, or vertical tilting of the lens.

A gyroscope is basically a highly developed spinning top. The rapid rotations of its heavy metal disk build up *inertia* along the same plane that the disk spins on. The inertia makes the gyro resist any force that would change the orientation of its axis. When this happens, the gyroscope, in effect, pushes back. The pressure the gyroscope exerts is measured by an accelerometer, which consists of two metal plates connected to each other and that sandwich a third plate that floats freely between them.

The force from the gyroscope moves the floating plate toward one or the other of the plates on either side of it. The change in distance also changes the amount of the electrical charge on the two outside plates. The charge increases on the plate that the floating plate moves close to and

decreases on the other plate. The data the sensors pick up is sent to a high-speed microcomputer. The microchip measures the charge differences and calculates from that the distance and direction the lens has moved.

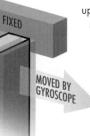

Electronic Image Stabilization

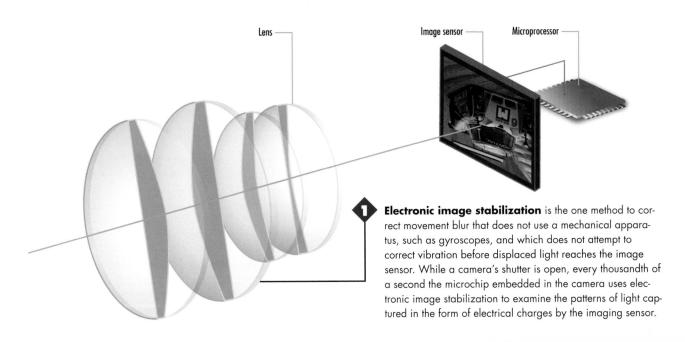

- The processor compares that image with the first one that was sent from the image sensor a thousandth of a second earlier. If the colors of all the pixels match, the processor puts the new image into storage along with its predecessors, and their combined electrical charges are added together to contribute further to the final digital photograph or frame of video.
- But if the images do not match, the processor looks for a pattern that does match the previous impression. Then the processor shifts the new electronic charges coming from the pixels so that they line up with the charges that preceded them.

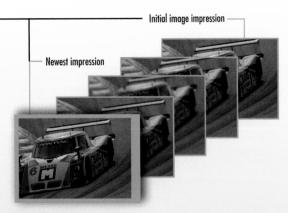

Because this method involves the processor manipulating the raw data on-the-fly, there is some image degradation.

Vari-Angle Prism System

In a lens using a vari-

angle prism (VAP) to correct movements, such as

some of Canon's video cam-

gyrosensors are used to detect

the slightest wiggle. The sen-

sors send electronic informa-

tion to a microprocessor built

in to the lens.

era lenses and binoculars,

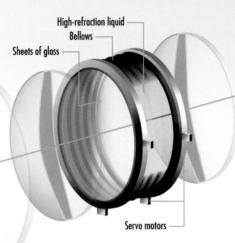

The microchip sends an electrical signal to **voice coil motors**, much smaller versions of the motors used to vibrate the cones in speakers. The motors sit at 90° angles to each other on the rim of the vari-prism. The VAP, which is positioned among the lens elements in the path the light passes, is made of two plates of glass connected by a flexible resin bellows. The space between the plates contains a clear liquid with the same refractive characteristics as glass. Ordinarily, light passes through the VAP without a change in direction.

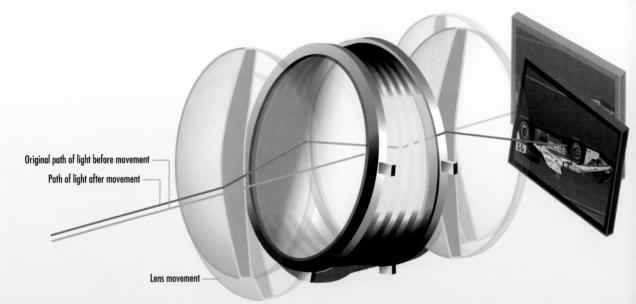

The chips' electrical signals create magnetic fields in the voice coils that, in turn, push or pull a metal plate onto which the glass walls are mounted. The voice coils widen or narrow different areas of the liquid-filled chamber so light now strikes the VAP at an angle. The size of the angle is calculated so that rays passing through the VAP are refracted precisely to put the light beams back on the correct path.

Piezoelectric Supersonic Linear Actuator Stabilization

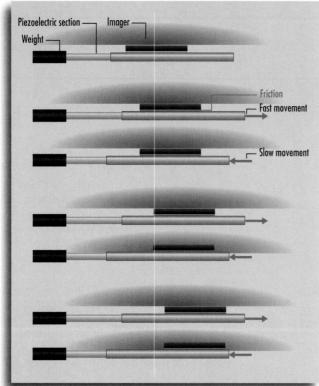

When current reaches an actuator, it's directed to a piezoelectric element mounted between a weight and a shaft. The current causes the piezo to expand or contract, depending on the direction necessary to make the correction. The

weight is designed to hold it back.

Each of the actuators' shafts presses against a different plate holding the image sensor. One plate is free to slide vertically while the other can move horizontally. Only friction connects the shafts to the plates, which is one reason for the initial slow movement of the shaft—so the movement doesn't overcome friction and cause a shaft to lose its grip on the plate. (Actually, this talk of slowness is deceptive. Because these corrections happen in a few thousands of a second, any "slowness" is purely relative.)

shaft moves slowly at first because the

When the image sensor is in its new, corrected position, the shaft withdraws by contracting or expanding quickly so as not to take the correctly positioned image sensor with it, like a tablecloth being jerked off a table so fast it leaves the table settings in their places.

Most digital cameras with antishake mechanisms try to bend the errant light rays as they pass through the lens so they still strike the correct pixels on the image sensor. It's like trying to deflect an arrow on the way to its target. Konica Minolta's attack on the shakes takes the opposite tact, as if some poor loser were forced to hold the target and move it to wherever the arrow's coming in. To achieve this, Konica Minolta has had to go with new technology throughout the process.

Motion Correction

A microprocessor inside the camera body receives movement information from the angular velocity sensors mounted next to the imaging sensor. One digital gyroscope is positioned to detect only vertical movement; the other detects only horizontal. The microchip combines the information to get a two-dimensional picture of camera motion, although the microchip cannot compensate for forward and backward motion, which has a smaller effect on photo sharpness.

The microchip sends electrical signals of its own to two piezoelectrical supersonic linear actuators—also known as **SIDM**s, for **smooth impact drive mechanisms**. Like the movement sensors, the SIDMs are mounted at right angles to each other to handle vertical motion (the Y-axis actuator) and horizontal motion (the X-axis actuator).

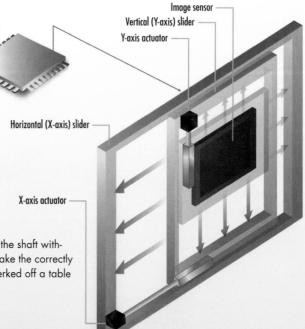

Processor

Coriolis force

Motion Detection

The newest method of countering camera shake, Konica Minolta's piezoelectric supersonic linear actuator stabilization, not only beats its predecessors for the longest name, Minolta also eschews its competitors' gyrosensors for detecting movement in favor

of "digital gyroscopes," or **angular**velocity sensors. The heart of the
sensors is two linked ceramic tuning
forks covered with a metallic conductor.

The ceramic material has piezoelectric qualities, which means it flexes when stimulated with an electrical current. When the ceramic is flexed, it generates a current.

One of the two tuning forks is set to vibrate at a specific frequency. The second tuning fork picks up the other fork's oscillation and resonates at the same frequency in what's called **sympathetic vibration**. The movement of the second fork produces electricity, which is monitored by an integrated circuit (IC) built in to the device.

If a trembling hand or a gust of wind causes the camera to twist along the axis of the forks, perpendicular to the direction in which the forks are vibrating, the movement creates a **Coriolis effect**—the same force responsible for the different directions that hurricanes spin in the northern and southern hemispheres.

As the force pushes against the piezoelectric ceramic, it produces an electrical current that modifies the current that was already being produced by the vibration of the second tuning fork. The IC calculates the difference in current created by the Coriolis

effect. From that, it figures the distance and speed that the camera has moved and sends this information to another microchip that compensates for the movement.

Image plane

Two of these digital gyroscopes are mounted at right angles to each other along the edges of the image sensor at the back of the camera.

One senses horizontal movements (yaw), and the other is for vertical movement (pitch).

Shift Image Stabilizer

This form of **image stabilization (IS)** is among the most common and is found in lenses by Canon, Nikon, and Panasonic, among others. It relies on an IS lens element mounted among the other elements that make up the complete lens. This element is like the other lenses that make up the complete lens, except it can change position.

2 Shift image stabilization technology uses one sensor to detect vertical movement and another to detect horizontal movement. Diagonal movements are detected by combining the results of both sensors. When gyrosensors send signals to the lens's own microprocessor telling how much the camera has moved, the microprocessor quickly sends signals to the voice coil motors mounted at 90° angles to one another along the edge of the IS lens element.

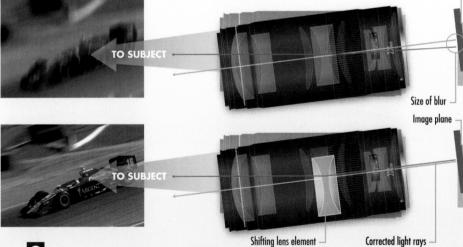

The motors slide the element in the direction opposite from the direction the lens moved. If the lens dipped down, the motors push the IS element up. The correction takes 2 thousandths of a second to complete.

Light now enters and exits the IS element at new angles that deflect the light so it regains its original path to the image sensor. Shift image stabilization is most effective for lower-frequency movements caused by platform vibration or wind. This type of stabilization is usually referred to as vibration reduction because it ignores the larger types of motion associated with recomposing an image or panning the camera.

CHAPTER

4

How Digital Cameras Capture Light

ALL photography is about light.

Photos may be of important or trivial subjects, in color or black and white. A picture might be as candid as the next minute's news or a painstaking pose, a slice of reality or a helping of the abstract. It can be still or moving, invoking weighty subjects or the flightiest of fancies. But whatever else photographs are, they are about light. They are about what light does when it flickers off a river, when it exposes the wrinkles and buried veins of age, how it transforms a sky, or how it creates depth and curves and textures you can feel with your eyes. Photos are even about light when there is none, or at least very little, when a photo's subject is buried in shadows and the slightest feature forcing itself out of the depths of blackness becomes enormously important.

Light is the tool and the curse of photographers. In a studio, hours can be spent adjusting lighting and shooting test shots to create the exactly right balance of highlights and shadows. In candid photographs, landscapes, and action shots, the state of lighting is more often an accident, forcing the photographer to make quick, on-the-fly adjustments and guesses about what light the camera will capture at...this very moment. If the photographer is successful, and lucky, he captures a moment of light and dark and color that will never exist again except in the bits and pixels where that moment now resides, possibly forever.

The photographer today has wonderfully digitized and computerized tools to help him decide when the light is just right for the nabbing. Digital photographers have still a larger advantage. They can turn fluorescent lighting into daylight, daylight into candlelight. They can change the sensitivity of their "film" in the middle of shooting or turn color into black and white. The digital photographer gets to play with light as if he made the rules that light beams must follow. And that's because he does make the rules. Here's how it starts, with the slice of time called *exposure*.

Diaphragm

How a Diaphragm Controls Light

Light that has been focused through the lens of a camera must pass through a round adiaphragm on its way to being registered as an image on the camera's sensor. How much light makes its way into the camera is controlled by an opening in the diaphragm. The opening, called the aperture, serves the same function as the human eye's pupil. The diaphragm is the camera version of the eye's iris.

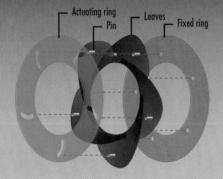

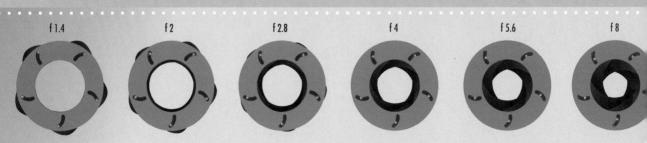

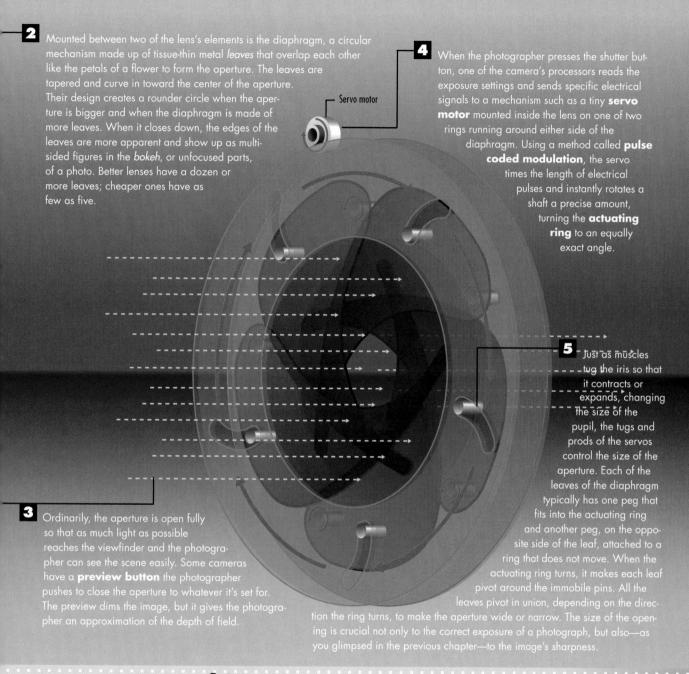

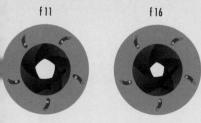

F-stops

The various sizes the aperture is set to are called **f-stops**, usually expressed as f/ followed by a number somewhere between 1.2 and 32. The number represents the focal length of the lens divided by the diameter of the aperture's opening. If the aperture on a 50mm lens is set to be 25mm wide, the f-stop is 50/25, or f/2. The ratio lets the same amount of light fall on each square millimeter of the film or image sensor, although the measured aperture from lens to lens can be different. A 150mm aperture on a 300mm lens exposes the picture with the same brightness as the 25mm opening on the 50mm lens (300/150 = f/2). This seemingly easy system loses some of its simplicity when you realize that bigger apertures have smaller numbers and vice versa. Each smaller f-stop lets in twice as much light as the next larger f-stop, and, of course, a setting of f/8 lets in half as much light as f/4. If you want to see f-stops in action, visit www.photonhead.com, where you can experiment with its SimCam without having to go to the trouble of actually photographing anything.

PART 2

How the Shutter Slices Time

Like most windows, the one in our sunbather's apartment has curtains, a necessity to let light in when you want it and to keep light out when you don't. Our digital camera has curtains, and they serve the same function as those in the window. Most of the time they're closed to keep the light off the image sensor, whose pixels are hundreds of times more sensitive to light than the palest skin. Then for a fleeting moment, a mere fraction of a second, the curtains open with the sudden swiftness of a conjuror and the precision of a surgeon. It's in that moment that the camera captures one fleeting moment of time.

Both curtains are spring loaded, but the springs are restrained by metal latches that hook into the spring mechanism so it can't move. Poised above each latch are the two electromagnets. The first burst of electrical current goes to the magnet associated with the curtain that is already open and covering the image sensor.

Image sensor

First curtain -

Second curtain

At the same time electronic signals race from one of a digital camera's microprocessors to tell the diaphragm what size to make the aperture, other signals stream to the camera's **shutter** to tell it how long it should open its **curtains** to expose the image sensor hiding behind them to the light streaming through the aperture. There are various designs for camera shutters, but the most common type in the 35mm cameras that have evolved into the digital camera is the **Copal square shutter**, named after the Tokyo company that developed it in the 1960s. That's what we'll look at here.

The electrical current travels to one of two electromagnets that are paired with two sets of curtains. The curtains are made of three to five or more thin blades of aluminum, titanium, or metal-coated plastic. The blades making up one of the curtains are spread out—but overlapping one another—to cover the image sensor so that no light reaches it.

Latch

Electromagnet

Mounted on the opposite side of the sensor from the first curtain, the second curtain's blades are collapsed so the curtain takes up little room in the already crowded inner chamber of the camera.

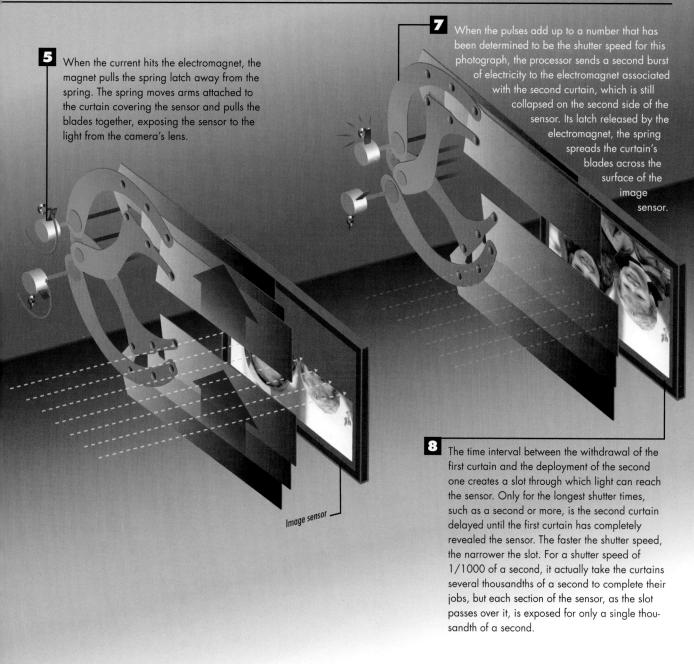

SECONDS: 00,001

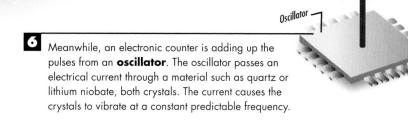

How Cameras Measure Light

Eyes are not the only things that can sense and respond to light. There are, luckily for photographers, various chemicals and minerals that, in combination with each other, can sense when light is striking them and respond by producing electricity. It's a good thing for photogra-Depletion Layer phers because these inanimate light sensors are immensely more sensitive and more accurate than the human eye when it comes to measuring exactly how much light they're seeing. Before then, exposing a photograph correctly was largely a matter of guesswork and experience. Now, a camera does it for the photographer with molecular precision while providing options for using light creatively that photographers a century ago could only imagine.

- The light passes through a layer of glass coated with an anti-reflective film and into the **P-layer** made of silicon that has been infused, or **doped**, with boron. The P-layer is no thicker than 1 µ—a micrometer, or one millionth of a meter. That particular thickness is what makes the photodiode responsive to light in the visible spectrum.
- Longer wavelengths in the light make it through the P-layer into the thicker **N-layer** at the opposite side of the photodiode. Along the way, the light also passes through the **depletion layer** formed at the conjunction of the P-layer and the N-layer.
- Before light struck the diode, electrons in the three layers of silicon moved in a fairly synchronized manner. When one electron broke off from a silicon atom, another electron took its place, much like customers at a busy but not overburdened lunch counter. When light enters the silicon, however, it raises the energy level of the electrons so that fewer of them settle into the vacancies left by other electrons. It's much as if all the customers at the lunch counter ate too much of the same bad, overseasoned chili. Suddenly they are rushing away from the counter leaving empty seats, called **holes** in semiconductor terms.
- An electrical field in the depletion layer pulls electrons out of the P-layer, accelerating them into the N-layer. It moves holes in the opposite direction, toward the P-layer.

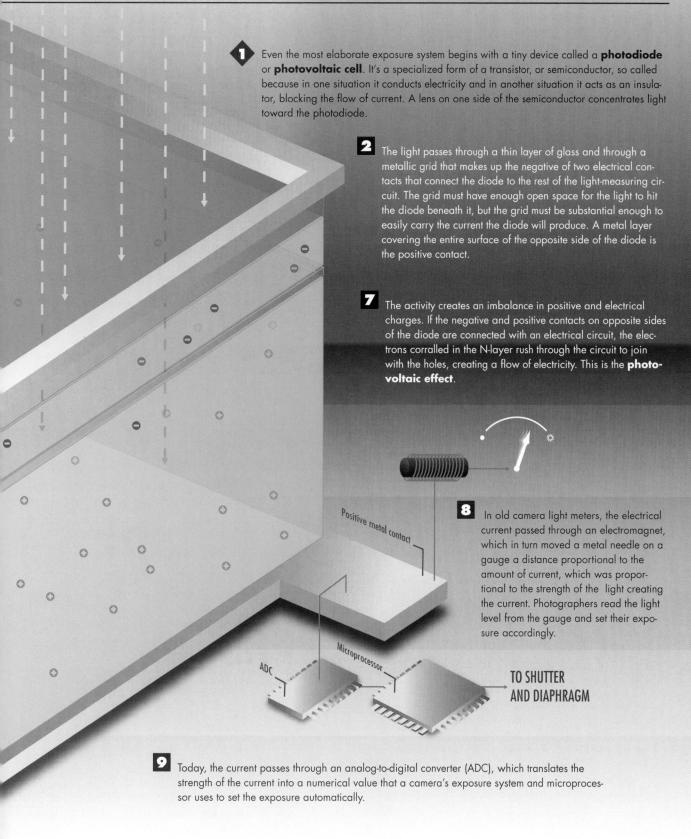

How Light Meters View the World

The most complex part of a digital camera is its exposure system. It's more than a photodiode measuring the light coming through the lens. Among the most versatile cameras, the exposure system has more than one way to measure light and mixes those measurements into a brew made of settings for the type of lighting; the sensitivity of the image sensor; and special settings for action shots, fireworks, black-and-white, or even special effects such as sepia toning. That brew is siphoned to set into action the diaphragm and shutter, all in the blink of an eye.

Less-expensive digital cameras—called **point-and-shoot (POS)** models—often have only one of the many ways of measuring light that more-expensive cameras boast. It's called **full-frame** and it typically uses one photodiode device mounted next to the lens. On better cameras, full-frame metering uses several photodiodes—as many as 45—mounted in the path of the light on its way from the lens to the shutter hiding the image sensor. Either type of full-frame averages the intensities of light reflected off a subject to determine a shutter speed and aperture that will produce an exposure that is expected to render everything in the photo. But unless a scene is evenly lit and contains only subjects with the same color value, full-frame exposures are usually less accurate.

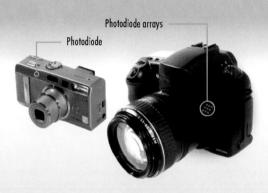

In the photo here, for example, the bright sunlight falling on the bricks behind the boy riding in his car has made the camera's autoexposure feature overcompensate and shut down the diaphragm too much. The result is muddy shadows revealing little detail in the most important part of the photo.

- This occurs because exposure systems think that no matter how bright or how dim something is, it is 18% gray (which is considered a medium gray). In these photographs, you can see white, gray, and black sheets of paper in their true colors when they are all in the same photo. But when each is photographed so that it is the only object measured by the exposure meter, the camera's exposure automatically is set to render the three sheets of paper as the same medium gray.
- To overcome the perils of using an average of an entire scene's illumination, better digital cameras have alternative ways of measuring light that can be chosen from a menu displayed in the camera's LCD screen or by one of the camera's control knobs or buttons. The first alternative is **center-weighted** measurement. It meters the light in an area that amounts to about a tenth of the total photo area. As the name implies, that tenth is located in the center of the screen on the theory that that's where the most important part of the scene is.

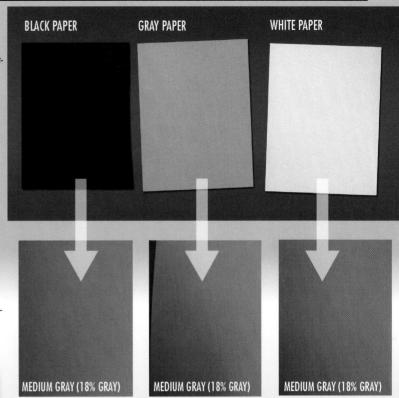

The other common alternative is **spot metering**, which gives the photographer greater ability to expose the part of the scene that is most crucial. Illumination is read from only a small circle in the center of the screen, allowing the photographer to expose for the lighting on a cheek that might be surrounded by dark hair and a beard that would otherwise overwhelm the light readings. When the crucial subject matter is off-center, some cameras have the capability to make small areas on different parts of the image the spot for purposes of metering. For those without such cameras, you can use the **shutter lock** described in the box below.

The Half-push

When the most important element of a photo is not in the center of the frame, most cameras have a shutter lock feature that lets them focus and get an exposure reading for their picture by aiming the center at that important element. Then, by pushing the shutter button only halfway, the autofocus and autoexposure settings are locked. The photographer then reframes the picture with that key element away from the center and presses the shutter button the rest of the way.

How Digicams Juggle Exposure and Creativity

In the few seconds it takes to snap a picture, there is a windstorm of activity as different parts of the camera measure, calculate, communicate, and finally send out electronic instructions to various other parts of the camera that result in a swirl of switches, gears, and exploding light. Most of this activity is centered on exposure, admitting into the camera the right amount of light for the right length of time to

register an image where crucial details are not lost in the shadows or blown away in the highlights. We'll look at each of the elements that go into calculating an exposure in more detail, but first, here's a whirlwind tour of the exposure.

Light from the subject of the future photo is caught by photodiodes that churn the ethereal light into thin currents of electricity. If the photographer is changing the zoom on the lens, the currents may vary as the zoomed frame takes in a changing amount of light. Those electrical signals shoot to a **microprocessor** that determines from the strength of the signals how much light is streaming from the subject to the lens. Before determining which exposure to set that corresponds to the light meter signals, the camera consults information coming from several other sources. entirely on their own, such as fireworks or candlelight. exposure should be.

Special programs: Some cameras include routines for altering exposure for situations most photographers, and most light meters, would be at a loss to handle

- **Exposure compensation:** The processor checks to see if the photographer has ordered that exposure be set for a little lighter or darker than the light meters themselves would dictate.
- 5 Bracket exposures: This setting tells the processor whether the photographer has ordered up additional exposures a stop (or fractions of a stop) above or below what the photodiode devices say the proper
- 6 ISO setting: On many cameras, the photographer has a choice of ratings referred to as International Order for Standardization (ISO). They are the digital camera's equivalent of ASA ratings on film. Although it's convenient to think of ISO settings as determining how sensitive the image sensor will be to the light that washes over it, in fact the sensor becomes no more sensitive. Instead, the electrical signals that the sensor generates are amplified, an important distinction as you'll see later. But all in all, the greater the number for an ISO setting, the less light the shutter and aperture must admit.
- **7** Exposure mode: The exposure mode setting tells the processor whether the photographer has already claimed the right to control the setting of the shutter or diaphragm, or both.
- Built-in flash: The processor does a quick check on the flash unit to determine whether the flash is open and ready to fire if need be.
- Shutter button lock: The processor must check to see if the photographer is holding the shutter button down halfway. If so, the processor ignores changing signals from the light meters and autofocus and bases the exposure settings on the light readings at the time the photographer locked exposure and focus by semipressing the button.
- Based on all this information, when the photographer presses the button completely to take the picture, the processor sends precise electrical signals to motors and switches controlling the diaphragm, shutter, and image sensor. The diaphragm closes to the proper aperture, and the shutter opens and closes for a precise slice of time. The image sensor, its pixels excited by the light that bursts through the lens, quickly sends the electrical current that the pixels produce in three streams representing red, blue, and green to be converted into digital values that are multiplied by any factor demanded by an ISO setting and stored in memory. Millions of loitering electrons, in less than a second, have become a photograph.

How Exposure Systems Balance Aperture and Shutter

After a camera's photodiodes have measured the light coming from the subject and the camera has sent that information to a microprocessor, all the information needed to obtain the perfect exposure is still not in. The processor must meld the light reading with other exposure controls the photographer might have set in anticipation of the special requirements of this particular photo shoot. Finally, for better cameras, the photographer has veto power to step in and impose his own idea of how a scene should be exposed. Most cameras, however, let you take advantage of specialized settings that take the worry—and thinking—out of photography.

Any combination of shutter speed and aperture that meets at the same diagonal line is an EV. Here, an exposure of f/8.0 at 1/60 of a second is equivalent to f/5.6 at 1/125 of a second. Both exposures have an EV of 12.

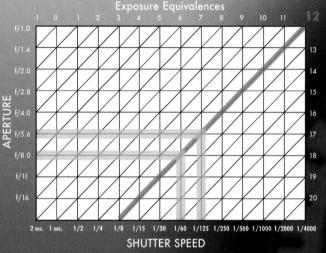

The digital processor's job of finessing aperture and shutter settings is simplified by the use of exposure values (EVs). These are numbers assigned to different combinations of aperture and shutter that result in the same exposure. When, for example, the aperture closes down one more stop, the exposure remains the same provided the shutter stays open longer. The new combination causes the same amount of light to fall on the image sensor as did the previous one. This chart shows the range of exposure equivalents.

4 Most digital cameras provide specialized settings, often referred to as scene modes, for situations that don't fall into the standard exposure modes. Some cameras provide more than two dozen such scene modes. Here are a few of the more common:

Portrait—Opens the aperture as wide as possible for a minimum depth-offield that eliminates distracting backgrounds that could draw attention away from the subject of the portrait.

Landscape—Sets the aperture as small as possible for maximum depth-of-field.

Close-up—Also sets for maximum depth-of-field because depth-of-field naturally shrinks as the distance to a subject gets shorter.

Action, or Sports—the shutter speed is set as fast as possible to freeze action.

Night Portrait, or Twilight—The shutter speed is set to slow, and the flash is brought into action. The flash illuminates the foreground, and the shutter remains open to pick up some of the background

- Exposure equivalences are the basis of a common feature among digital—and film—cameras: exposure modes. The photographer chooses among modes using a knob located conveniently near the shutter button. Typically the modes include
 - Automatic Exposure—The processor works unassisted except for the light meter readings and information from the lens that suggest a shot might be a landscape or one that requires a fast shutter to defeat shaky hands. The chip's software decides on both the shutter speed and aperture, usually choosing a combination that works perfectly fine for the average shot.
 - Programmed Exposure—Similar to automatic mode, except that the photographer can change the shutter or aperture on-the-fly and that the processor responds by adjusting the aperture or shutter, respectively, to maintain the same exposure equivalence.
 - Shutter Priority or Time Value—The photographer chooses the shutter speed, and the processor picks a complementary aperture setting. Shutter priority is useful when it's important, for example, to have a fast shutter to freeze an action shot.
 - Aperture Priority or Aperture Value—Just the reverse of shutter priority. The photographer chooses the aperture, and the processor picks the shutter speed. It's useful for a portrait when the photographer wants to maintain a large aperture so the background is blurred and unobtrusive.
 - Manual—For those times when the photographer has a better understanding of the lighting than the light meter does.

The photographer's choice of exposure mode influences which exposure setting, from among several EVs, the processor picks. The chart here shows a multiprogram autoexposure system that allows the photographer to select fully automatic, high-speed, or maximum depth-of-field without having to pick any specific shutter or aperture setting. The exposure system sticks to one of a few specific paths that run through the range of aperture and shutter settings. The setting in each of the paths meets the requirements of the photographer's selection.

For the average photograph for which the photographer has not chosen any special priority, the exposure system chooses a setting among the EVs shown here in yellow. For depth-of-field priority, the camera's processor chooses among the blue EVs. For action shots, the choices are concentrated along the high-shutterspeed EVs, marked in green.

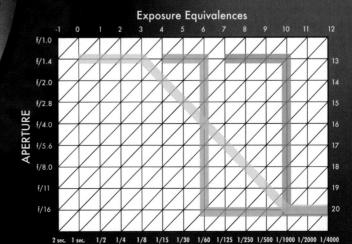

How Digital Photographers Remain Masters of Their Domains

Despite the sophistication and the artificial intelligence found in digital cameras, there still are circumstances when the photographer must assert the human capacity to understand things that even today's intelligent machines do not. Digital features let photographers give a nudge-nudge to their cameras' very best judgments, and the prospect of taking a badly exposed photo shrinks to nonexistence.

For exposure, the nudge is called **bracketing**. And it puts the element of chance back amid the precision of modern cameras.

How Bracketing Gives Digital Photographers Insurance

The photographer sets the bracketing feature on one of the camera's menus. Typically, the menu gives the photographer two types of choices for bracketing. One tells the camera how many pictures to take each time the photographer presses the shutter button. The minimum number is an additional shot on either side of the "official" exposure determined by the light meter readings.

The second choice is how much each of those extra exposures should vary from the original settings. Some cameras permit overexposures and underexposures as small as a third of a stop, which lets a third more or a third less light reach the image sensor. The maximum compensation per bracket is usually one stop, which doubles or halves the light. Within a range of one stop above and below a camera's reading, a photographer is almost always certain to find the perfect exposure.

How Photographers Use Exposure Compensation

If you recall a few pages back in "How Light Meters View the World," a camera's exposure system averages all the light values coming from different sources: a blue cloudless sky, long purple afternoon shadows, and pink blossoms pushing through deep green leaves. After it has averaged all that, the camera's system assigns a value of middle gray—actually an 18% gray—to that average and sets the exposure for that value only. For the average outdoor scene, the result works well.

In both photographs of the seal, the snow and the animal's white coat practically fill the frame. An exposure system sees nearly pure white as the average light value in the scene and, as shown in the simulation above, underexposes the shot so all that white gets only enough light to turn it into middle gray, which makes for a dirty seal and dirty snow. Just the opposite—a black cat on a black couch—would trigger an overexposure and result in a murky, washed out kitty.

How Photographers Get in the Zone

How does even an experienced photographer know how much exposure compensation to use? Next to seat-of-the-pants guesses, the most popular method is the Zone System. It divides the **grayscale** range into 11 **zones** from 100% white to 100% black. Each of the zones corresponds to a one-stop difference from the zones preceding and following it.

The zone system was developed by Ansel Adams as a way, combined with careful, custom developing and printing, to give his landscapes the full range of tones possible in black and white. Is it possible for Adams's technique to be relevant for photographers working in color, with no film developing, and in entirely different ways of printing? The answer is yes.

Zone	% black	RGB
0	100%	0
1	90%	30
2	80%	55
3	70%	80
4	60%	105
5	50%	128
6	40%	155
7	30%	180
8	20%	205
9	10%	230
10	0%	256

Of course, it takes an experienced eye to gauge zones correctly in the real world, where things are in colors rather than shades of gray. It's not necessary, however, to assign a zone value to every color in a scene. What works is to correctly identify one color that translates into a Zone V or 18% gray, the middle gray that a digital camera's exposure system sees as the proper shade for all things. Take a spot reading of that color to set exposure, and the entire scene is exposed correctly. Grass will usually translate as a Zone V; Caucasian skin is usually a VI; and a shadow from sunlight is often a IV.

How Digital Cameras Create a Whiter Shade of White

Eyes do only half the work of seeing. They generate a lot of nerve impulses in response to stimulations from light striking the retina. But you ain't see nothin' until the impulses are interpreted by the brain. All the information that seems to come so naturally through the eyes—shape, size, color, dimension, and distance—is the result of the brain organizing sensory information according to a set of rules the brain starts compiling soon after birth.

The truth of this is found in how we can play visual tricks on the brain with optical illusions, 3D movies, and trompe l'oeil paintings. The brain plays one trick on itself: It convinces itself that white is white even though under different lighting—daylight, incandescent, fluorescent, and so on—white might actually be gray, brown, or blue. Photographs, though, are callously truthful. They capture light that the brain insists is white and reveal its true color. This is why digital cameras have a feature called **white balance**.

White light is the combination of all the colors of the visible spectrum, something easily demonstrated by shining a white light through a prism. Different light sources, however, produce what the brain is willing to accept as white by combining the colors of the spectrum in different proportions from those found in daylight. Some sources use colors from a continuous spectrum. Others use light from only a few narrow bands in the spectrum.

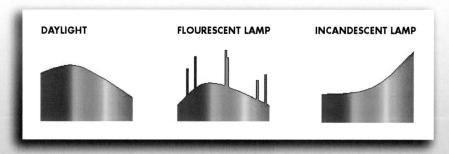

Artificial Light Source	Kelvins
Match flame	1700
Candle flame	1850
40-watt incandescent tungsten lamp	2650
100-watt incandescent tungsten lamp	2865
Photoflood or reflector flood lamp	3400
Common fluorescent tube	4000
Xenon arc lamp	6450
Daylight Sources	
Sunrise or sunset	2000
Early morning or late afternoon	4300
Noon	5400
Overcast sky	6500
Average summer shade	8000

2 The colors these light sources produce are correlated to the temperature of the light measured in Kelvin, which starts with 0 at absolute zero (-273° centigrade). The use of Kelvin is more convention than science. The Kelvin temperatures assigned to colors do not translate to the heat generated to produce the colors. In other words, light that has a warmer appearance has a lower temperature and light that has a cooler appearance has a higher temperature.

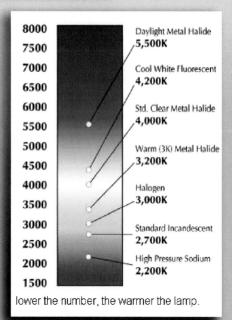

Of these temperatures, the ones most commonly affecting photography are the temperatures of outside light, ranging around 5500K, and those from inside, artificial lighting, around 3200K. The lower temperatures tend to have a redder, warmer tint that gradually changes to a bluish tint at the higher temperatures. As a consequence, photos taken indoors with film designed for outdoor use or taken digitally with a camera set to expect outdoor lighting will have a warm, orange discoloration. Photos taken outdoors with either film or a digital imager expecting indoor lighting are cold and bluish. The pictures of Daffy were shot without color correction, left to right, in flourescent light, daylight, and incandescent (tungsten) light. The spectra show how colors were distributed in each photo.

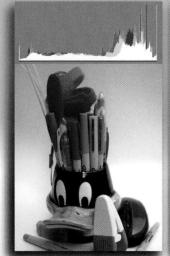

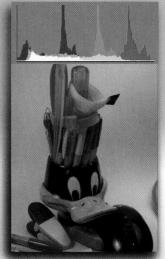

In film photography there are three ways to counter the inconsistency of light: film designed for outdoor or for artificial lighting, lens filters that dose the light with colors that balance out the inaccurate hues of outdoor or indoor light (filters can also be used in the darkroom, but relatively few photographers do their own color film printing), and a flash unit that gives outdoor colorations to indoor scenes.

The fixes for film photography require some degree of planning, and they are tricky to accomplish given all the possibilities for false whites. Digital photography can correct for off-white lighting on an ad-hoc basis by changing a setting for white balance. On some digital cameras, the process of setting white balance is accomplished by giving the camera an example to go by. The photographer merely presses a certain button while pointing the camera at something known to be white (despite our human tendency to interpret many different hues of white as being identical). This is similar to taking an exposure meter reading by pointing the camera at something known to be a medium gray. But the two types of readings are measuring different qualities of light around your subject matter, and taking one measurement does not replace your need to take the other measurement. White balance can also be set by dialing in a specific Kelvin temperature or a precalculated setting for common situations such as indoors or candlelight.

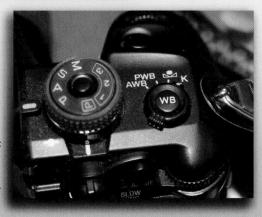

The camera's software notes the ratio of red to blue pixels in the white example. (Green does not have a significant effect on white balance.) If the ratio doesn't match the usual proportions of red and blue for a white object in normal daylight, the camera's processor adds more red or more blue pixels to the image to correct the color. Subsequently, when a photo is snapped, the processor makes the same red/blue adjustments to it.

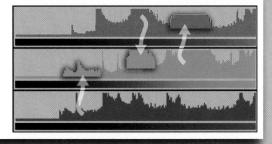

How Photos Make Noise

We've all driven through the night, trying to tune in any radio station to keep us company and keep us awake as we motored through stretches of countryside barely on the fringes of distant radio signals. What faint broadcasts we could receive sounded as if they were being pan-fried as the incoherent sizzle of static would swell to drown out music and voices. Radio static comes from the random dance of electrons and stray electromagnetic waves that have been throwing a party throughout the universe since the Big Bang. The same type of electromagnetism, though not with so grand an ancestry, peppers digital photographs with visible static, **noise** as it's called in photography despite its silence. Here's where it comes from, what you can do to avoid it, and how, sometimes, you need it when it isn't there.

Photographic noise is digital photography's equivalent of the grain in photos derived from film whose sensitivity to light has been pushed to the limit. In film, grain shows up as dark clumps that rob the photographs of finer resolution. In digital photographs that have also stretched normal exposures to eke out some detail in the shadows, noise appears as white or faint, pastel specks that can add texture or simply be distractions. Noise commonly comes from several sources.

Digital photograph shot at 3200 ISO, f/22 for 30 seconds

Dark noise comes from the imaging sensor and its accompanying circuitry. The heat these electronics produce boils off electrons that bounce around in the form of dark current until they end up in one of the photosites, where they're counted along with the legitimate photons captured through the lens. Depending on the type of image sensor used, an increase of 6°-10° C can double dark noise. Some photosensors, called hot pixels, generate more dark current than their neighbors and so produce more noise, but at known locations.

Signal noise is the noise that's inherent to all imaging and electromagnetic transmissions, which are the **signal**. The photons raining onto the photosensors do so in a statistical pattern called **Poisson statistics**. They decree that the rate of photons arriving at each photodiode, or **photosite**, fluctuates over time so that one pixel may record twice as many hits as the one next to it, producing inevitable noise. Put simply, noise is the everyday background clatter you can't get away from because there is no such thing as a pure signal. It's the electronic equivalent of traffic sounds, birds, and kids playing outside. Some signal noise is necessary to give objects texture. Photoshop backgrounds and computer-generated art without noise look flat and unrealistic. There are, in fact, programs that let you add noise to photos that are too quiet. The ideal is a **noise-to-signal ratio** that is low but still has some presence.

Amplified noise is akin to the grain you get using a high ISO film, especially when you push the film by exposing it as if the film had a higher ISO than it does. When you use a high ISO setting on a digital camera, the camera's sensor doesn't become more sensitive. Instead, the camera increases its amplification of the signals created by the light photons. As you amplify the signal, you also amplify the background electrical noise that is present in any electrical system. Even if no extraordinary amplification is used, reading the signals so they can be converted to digital values still contaminates the signal with noise originating in the amplifiers. This is also called **read noise** or **bias noise**.

Accumulative noise is akin to amplified noise. When you use extremely long shutter speeds in low light situations, you also give noise from its various sources a longer time to accumulate until, like amplified noise, it becomes visible.

electrons boiling off circuitry

CMOS amplifier

Photons

Random noise comes from unaccountable fluctuations in current or voltage in the camera's circuits, electromagnetic attacks from outside the camera, and even the occasional cosmic ray.

Hushing Your Photo

With so many sources of noise, you'd think there must be many ways to silence it. You're right. No one method works best in all situations, and unless

you do a lot of night photography—pushing the exposure with long shutter times and high ISOs—you usually don't have to worry about noise. If you do shoot in noisy situations, you're still covered. Some camera makers include circuitry to baffle noise. Because the locations of some noise are predictable, the camera's processor subtracts from noisy pixels a value that brings them in line with less raucous photodiodes. If the camera doesn't get rid of noise, most photo editing software can.

How Histograms Run the Gamut

The signature look of Ansel Adams's photographs is the rich, dimensional details that fill every inch of his prints. Sunlight gleams off rivers without washing out the water itself. Shadows give mountains density and form without hiding the trees, waterfalls, and outjuts that fill the shadows. Some of it, even Adams admitted, was luck, having a loaded camera pointing at the right spot when bulging, dark clouds decide to part long enough for the light to extend a finger to stroke the landscape. The rest of it was hard work and genius. Adams spent as much time polishing his own technique of developing film and perfecting his print-making as he did shooting largeformat pictures in the field. Few of us have the patience, knowledge, or equipment to follow Adams's lead. But digital photographers have something almost as good: It's the histogram. A histogram tells you instantly whether your exposure is simply correct for much of a picture or whether light and shadow are perfectly balanced for the entire photo.

Ansel Adams's "Tetons and Snake River"

On many digital cameras the LCD screen that functions as viewfinder and private screening room also provides a graph—a histogram—that provides more information than a light meter can give you. An exposure deemed acceptable by a light meter, when analyzed in a histogram, can actually turn out to consist of clumps of darkness and light that smother and burn away the details that add visual richness to a photo.

While the photographer is composing a shot, the digital camera's processor tallies up how many of the imaging sensor's pixels fall into each of 256 levels of brightness. The processor graphs the levels to 256 columns—or fewer for expediency—but still enough to do the job. The column farthest to the left represents 100% black. The column farthest to the right represents

100% white. The columns between them represent a steady progression of brightness levels, beginning on the left with a level virtually indistinguishable from black itself and proceeding to the right, with each column slightly lighter than the one to the left of it. The height of each of them is proportionate to the number of pixels of each shade found in the frame being shot. On some cameras, the histogram reacts in real time as you adjust the exposure so you'll know before you press the shutter how close you're coming to an acceptable dynamic range.

Dynamic range is a ratio of extremes. It exists in music as well as photography. A piano has wide range based on the ratio of the highest note it creates to the lowest. Cymbals and tubas both have small ranges because there's little difference between their highest and lowest notes. In photography, dynamic range is the ratio between the darkest pixel and the lightest. When dynamic range is narrow, the result is a photo such as this one. The red dots under the bridge show where the colors aren't covered by the sensor's gamut—the range of colors the camera can capture. For values outside its gamut, the camera substitutes the nearest value it can provide. In this photo the gamut runs to blacks too soon to capture the shadow details beneath a bridge. It's like an orchestra that lacks a bass section.

Inadequate range also causes details to wash out in light areas. Here overexposure is documented by a histogram in which the columns crowd the left edge. This photo is overexposed by a seasoned photographer who knows that sometimes no single exposure captures an image successfully.

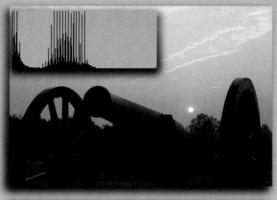

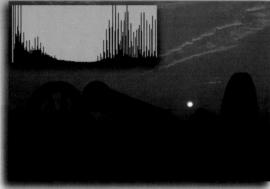

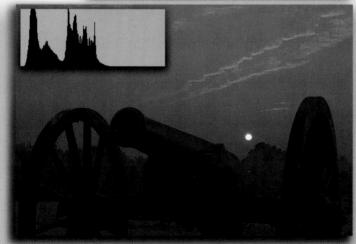

Nature photography by Ed Knepley (www.knepley.net)

After deliberately overexposing a shot by one
F-stop, the photographer underexposes the same shot by two F-stops. As expected, the columns congregate on the right end of the histogram in the second shot. In this variation, light areas are properly exposed but the same shadow detail that was visible in the first photograph recedes into the darkness.

In the digital darkroom, the photographer combines the two pictures to capture details in both the light and dark areas. Although aesthetic judgments might lead to photos that have a predominately dark or sunny cast, generally a photo looks best-looks richer-if its histogram consists of columns distributed across the bed of the graph. Some peaks and valleys along the way are perfectly acceptable. The pattern to avoid is any clumping or vacancy at either end of the histogram unless your subject is primarily bright or dark.

CHAPTER

5

How Light Becomes Data

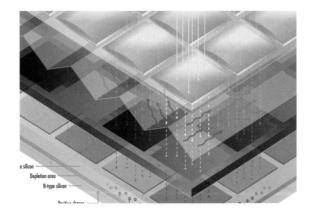

THE real difference between a film camera and a digital camera is not how the cameras take pictures, but how they store them. After a picture is stored on film, there is only so much that can be done with it. How the film is processed can change the image—once. Then the picture is frozen in the form of chemical molecules that have clumped together to form microscopic dots of color. There's no way to manipulate those molecules. Sure, you can disguise the information stored on the film. When you make prints from the negative, you can burn here and dodge there, or use a special paper for a silvery look. You can...well, that's about it. It's purely cosmetic. The fact remains that after visual information is stored on film, it is fixed for all time—or until the chemicals deteriorate so much that the information is lost entirely. But with a digital camera, or with film-based photos scanned into your computer, there's no limit—none, whatsoever—to what you can do with an image after the camera stores it. That's because the image is stored as a huge array of numbers. And as you learned early on about numbers, they stretch on to infinity, Because images in digital photography are stored as numbers, manipulating them can be as simple as fourth grade arithmetic. A pure color (and on your computer monitor that means red, blue, or green) is recorded as one of 256 possible shades, with the purest rendition of that color as 255 and the complete absence of that red, blue, or green as 0 (black). To lighten the photograph, all anyone has to do is add 25 or so to the color value of every pixel in the picture—all 3—5 million of them. If you want to lighten only the shadows, just choose those pixels that have a value less than 125 and add only 25 to them. Or, go wild and rip out entire sections of the photograph and replace them with entirely different constructs of numbers that represent anything from comets to cattle.

The math is simple, in principle at least. The tricky part is changing all the possible combinations of colors into numbers. Here, we'll show you how your digital camera pulls that off.

Spectral sensitizers

How Film Photography Captures an Image

Digital and film cameras are 90% the same. Optics, exposure, timing, and the skill it takes to use either of the cameras are not much different from one another. Where the difference is greatest is in the topic of this chapter—how light streaming through the lens is trapped and preserved, how film and electronics both take a slice out of time and space to make them into something immutable. We're going to step into our Way Back Machine for a short hop to a few years ago, when digital photography was esoteric and imperfect. When all professional photography was still an analog process—a process so esoteric as to make it a snap to learn how to use those new digital computers.

Although we usually think of light as something to help us avoid walking into walls, it's also packed with energy—a fact you can demonstrate to yourself by lying in the sun too long. That energy is essential to photography. In film photography, the energy in light ignites chemical reactions when color or black-and-white film is exposed to the light when a camera's shutter is tripped. The light, focused by the lens, shoots through layers of a **gelatin emulsion** about a thousandth of an inch thick that rests on a base made of **celluloid** or **polyester**, both transparent plastics. The base, 4–7 times thicker than the gelatin, exists primarily to support and protect the fragile emulsion layers.

Buried throughout the gelatin are microscopic crystals that are there to make a record of where the light strikes the film. They are the chemical equivalent of the photodiodes in a digital camera's image sensor. The crystals are made by combining silver-nitrate with different mixtures of halide salts, including chloride, bromide, and iodide. Their crystalline structure allows film manufacturers to grow them smaller or larger. The greater surface areas of larger crystals make the film more sensitive to light but result in lower resolution and contribute to noticeable grain, the speckled equivalent of noise in digital photographs. Smaller crystals, while not able to gather in as much light, can delineate smaller features in a photograph. Silver-halide crystals The result is a trade-off between film that can take photos in dimmer light, with faster shutter speeds and using larger Gelatin apertures, or film that captures more and smaller details with less grain but requires more light. Base (celluloid or polyester)

COLOR FILM

The sensitivity of the crystals, which ordinarily are mediocre receptors of light, increases when certain chemicals are fused into the crystalline structure. These organic molecules, called **spectral sensitizers**, increase silver halide's sensitivity to light generally. In color film different combinations or sensitizers make crystals embedded in separate layers in the emulsion, respond to specific colors.

When light strikes one of these crystals, a **photon** (the particle form of light) raises the energy level of loosely bound electrons in the crystal's halide salt. The electrons unite with positive holes in the silver portion of the crystal to form a pure atom of silver. In color film, crystals in different layers are sensitized to respond only to red, blue, or green light rays.

REDUCING AGENT

The pattern of millions of silver grains forms a **latent** image, one that is not yet visible. Color film forms three latent images, one for each of the layers devoted to a specific color. To make the image visible, the film is **processed** through a chain of chemical baths. The first is a **reducing agent**, commonly called **developer**, that converts silver ions into silver metal.

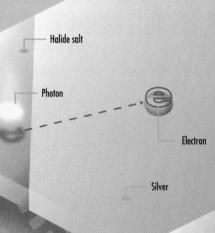

STOP BATH

The grains that make up the latent image develop faster than the other crystals. The right combination of temperature, agitation, and time is followed by a stop bath solution that neutralizes the reducing agent before it changes the unexposed grains.

A **fixing bath** dissolves the unexposed and therefore undeveloped remaining silver halide that was not exposed to the light, leaving only the silver metal behind forming, in black-and-white film, a negative of the pattern of light the camera's lens had projected onto it.

In color film, chemicals called

couplers are matched with the

color-sensitized silver halide in each

of the three color layers. During developing, the couplers form red, green, or
blue dyes concentrated around the silver
grains left by the reduction process. After a
brief drying, the film is ready to produce prints
or to become slides.

How a Microchip Catches a Picture

Here we are, finally, at the point that separates the digital from the analog. The microchip imaging sensor that takes the place of film is the heart of digital photography. If you've been reading since the beginning of the book, you already have an idea of the workings of those microscopic devices that make up an image sensor: pixels. It's a term that's often used loosely but is short for picture elements. Basically, it's a supercharged version of the photodiode we saw at the core of light meters in Chapter 4, "How Digital Cameras Capture Light." While the basics are similar, the light meter measures only a blurred average of an image. Unlike the light meter, the imagesensor doesn't measure simply the intensity of light. It must distinguish all the gradations of light in all the colors that play on its surface, pass that information on in a way that lets it be translated to numbers, and then get ready to capture the next image—all in slivers of a second.

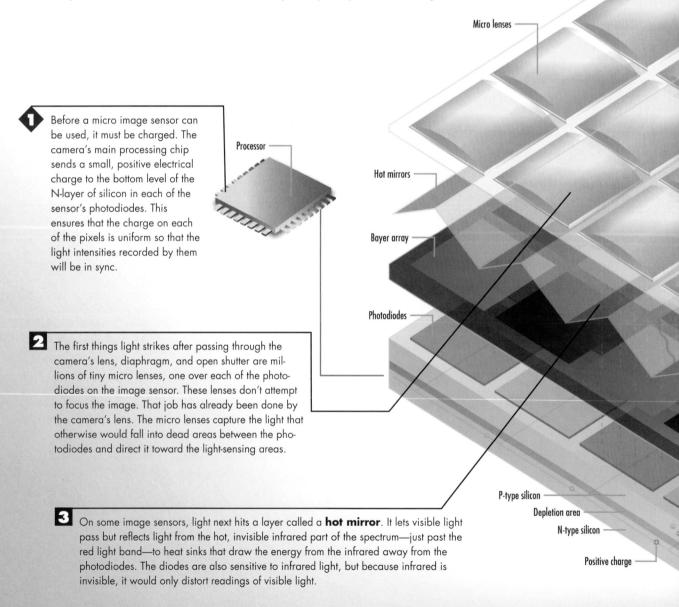

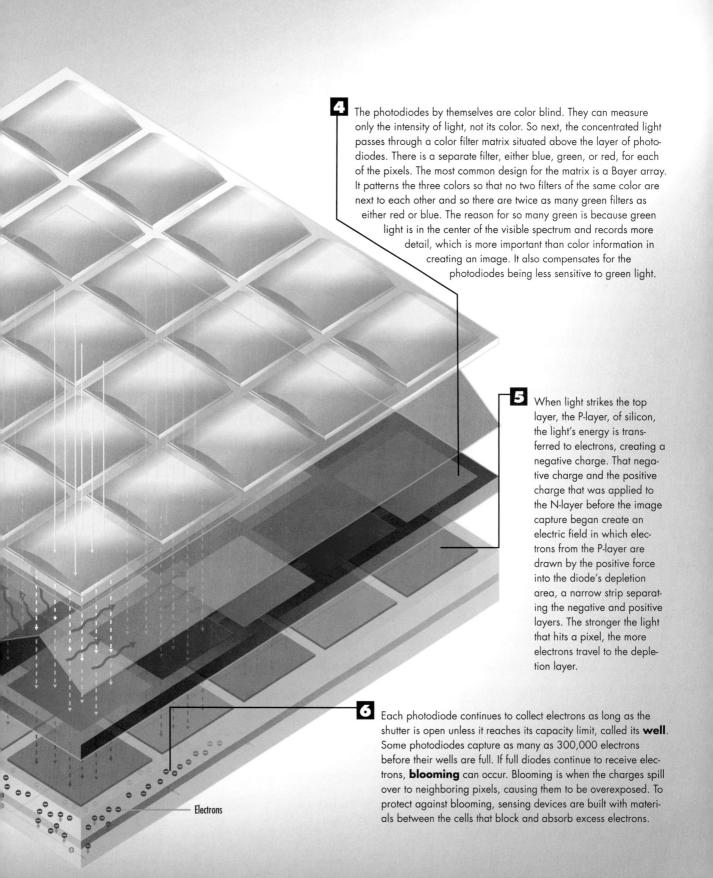

How Image Sensors Differ

The image sensor we looked at in the previous illustration is based on a common design used in most digital cameras. But there are exceptions to the layout of the light receptors for the different colors. And once the photodiodes, in any configuration, have gathered their information, there are differences in how that information is turned into digital data that the camera's microprocessor can tweak before storing it on a memory card. Here are the most important exceptions to the rule.

How the Fuji SR Sensor Has Double Vision

0

The ultimate challenge for photographers is to capture the greatest dynamic range in their photographs. **Dynamic range** is the ratio of the highest non-white value and smallest non-black value. More simply, it means that details are easily discernable in the lightest and darkest portions of the photograph. In this picture, there is enough light to delineate the granules of dark

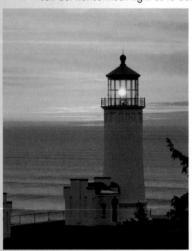

The photos to the left show how adjusting exposure can't always compensate for an image sensor's poor dynamic range. If you increase exposure to show the details in the shadows of the lighthouse, the colors in the sunset wash out. If you decrease exposure to capture saturated colors in the clouds, the lighthouse details are lost in the shadows.

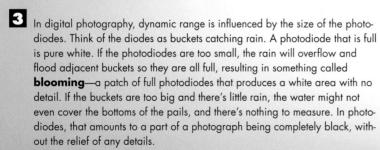

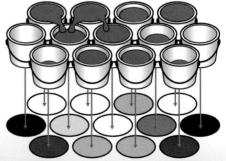

S (Sensitivity) Pixel High sensitivity Captures bright dark areas with shadow detail, but over-exposes light greas

The smaller photodiode is set at a lower sensitivity and works as if it wore sunglasses. This prevents it from filling up quickly and causing blooming. As a result, it can capture the detail information in the areas that are so bright that they blind the large photodiode, which stares at the same light with a wide open eye.

A fast algorithm built in to the camera's processors combines the readings taken by each pair of photodiodes to create the optimum exposure for the pixel that they represent, with each diode providing a proper exposure where the other can't. By combining the results, the Super CCD SR produces a picture comparable to those produced with a 12-bit color scheme, which has a range of 4,096 brightness levels, even though the photodiodes, individually, yield only 8 bits, or 256 brightness levels.

How the Foveon Image Sensor Stacks It On

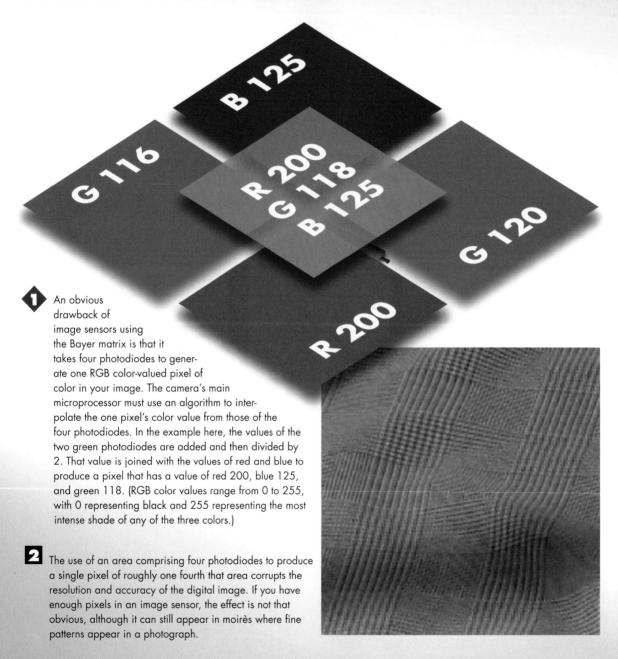

The Foveon X3 image sensors found in some
Sigma and Polaroid cameras attack the deficiencies of
Bayer matrix sensors by eliminating the matrix. They use a
natural property of silicon that makes it absorb different colors of
light at different depths in the silicon. Blue light is absorbed near the
surface, green farther down, and red deeper still.

In the Foveon photodetectors at each of the three levels convert the energy from the three colors of light into three separate electrical signals that are used to represent a single color pixel. In contrast with the Bayer matrix photodetectors below, no light is lost to filters absorbing two of the three colors and less surface area is lost to the layout of the separate receptors for each color.

How an Image Becomes Data

The street you're driving down doesn't suddenly end here and start again over there, with no way to bridge the gap. Time doesn't stop for 5 minutes and then pick up again where it left off. Of course, if it did, how would we know? The point is that we're used to thinking of things as analog—smooth, continuous objects without any quantum gaps between here and there. But in the computer world—and your digital camera is a computer—nothing is smooth and continuous. It's digital. There are gaps between this point and that one, between this moment and the next. Before we can do all the wonderful things available to us now that a computer is packed into our camera, we and our cameras have to communicate—we with our words; the cameras with a mathematical alphabet of only 0s and 1s.

0

Anything in the universe can be measured in analog or digital terms.

Analog simply means that the expression of the measurement is analogous to whatever it's measuring. An old-fashioned thermometer with reddyed alcohol in a tube gives an analog representation of how hot it is because the alcohol rises, literally, as the temperature rises. A digital thermometer expresses the temperature in numbers on a small LCD screen. The numbers themselves don't grow larger as the temperature rises.

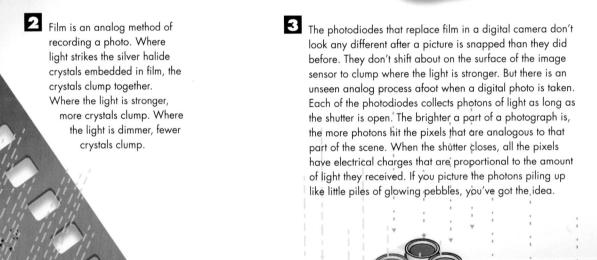

What happens next depends on whether the image sensor is a **CCD** (charged coupled device) or **CMOS** (complementary metal oxide semiconductor). Don't bother with the full-fledged names. Everyone uses the acronyms, and they won't be on the quiz. You will hear a lot of technohype from camera makers citing reasons one technology is better than the other. You can ignore that, too. The type of imager is just one factor that contributes to the photo that eventually will come out of your printer. It's the print that's important. Whether you're happy with it or not doesn't hinge on the type of image sensor. But here, for the sheer joy of knowledge alone, are the differences in how the two types of chips work.

cco Image Sensor

. Read-out Register

CCD

The charges in an **interline CCD** imager, which is what most CCDs are, begin an orderly procession toward their future existence as digital numbers like well-behaved schoolchildren in a fire drill. At one end of the imager, the charges move down and out at the bottom of the column as if someone were continually pulling the bottom can of Coke out of a dispenser.

When the last charge has rolled out of the bottom of the column, the charges in the second column shift to fill the vacancies left by the newly departed charges. The charges in the third column move to the second column, and the thousands of remaining columns follow their lead like a panoramic Busby Berkeley number.

CMOS Amplifiers Photosites

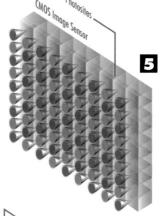

4 Unlike the photosites in CCDs—pretty much passive capacitors that do little but store an electrical charge until a control somewhere else tells them what to do with it-a CMOS sensor is able on its own to do some of the processing necessary to make something useful out of the charges the photosites have obtained from the light.

The first thing the CMOS image sensor does is use the amplifiers that are part of each photosite. This eliminates the need for the charges to go through an amplifier in single file after they've left the sensor.

When a column of charges falls out of the imager, it is detected by the **read-out register**, which takes them to an amplifier. Until they are amplified, the charges are more faint static electricity than electrical current. The amplifier pumps energy into the charges giving them a voltage in proportion to the size of each charge, much as a flagging video game character is pumped up with "life force" by jumping on a coin.

6 More importantly, the onsite amplifier eliminates the slow classroom drill CCDs use to leave their nest. As soon as the amplifiers have turned the charges into actual voltages, those voltages are read over a arid of X-Y wires whose intersections correspond to locations of the photosites. It's the voltages' way of saying simultaneously, "Beam us up."

How Algorithms Smooth Out a Picture's Rough Spots

RAW

In the creation state, while each photodiode was soaking in the rays of either red, blue, or green light colored by the filter hanging above it, the diode was ignoring the other two colors. That means two thirds of the information needed to make up our photograph is missing! Of course, there must be some scientific, high-tech methodology the camera can use to supply the missing colors for all those millions of pixels. There is, It's called guessing. But because scientific types who design cameras don't like to be caught making guesses, they have another name for it: Interpolation. And on days they feel particularly self-conscious, they call it demosaicing.

> If we could look at a photograph before it was processed and otherwise manipulated by the camera, it would look something like this. It's a red, blue, and green mosaic, which helps explain demosaicing; it means becoming something other than a mosaic. (We faked this photo, by the way. Just so you know.)

As soon as the newly digitized color values come out of the analog-to-digital converter, they are rushed over to another chip, the array processor. Its job is to guess the values of the missing colors based on the third of the values it does have and algorithms—a cross between a formula and a plan of attack. One such algorithm is bilinear interpolation. To determine the missing green and blue values of the pixel in the center, now occupied by only red, bilinear interpolation averages the values of the four nearest green and blue pixels.

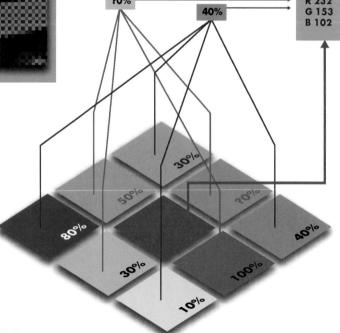

Still other algorithms reach out to pixels located farther away than their nearest neighbors. Different algorithms battling to achieve the perfect interpolation weight differently the values of different pixels. By applying those weights to different patterns the array processor sharpens some areas and blurs others. And sometimes, the results are not what was expected. In the lighthouse photos here, different algorithms have been applied to the same photo, revealing common **artifacts**, visual characteristics that are not a natural part of the photo's subject. In addition to the **blur** in the upper-left version, the interpolation used on the copy next to it exhibits **tiles**. You might have to study the photo a bit to see the pattern of vertical and horizontal lines added to it. In the bottom-left interpolation, the **watercolor** effect washes out the color in some areas, such as the red life preserver. And **shift color** in the bottom-right rendition

ORIGINAL, UNSAMPLED PHOTO

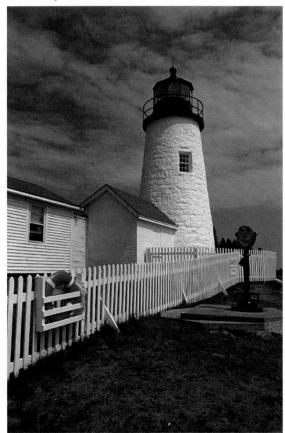

produces hues that were never in the original photos. Also, look for loss or gain in detail with different interpolations, as well as moiré patterns on the building to the left and on the fence, color artifacts on the light house above the building attached to it, and the good-to-terrible rendering of the lighthouse window.

BLURRED

WATER-COLORED

SHIFTED COLOR

Photos courtesy of Sabine Süsstrunk of the Swiss Federal Institute of Technology Lausanne and David Alleysson of Universite Pierre-Mendes France

How Big Photos Fit in Small Chips

All those little Os and 1s that your digital photographs are made of sure add up. Each of the pixels in a photo requires at least 24 of those bits, eight for each of the three colors that go into every small, small dot of color. Some high-end cameras double the number of bits. And all digital cameras demand still more bits to record the interpolated images and in-camera enhancements such as sharpening. To keep things simple, let's say you have a 5-megapixel camera, not an extravagant number these days. That means one photo in 24-bit color needs more than 120 million bits. Shoot as many pictures as you can with a 24exposure roll of film, and you're up to almost 3 billion bits. And who stops at 24? Digital cameras have to pack those billions of bits away somewhere. This is how they manage it.

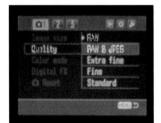

Most digital cameras provide a choice of digital file formats to use for saving files. Most commonly, you'll have options for RAW, TIFF, and JPEG formats. Each has a different purpose

22 RAW files are the image before it's had any kind of interpolation, resizing, color correction, sharpening, or anything else that would spoil its pristine character. Once any of these necessary improvements are performed on a RAW file, you have lost visual information that cannot be recaptured. But working with a RAW file lets a photographer exert the most detailed control possible over the processing and polishing of a photo—more than what is possible with any other format.

While not a virgin version of the photograph, as is a RAW file, a TIFF file is almost as big and contains most of the information found in a RAW file. The important consideration in using a TIFF file is that they are not compressed. They remain as big as they were to begin with, if you don't crop them, and they have the same number of pixels.

A **JPEG** file, on the other hand, was designed to be squeezed and squeezed again so that it takes up as little storage space as possible while still providing a reasonably accurate depiction of the original picture. But squeeze it once too often and you'll cross the line between an acceptable photo and a bad one. There's no going back.

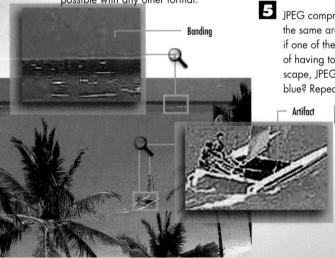

JPEG compression works on the principle that in most photos many of the pixels in the same area as each other are identical, or so identical that no one will ever notice if one of the colors edges up or down a notch to match its neighbors. Then, instead of having to store the same information for blue sky that makes half a photo land-scape, JPEG compression tells the software storing an image, "You see this color of blue? Repeat it for the next million and a half pixels." That takes up less space.

JPEG is a **lossy** form of compression, so whatever information was discarded to save space is lost forever. JPEG files are compulsive compressors. Each time you save a JPEG photo, or even rotate it 90°, it calculates another scheme to save space. A JPEG file that's been compressed too much or too often loses details. It can develop **banding**—strips of the same solid color where there should be shading—or other **artifacts** caused by JPEG's attempt to depict something with too little data. You can call for more or less compression when you save a JPEG, but important photos are best saved in TIFF or some other **lossless** format and copied to JPEG when you want to send them over the Internet.

Jump drives (not used in cameras but a popular form of flash memory.)

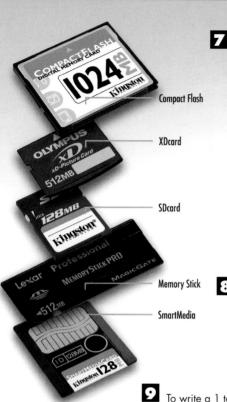

Whatever format you choose for saving your photos, their first stopping place will be some sort of **flash memory**. Flash memory comes in the form of thin cards, fat cards, chewing gum-size sticks, and even key chains. Increasingly, flash memory makers are developing faster methods of getting data from a camera into the memory to keep pace with cameras that take multiple shots in a few seconds. The faster memory cards move data more than 100 times as fast as the slowest. What they all have in common is that they do not lose whatever is stored in them simply because someone turns off

Unlike ordinary memory, in which a single transistor is used to store either a 0 or a 1 and must be constantly refreshed by a supply of electricity, flash memory uses two transistors on different electrical lines that intersect each other to save a single 0 or 1 bit. One of these transistors is called the **control gate** and the other is called a **floating gate**.

To write a 1 to the intersection of the two transistors, an electrical charge passes through the floating gate, through a layer of metal oxide that separates the transistors, and on to the control gate.

the camera.

Energy from the current also causes electrons to boil off the floating gate and through the metal oxide, which drains them of so much energy that they cannot return.

A **bit sensor** near each of these intersections compares the strength of electrical charges on both gates and, if the charge on the control gate is at least half that of the floating gate (which it would be after getting that transfusion of electrons), the bit sensor proclaims that the value stored there is a 1. If the sensor doesn't detect a significant charge, the bit is a 0.

When it comes time to erase or rewrite the bits stored in flash memory, a strong electrical current flows through the circuitry to predetermined sections of the chip called **blocks**. The energy in the blocks disperses the electrons so they are again evenly spread among the gates.

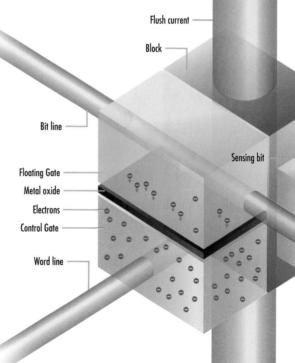

P A R T

How the Digital Darkroom Works

CHAPTERS

CHAPTER 6 HOW SOFTWARE MANIPULATES PIXELS 106

CHAPTER 7 HOW DIGITAL RETOUCHING RESCUES FAMILY HEIRLOOMS 122

CHAPTER 8 HOW THE DIGITAL DARKROOM MAKES

GOOD PHOTOS INTO GREAT FANTASIES 130

How Software Changes Photos by the Numbers

The humongous advantage of using numbers to represent images is that you can lighten an image, darken it, bring out contrast, sharpen it or blur it, turn it upside down, or transform it into a psychedelic abstract, all by using simple arithmetic. It's not so simple that we can sit at a computer with the Mona Lisa on the screen and subtract numbers from the color values in Mona's portrait, turning her smile into a frown. It would be an excruciating job, the kind of job computers are made for. A PC can calculate a frown job on Mona in less than 10 seconds. It's all just a numbers game.

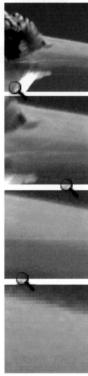

Your digital camera records your digital photo as a set of tiny pixels. As you look closer at a photo, though, you begin to see the pixels as jagged edges and then squares. What you thought were distinct lines and boundaries turn out to be more gradual transitions between colors.

Zoom in far enough, and you see that each pixel is actually a tiny square consisting of a single, solid color.

Red value: 242 Green value: 149 Blue value: 153

Red value: 107 Green value: 114 Blue value: 27

When you tell your image editing software to make a change, such as sharpen, brighten, or apply effects, the software looks at the differences in color between pixels. Often, it compares those values with pixels that are close but not touching the pixels under scrutiny.

P A R T

How the Digital Darkroom Works

CHAPTERS

CHAPTER 6 HOW SOFTWARE MANIPULATES PIXELS 106

CHAPTER 7 HOW DIGITAL RETOUCHING RESCUES FAMILY HEIRLOOMS 122

CHAPTER 8 HOW THE DIGITAL DARKROOM MAKES

GOOD PHOTOS INTO GREAT FANTASIES 130

"The camera cannot lie, but it can be an accessory to untruth."

—Harold Evans, "Pictures on a Page"

seems unfeeling to speak of converting a photograph to data. Whether the photo is of a soldier at the moment of his death or a centerfold at some less painful moment, surely no one would suggest that all that is beautiful and exciting in a work of art can be reduced to a few million binary numbers. Well...yes, we would. As unromantic as it might seem, nearly anything can be expressed as numbers.

The blue of your true love's eyes? That's PANTONE 468. The rousing opening chords of Beethoven's Fifth? IBM a few years back ran two facing magazine pages filled with tiny 0s and 1s. It was the binary notation to the opening *dum dum de dum!* And the photograph of your children that you've carried in your wallet until it's grown creased and frayed and torn? Run it through a scanner. That will divide the photo into millions of microscopic areas and assign each one of them numbers representing color, brightness, and hue. As for all those savages of time, submit the scanned photo to an image editor, and it will suck up some of those numbers from the scanner, do a little math, do a little trigonometry, and get down tonight with a totally restored photo.

Okay, so math still doesn't ring of romance (unless you're Russell Crowe). But it is essential to creativity in the world today. That gets overlooked when a lot of people talk about multimedia and computers. The argument usually goes that audio and video have added so much to the computing experience, when it's really the other way around. By not reducing—rather by expanding—music, shape, color, and a range of other human experiences and expressing them with numbers linked to a fast processor, one can easily experiment with art and with knowledge, trying out what would have consumed a lifetime less than a lifetime ago.

How Software Manipulates Pixels

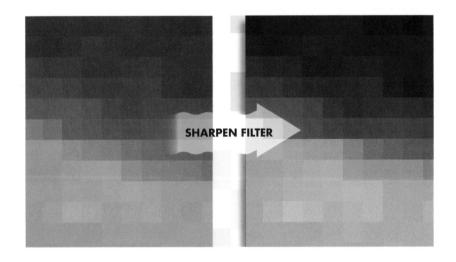

THE numbers racket rarely pays off as well as it does in retouching photos—digital photos, that is. For when you've shot or scanned a photograph, all those areas of color and light and dark can be assigned a number, several numbers, in fact, for color, position, and hierarchy. Then you're only a calculator away from improving that picture for an off-color hue here, a touch of red-eye there, or (on the more drastic side) getting rid of irritating relatives entirely.

Practically any operation that can be carried out with photo-editing software starts with the number of some pixel in the photo. If you want to eliminate a wart, you first must get the numbers representing the color of the skin surrounding the wart. From there, it's a relatively simple matter of using the software to change the pixels depicting the wart so they have values for color and lightness that match the surrounding skin.

That's a simple example. All the examples in this chapter are kept intentionally simple because they're easier to explain and because, once you grasp programs such as Adobe Photoshop and Paint Shop Pro at their simplest, the more complex operations fall into place naturally.

How Software Changes Photos by the Numbers

The humongous advantage of using numbers to represent images is that you can lighten an image, darken it, bring out contrast, sharpen it or blur it, turn it upside down, or transform it into a psychedelic abstract, all by using simple arithmetic. It's not so simple that we can sit at a computer with the Mona Lisa on the screen and subtract numbers from the color values in Mona's portrait, turning her smile into a frown. It would be an excruciating job, the kind of job computers are made for. A PC can calculate a frown job on Mona in less than 10 seconds. It's all just a numbers game.

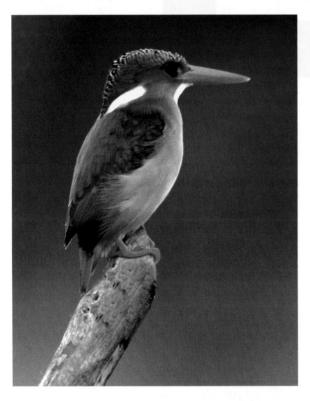

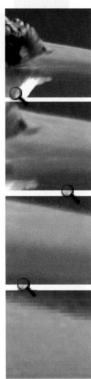

Your digital camera records your digital photo as a set of tiny pixels. As you look closer at a photo, though, you begin to see the pixels as jagged edges and then squares. What you thought were distinct lines and boundaries turn out to be more aradual transitions between colors.

Zoom in far enough, and you see that each pixel is actually a tiny square consisting of a single, solid color.

3 When you tell your image editing software to make a change, such as sharpen, brighten, or apply effects, the software looks at the differences in color between pixels. Often, it compares those values with pixels that are close but not touching the pixels under scrutiny.

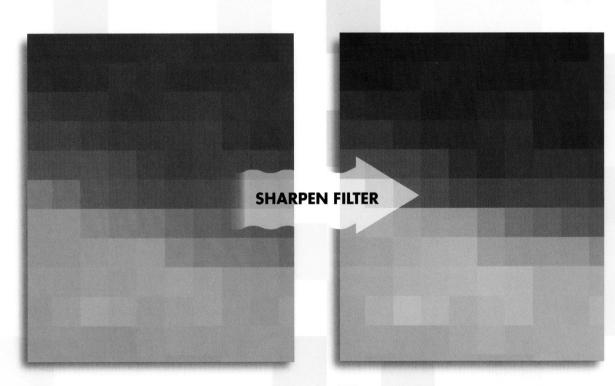

- The software applies a mathematical formula to recalculate the color of each pixel. It starts with the formula for the type of editing or effect you are asking it to do. It also takes into account the differences in color between pixels, often those in or near transition areas.
- Not all pixels are changed equally. Some pixels might retain the same general color but take on a slightly darker or lighter tone. Other pixels might be assigned a very different color. Pixels that are not near a border area might not be changed at all.

How Software Focuses Pictures After They're Taken

When a digital camera translates the continuous gradations of color into discretely colored pixels, finer details get approximated. The result is a slightly softer look than photographic film would yield. To compensate, digital cameras usually do a bit of electronic sharpening before they send the image to your computer. Once on your computer, your digital darkroom can add sharpening effects using the same methods.

What does it really mean to **focus** an image you've already taken? To the digital darkroom, it means increasing the contrast between certain pixels by making some darker and others lighter. You can see this when you zoom in.

Dark lines are a bit darker, and the light areas next to them are a little lighter.

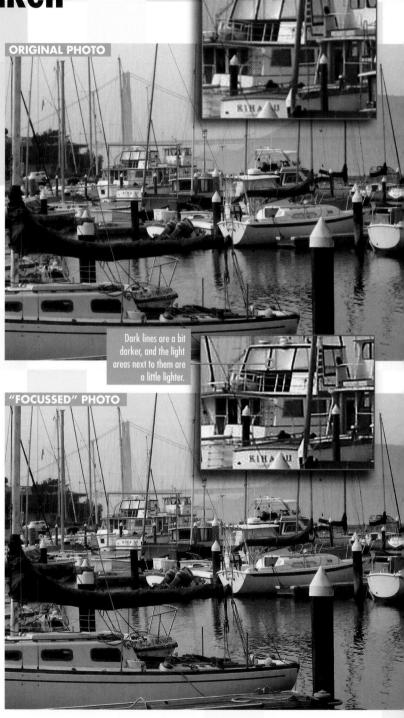

To determine which pixels it will change, the digital darkroom compares neighboring pixels to see if the tone of one exceeds the color of another by a preset threshold. (You can, with some photo editing programs, set the threshold to finetune the degree of sharpening applied.)

DOES NOT MEET THRESHOLD:

Do not change

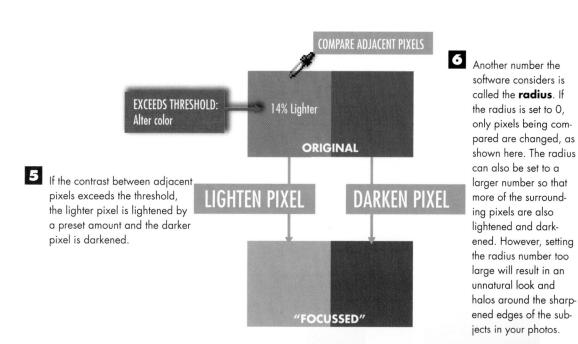

When Unsharp Is Sharp

Photo editing programs have more than one way to sharpen an image. Commands such as **Sharpen** and **More Sharp** don't require a lot of explanation. The function described here is called **Unsharp Mask**, a term that seems to be going in the wrong direction. It gets its name from the fact that areas with significant changes in contrast look sharp while areas without big changes in contrast look smooth and less defined and are therefore effectively masked from the sharpening filter.

How Blurred Becomes Better

Much of our time and effort as photographers is to get the focus just right. We welcome innovations such as autofocus and antishake mechanisms that help us get sharp images. Crisp focusing is so important that it seems contrary to a photographer's instincts to deliberately make a photo blurry and less focused. But blurs do have their place.

> Sometimes you want to hide things in a photograph as much as you want to show other elements. For instance, the high level of detail gives this photo a harsh appearance.

Applying a slight blur gives you a more aesthetically pleasing effect.

There are many different ways to apply a blur to a digital photo, but all blur functions recalculate the color value of a particular pixel by averaging it with the pixels around it. Of course, if you averaged the color of every pixel in the entire photo, and applied it to every pixel, our portrait would look like the brown square to the left.

- Instead, blur functions calculate a **weighted** average of neighboring pixels that looks something like this. The color of the pixel being considered (center) carries the most weight in the averaging process.
- Pixels directly adjacent are weighted less, and the weighting falls off drastically after that.

1		1	2	1			
	3	13	22	13	3		
1	13	60	100	60	13	1	
2	22	100	160	100	22	2	
1	13	60	100	60	13	1	
	3	13	22	13	3		
		1	2	1			

Here, the color of the pixel itself is counted 160 more times than a pixel at the end of the radius of pixels being used to calculate the new color.

Different types of blur functions use different numbers to calculate the color value of the pixels, or widen or narrow the radius of pixels being used. Some blur functions use this method to change every pixel in the image, while others will not make changes at perceived edges.

How Software Changes Exposure After the Shot

There are two different exposure problems that can occur when you take a picture: underexposure and overexposure. These can happen even with the finest digital equipment because not all subjects are lighted equally nor are all photographers equally gifted in capturing a scene. If the equipment doesn't make a mistake, the photographer will, sooner or later. Luckily both types of poor exposure can be fixed in the digital darkroom.

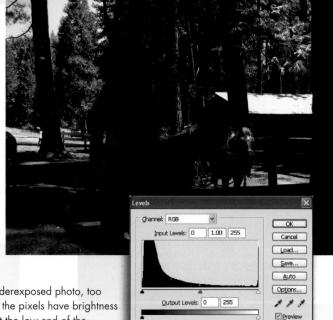

Underexposure

Underexposure is a result of not enough light getting into the camera. The shutter speed was too fast or the aperture set too small. Although you might not see them, details of your image can hide in dark tones and shadows.

In an underexposed photo, too many of the pixels have brightness values at the low end of the dynamic range. If you simply raise

the brightness of every pixel equally, you get a washed-out look. What the digital darkroom will do to fix underexposure is to treat different levels of brightness differently.

Colors will be made brighter to different degrees, depending on how dark they are, how much of that color exists in the picture, and where they are located. If there are no absolute whites in the photo, the lightest color might be brightened to white to increase contrast.

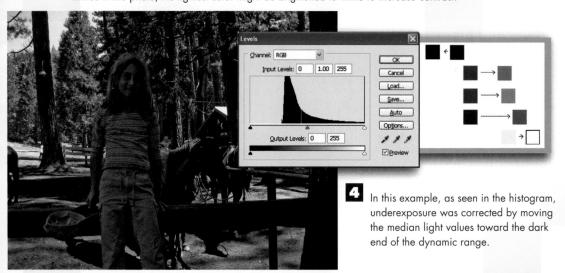

Overexposure

Overexposure, when too much light gets into to the camera, can be corrected much in the same way, by recalibrating the lightest and darkest pixels, and then by darkening pixels in the mid-toned colors and highlights.

Overexposed images can be more difficult to correct than underexposed photos. Overexposed images can lose details in the highlights, yielding white areas with little or no information.

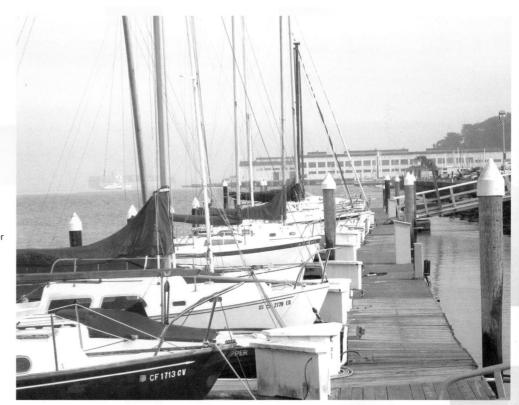

Here, the boats run together without borders.

3 Correcting the image can't add the needed detail.

exp tain dist whi why taki it's tow than

Only the correctly exposed photo contains enough detail to distinguish between the white boats. This is why, even when you're taking digital pictures, it's better to lean toward underexposure than overexposure.

How Software Corrects Bad Lighting

One of the most common problems of the amateur photographer is that of the backlit subject without a flash. Here, the camera makes its adjustments based on the bright background, which turns out perfectly exposed. Unfortunately, because light from behind a subject puts it (or him or her) into shadow, the subject is left underexposed.

While use of a flash would have prevented the problem, the digital darkroom can provide a flash fill after the fact. It treats the photo like two photos: one that is perfectly exposed and one that is underexposed. To find the two areas, it calculates the brightness values of groups of pixels.

Areas that are predominantly dark are designated as part of the underexposed portion.

The digital darkroom masks off the areas that have a balance of color tones and leaves these areas alone.

To the remainder of the photo, the software applies the routines it would use for an underexposed photo, adding the same amounts to the values for the three colors that make up the pixels. The higher values represent lighter shades.

The result is that the correctly exposed background is retained and the underexposed subject has come out of the shadows.

How Bigger Photos Preserve Little Details

Suppose you had just completed an attractive mosaic covering a wall when the boss comes along and says there has been a change in plans. The wall is going to be twice as long and twice as high; you'll have to make the mosaic four times bigger. There are a few ways you could do this. You could replace every $1'' \times 1''$ tile with tiles of the same color that are $4^{\prime\prime}\times4^{\prime\prime}.$ Or you could spread out the tiles you have and try to figure out the colors of all the missing tiles that need to fill up the spaces between the original tiles. Or, you could quit and become a video software engineer, which means you'd still face the same problem.

If you zoom in close on the hub of the front wheel, you can see that the hub is made up of more pixels in the enlargement than in the original.

50 PERCENT ENLARGEMENT

- You can best see how your software creates the new pixels by looking at the pixel level. This simple image is made up of only 4 pixels. We'll perform a five-fold enlargement, bigger than most, but good to illustrate the process.
- First, the software spreads the existing pixels apart.
- Next, it fills in the white space with duplicates of the existing pixels.

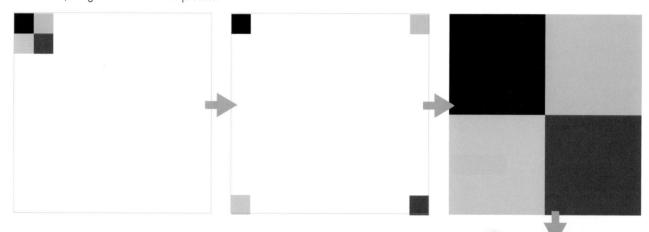

Better Ways to Enlarge Images

If you want to enlarge your image substantially, it's better that you do it in a series of small increments of no more than 110% at a time until you reach the desired size. The reason is that your image editor will have smaller gaps to fill in after spreading the existing pixels and your final result will look much smoother than if you tried to make a substantial enlargement in one pass. Think about it this way: It's easier to walk up or down a flight the stairs one step at a time. You can probably skip every other step without too much of a problem. But things starting getting more difficult the more steps you try to skip on your way up or down.

Leaving the photo like this would result in a blotchy-looking image. To prevent this, the software uses one of many algorithms to create transition among the original colors.

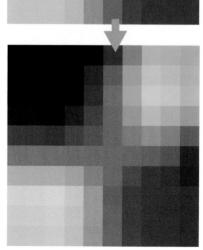

How a Digital Darkroom Makes **Good Photos Better**

Most of us would be delighted if all darkroom software could do is save our photography from our mistakes. But it gets better than that. You can improve photos you think couldn't be improved—at least not technically—by running them through programs such as Photoshop and Paint Shop Pro. The fact is that you could have been looking at marginal photos for so long that they looked perfect to you. It's similar to our inability to distinguish among shades of white. We don't see that a photo's slightly overexposed or underexposed, that there's a

greenish cast to it, or that is has a dullness that's not really apparent until darkroom software banishes the flaw. Software makes good shots into photos that pop off the screen and the paper. These improvements are based on the information the software finds in a histogram, which is a record of the color and brightness values of every pixel that makes up your picture. Here's how it works.

To each pixel, the software assigns a tone value, a number from 0 (representing pure black) to 255 (for white). The software then counts how many pixels of each tone value are contained in the picture and can often display this information in a bar graph called a histogram. Along the horizontal axis are the tonal values. Each bar displays the number of pixels in the photo that have that tonal value.

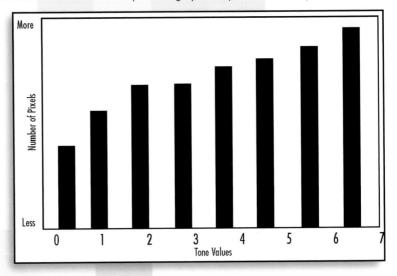

When you graph all 256 tones and the millions of pixels in an image, the histogram can look something like this. There is no "right" way for a histogram to look. It can have a single, bellshaped curve in the middle, or it can have multiple humps. A photo with a lot of snow or sand will have a big hump on the right side, while a night scene might have a lot on the left side.

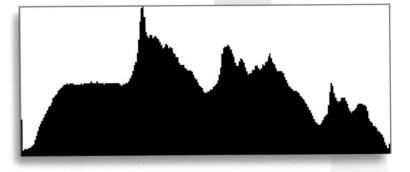

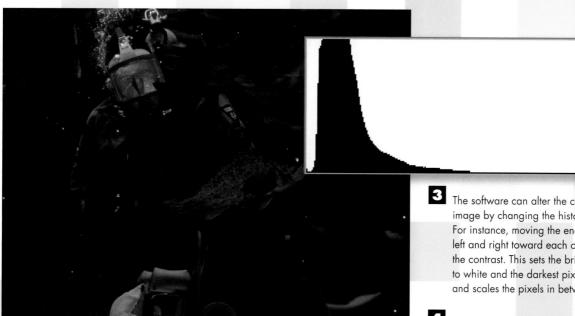

3 The software can alter the color of an image by changing the histogram curve. For instance, moving the endpoints on the left and right toward each other increases the contrast. This sets the brightest point to white and the darkest pixel to black and scales the pixels in between.

This was done to the picture on this page, but we also see that the curve was moved slightly to the right and tilted in that direction. This has the effect of boosting the midtones, bringing out the color in the uniform and in some of the fish.

5 When the color scale was stretched out to fill the range from 100% black to 100% white, the software recalculated the color values of some of the pixels to incorporate the new values into the photograph. The change expands the photo's dynamic range so that all areas of the spectrum are represented.

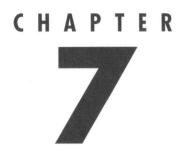

How Digital Retouching Rescues Family Heirlooms

ONCE upon a time your ancestors were younger than you are. They were filled with life and color and energy, and although it was a rare thing to happen back then, they decided to have someone take their photograph. If we're talking ancestors far enough removed from the present day, it was a big event and your ancestors put on their Sunday-go-to-meeting clothes and their most solemn faces and stood still for a photograph that was, no less than the pyramids, a declaration to future generations: "We were here and this is what we looked like and we mattered."

Or it might have been a snapshot Mom and Dad took on their first date using Grandpa's new Brownie.

Either way, these are more than photographs. They are pieces of time that can never be done over again. And way too many ancestors are fading, peeling, crumbling, or serving themselves up as lunch for cockroaches in the attic.

A few years ago that story wouldn't change. If you could find all your old family photos, art restorers were expensive and many of them didn't guarantee their work for this lifetime—never mind the next lifetime and the one after that and the one after that.

Then came Photoshop and its kind, and suddenly everyone's a photo retoucher—a darn good one, too. It's now possible to restore a photo as well or better than the job done by the so-called pros. There are many ways to restore photographs, and we wouldn't be able to tell you all the tricks in just one chapter. But here's enough to get you started and show you how simple it can be.

How Software Removes Dust and Scratches

The advantage of digital photos is that they can live indefinitely in the form of 0 and 1 bits without the slightest mar. But most photographs taken a generation ago or more aren't digital (yet), and they've usually suffered the scratches and soils of shoe boxes, drawers, and wallets. Scanners come to the rescue, but they need help from a photo editing program to erase the scars of your heirloom photos' previous existence. The first tools of choice for photo restoration are the cloner and healing tools, which easily fix a photo album full of imperfections with a dynamic form of copy and paste. To see how, let's look at where an ordinary copy and paste fails.

> Copy a patch that is similar in texture and color, and paste it on top of the dust specs in the hair.

With the hair, the texture and color match, but there's no transition from the patch to the surrounding area.

Two other tools found in photo editing software, cloning or healing brushes, produce different results. These tools don't simply cover the photograph wherever they paste. Instead, they use different methodologies to mix the new material with the old, so that the new retains elements of the area it is covering up. More advanced photo editing software lets you clone specific qualities from one part of a photo, such as the colors, without including other elements, such as the patterns. Both tools also use feathering, a common feature in photo editing software that smoothes the boundary of the patch so there is a gradual transition between new and old materials.

Even when you look very closely, it's tough to see where the new material has been pasted. But these are relatively minor repairs. In the next illustration, you see how these and other tools can restore an almost hopeless photographic heirloom.

How the Digital Darkroom Rescues Damaged Heirlooms

Minor dust specks and scratches are one thing, but what about a discolored old photo that has partly disintegrated or has tears? This photo, easily 100 years old, shows its age. Tiny scratches and spots show up against the dark clothing and backgrounds. The seated woman has deep scratches across her collar and dress sleeve. And all three of them look miserable. Still, there's virtually no job that a team of touch-up tools can't get together to take care of.

Compared to the previous retouch job, the spots and scratches here are a bug infestation. The Dust & Scratches tool in Photoshop is an insecticide bomb, cleaning them all out at once. It affects the entire photo (or the area you've selected) covering over spots and scratches, such as those marked here with white arrows, using the colors of the surrounding pixels. It only works on flaws that are smaller than the limitations the red arrow is pointing at for Radius (size) and Threshold (how different pixels must be to become suspect). If the Radius and Threshold are set too high, the entire picture becomes blurred. That's why some spots—those marked with blue arrows—must each be blotted out manually.

Here are the results of the Dust & Scratches and other touch-ups. The D&S tool softened the standing woman's hair, so the Sharpen tool was used to bring back the suggestion of strands of hair. The scratches on the sitting woman's dress were too big also, but because of the spots on the dress, we couldn't use the Healing tool. The Clone tool works, copying everything from a moving source a set distance away) onto whatever the tool is pointing at. It's similar to the healing tool except it's more a manual operation that works well for large jobs

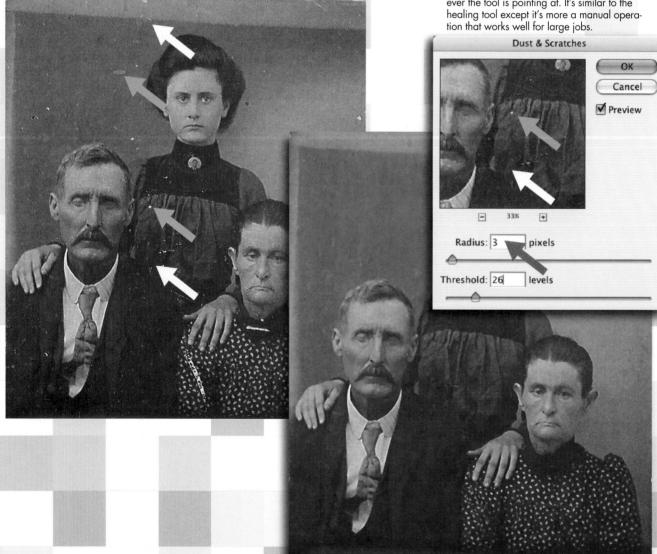

3 All that was left to do was try to help the man in the picture not look as if he couldn't stay awake. This sort of touch-up requires a leap of faith. You assume the younger woman is his daughter, and therefore she's likely to have inherited his eyes. The Healing tool enables an organ transplant of sorts. The eye on the left fit with little fuss, but the eye on the sort and transplant of sorts. but the eye on the right but the eye on the right required some darkening with the Burn tool, which emulates when photogra-phers in film-based dark-rooms let light shine through circles they made with their hands to darken chosen areas of a print they were exposing with an enlarger.

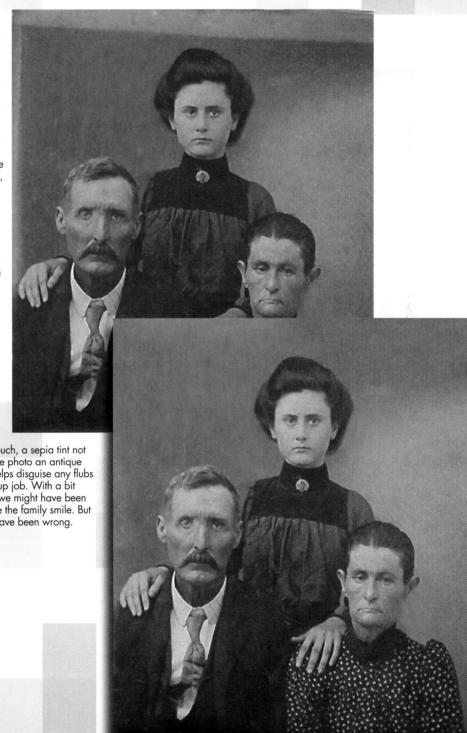

For a final touch, a sepia tint not only gives the photo an antique touch, but helps disguise any flubs in the touch-up job. With a bit more work, we might have been able to make the family smile. But that would have been wrong.

How Software Brings Pictures Back to Life

Color photos are subject to the same slings and arrows of outrageous shoe boxes that torment black-and-white pictures—the dirt, the creases, the spills, the humidity, and of course the fatal reactions that occur when the still-active chemicals of one photograph are crammed up against those of another picture for a decade or so. But the chemicals in color photos are still more volatile and more susceptible to turning the only picture of beloved Uncle Ernie into what looks like an extraterrestrial blob of protoplasm. Luckily for all the myriad misfortunes that can affect photos, we have an arsenal of E.R. weaponry to bring them back from the brink. There are so many tools in the digital darkroom, there's no space to cover them all in detail, but here are some of the most common devices available in programs such as Photoshop, Elements, and Paint Shop Pro to bring color—the right color—back to the cheeks of fading ancestors.

Levels (histograms) is the most versatile of several methods to isolate and tame discolorations that have taken over the photograph.

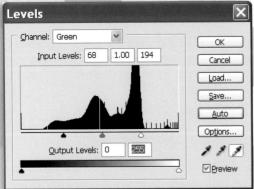

Burn and **Dodge** duplicate the techniques of the old chemical darkroom so the retoucher can darken and lighten specific portions of the photo.

Healing brush repairs numerous dust spots, scratches, and assorted and unexplained flaws by duplicating the pixels surrounding the damage so they cover the defects seamlessly.

Selection tool isolates the mother and baby so the rest of the photo can be worked on without affecting an area that needs special treatment. The selection can also be reversed to work on the background without worrying that touch-ups will spill over into the mother and child.

Variations are used as a final

touch so the retoucher is able to see and choose from a selection of thumbnail versions of the same photograph in which hues and brightness are slightly

varied. This enables the

most pleasing result.

retoucher to see, at a glance,

which variation produces the

Layers provide a way of working on a duplicate of the photograph within the same file and then controlling how changes are blended into the original picture. Two duplicate layers of the washed-out image that emerged from color changes were multiplied to increase the contrast and color depth of the photo.

> Gradient tool fills a sky that has lost all hint of color, permitting the blue to fade as it approaches the horizon.

Airbrush brings out clouds that had been submerged by the blue gradient. The airbrush also added a hint of eyeballs that had been lost entirely in the shadows of the mother's eyes.

Cloning tool covers bigger and more complex flaws by copying, through a sort of artistic wormhole, good portions of the photo to replace flawed areas with the same control you have using a brush. Here, some of the dark trees on the right were replaced with light trees from the left of the photo.

Sharpen tool restores definition to edges that have become blurred through fading or by the retouching itself.

How the Digital Darkroom Makes **Good Photos into Great Fantasies**

PHOTOGRAPHY tends to be thought of as a realistic art. But it doesn't have to be that way. Photographers can be kids, too, and they get delight out of creating fantasy worlds or just rendering a small touch of magic. Or for a different type of the fantastic.... Sure, you can draw a picture of the boss with devil's horns and smoke coming out of his nose. But how are you going to be sure that anyone will recognize that your devilish creation is supposed to be your boss? The solution for sure-fire, unambiguous ridicule is to start with a photograph. Plenty of software programs out there are already configured to let you convert a photo of the boss, a loved one, a political figure, or the goat of the moment into a professionally rendered, photorealistic source of general mirth. Here we show you what you can do with morphing programs, home-sized versions of the same special effects technology that lets the T-1000 from *Terminator 2* change form so easily.

How to Make a Red Rose Blue

One of the most magical tricks of the digital darkroom is the ability to take a real-world object and give it a new color. We like red and yellow roses, but without too much effort, we can turn several of them blue. The thing that makes the change convincing is that the original shading is retained. Highlights are still highlighted and dark spots are still dark—they're just a new color. (Notice, too, that the yellow roses turned out to be a lighter shade of blue than the red roses.)

In place of a normal painting mode, the image editing software offers a special color-blending mode. It preserves the gray levels of the original colors while blending in the hue and saturation of the new color.

Each pixel in a digital photograph is made up of three dots of color: red, blue, and green. Each of the colors is assigned a number from 0 to 255 that describes how light or dark the color is. So, instead of painting the rose one shade of blue, the digital darkroom calculates the values of gray represented by the pixels and uses shades of blue that correspond to the different values of gray. This gives us a range of blue, like this.

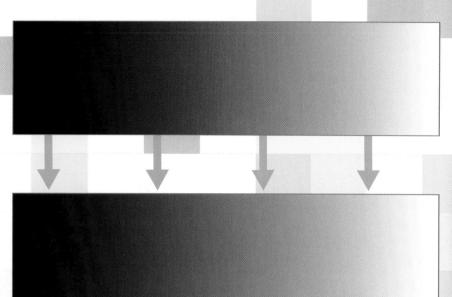

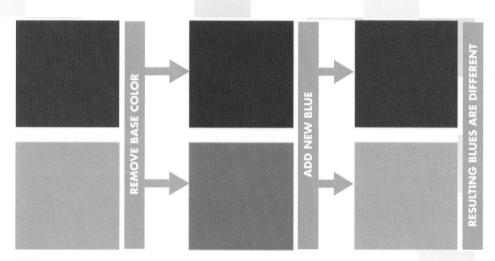

The reason the yellow roses come out to be a lighter shade of blue than the red roses is that the gray values of the pixels in the yellow roses are lighter than those of the red pixels.

How Digital Photos Make Fun of You

Raising a young boy to be a man is no easy chore—unless you have morphing software. **Morphing** converts one image into another in a number of discrete steps, each of which is a blend of the characteristics of both. Although there are many mathematical methods of morphing, the basic procedure is a combination of two techniques: cross dissolving and warping.

Cross dissolving is the same technique used in slideshows and PowerPoint presentations: One image fades out while another fades in. A computer producing the effect begins by holding both images in memory simultaneously as it displays the first image.

The morphing software randomly chooses some of the pixels in the first image and replaces them with the pixels from the same positions in the second photo. It repeats the process until it replaces all the original pixels. This gives us a dissolve, a commonplace feature of any movie. But it's not yet a morph. It needs to warp as well.

In one common **warping** method, the user manually places dots on one face and partner dots on the other face to identify major features, such as the nose, mouth, and eyes.

The software also makes a record of what is inside each of the regions the dots define. It uses this information when it performs a cross dissolve, replacing pixels in one photograph with pixels from the other. The software simultaneously repositions the transported pixels and the polygons they form to warp the emerging image so the pixels move steadily toward the positions they occupied in the picture from which they came.

The end result is the same as the cross dissolve: One picture replaces the other. But when all the stages are displayed in an animation, warping makes the subject of one photo morph gradually into the other. (By working with two copies of the same photo, you can warp without dissolving. The effect is to distort the original image so it grows a bigger nose, longer hair, or bulging eyes.)

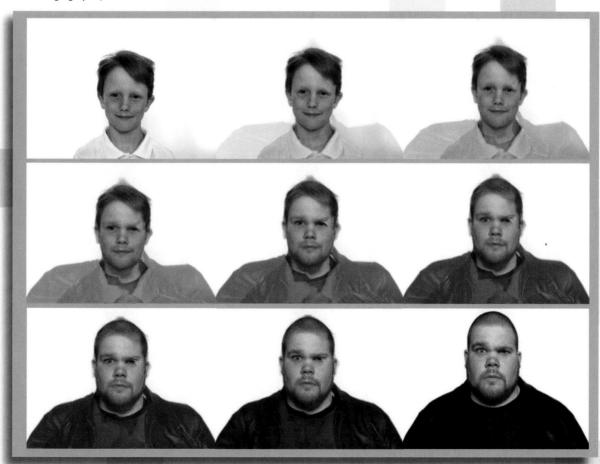

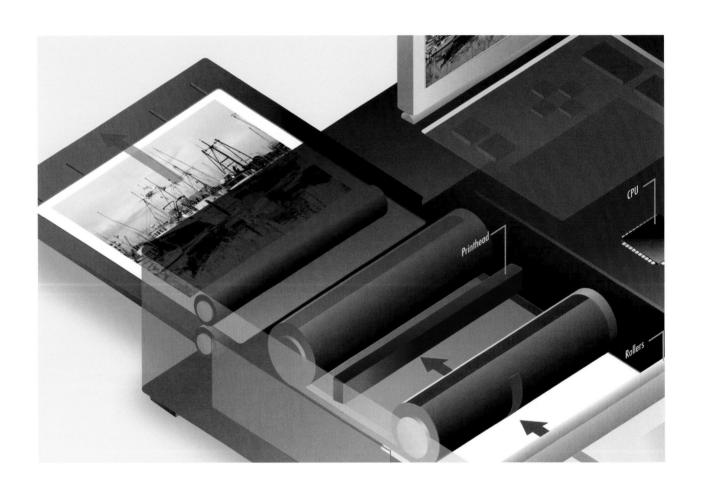

P A R T

How Digital Print-making Works

CHAPTERS

CHAPTER 9 HOW COMPUTERS AND PRINTERS CREATE PHOTOGRAPHS 140
CHAPTER 10 HOW PRINTERS DELIVER PHOTO-QUALITY PRINTS 148

—Diane Arbus

SOME 20 years ago, the state of the art in computer-generated graphics was a table-filling device called a **plotter**. It was a wonder to behold. A mechanical arm moved to one of several ink-filled pens lined up on one side of the plotter's broad, flat bed. Servos clamped the tip of the arm shut about the pen, pulled the pen from its holder, and whined and growled as they pushed the arm back and forth over a sheet of paper where it drew with the boldness and certainty of an artist who knows exactly what he wants down to the tenth of a millimeter. Suddenly, the arm would rush back to the sidelines to exchange one pen for another and add strokes of another color to the emerging artwork. For all this rushing around, completing a drawing could take an hour, which was fine because watching the creation of the artwork was always far more interesting that the finished piece itself. Plotters, a tool welcomed by architects and draftsmen, were not destined to be the tool that took computers into the brave new world of digital photography. They were too slow and lacked subtlety in their pen strokes. The only other output devices for color graphics at that time were crude printers with multicolored ribbons, invariably marketed to schools and children.

Color graphics printing and photo printing went mainstream with improvements in the inkjet printer. The first inkjets, with only three or four colors printing on common paper, were hardly fit for photos. Photographers owe a debt to Canon and Epson (later joined by Hewlett-Packard) for pursuing a goal of better and better inkjet printing that has come to rival traditional photo printing. They did this in a market for which it is still to be established that there is a mass need for personal photo printing. The drugstores and photo retailers are struggling to be the providers of photo printing for digital photographers, and when you can send photos over the Internet and eliminate the hassle that goes with running your own printer, it might turn out that photo printers become a tool of only the most dedicated and meticulous photographers.

How Computers and Printers Create **Photographs**

IF you are now thoroughly enamored of your digital camera and looking forward to printing your pictures yourself as the next step in your growth as a photographer, this just might be the chapter that disabuses you of that notion.

Printing your own *primo* photographs entails a lot more that pushing them through whatever inkjet printer might be handy, especially now when a lot of printer manufacturers are flooding the market with cheap, and slow, inkjets labeled as photo printers. It's not that you can't print photographs on them, but for the quality and the time involved, they're not worth it.

If you're really, really serious about turning out exhibit-quality prints, you'll need a printer from Canon or Epson (Hewlett-Packard is getting into the running), and it shouldn't stop at a measly four colors of ink. Six is the minimum, but think about eight or nine. Then there's good photographic paper. It should ring in your ears like a huckster's line, but really, for the best results you should use your printer's brand-name paper.

Oh, and do you want your prints to look like the image you started with? Then you need to calibrate your monitor, scanner, printer, and anything that's in the flow from the time you snap the picture until it chugs out of the printer's paper train. If their displays aren't all in sync, what you see on your monitor or camera's LCD won't necessarily match what comes out of your printer.

Are you sure you wouldn't rather drop off a photo disc at the drugstore? Yes? Then read on!

How an LCD Screen Displays Your Photo

Long before your photo appears as a print, it has a brief life on a liquid crystal display (LCD) screen, either the small one on the back of most digital cameras or the larger screens on your laptop or desktop computer. LCD screens and their older, more cumbersome cousin, the **cathode ray tube (CRT)** use different methods to produce the same three colors that blend into full-color pictures. But curiously, they don't use the same colors that photo-quality printers use. All color screens use red, green, and blue, which is why you'll hear them referred to at times as **RGB** displays. Printers use two off-shades of red and blue (magenta and cyan) and a standard yellow—at least to begin with. Now the more overachieving color printers are adding more colors and subtler hues to reproduce richer and more accurate color prints. We'll get to them in the next couple of illustrations. For now, let's look at your pictures on a LCD display, whether on a desk or camera.

A fluorescent panel at the back of an LCD screen emanates a white, even light. Each light wave vibrates as light waves normally do, in all directions perpendicular to the direction it's traveling.

- When the light waves hit a polarizing filter, most of the waves are blocked by the filter's microscopic structure, like the blades of a Venetian blind, that let pass only those light waves vibrating in a specific direction. The polarizer has some leeway in the waves it permits through, which is why the LCD display can produce different shades of red, blue, and green.
 - The polarized light next passes through a sheet made up of thousands of liquid crystals in a grid pattern. One of the properties of the crystals is that they twist when an electrical current passes through them, and the light rays follow the curve of the crystals. The stronger the current, the greater the distortion until some of the light waves leave the crystal panel vibrating 90° from their original orientation.
 - The light passes through sets of red, green, and blue filters grouped together to form colored pixels.
 - Light waves from the different cells—some still vibrating in their original orientation, some turned 90°, and the rest twisted at some point in between—encounter a second filter mounted so it polarizes light in an orientation 90° from the direction of the first filter. Light that underwent a full 90° twist passes through the second filter completely to create a dot of red, blue, or green. Light waves that were not distorted at all are blocked totally, producing black dots. All the other rays of light, being twisted to varying degrees, pass through the second filter partially, producing some greater or lesser shade of color. Our vision perceives the colors of the adjoining light rays as a pixel of one color from the thousands this method can create.

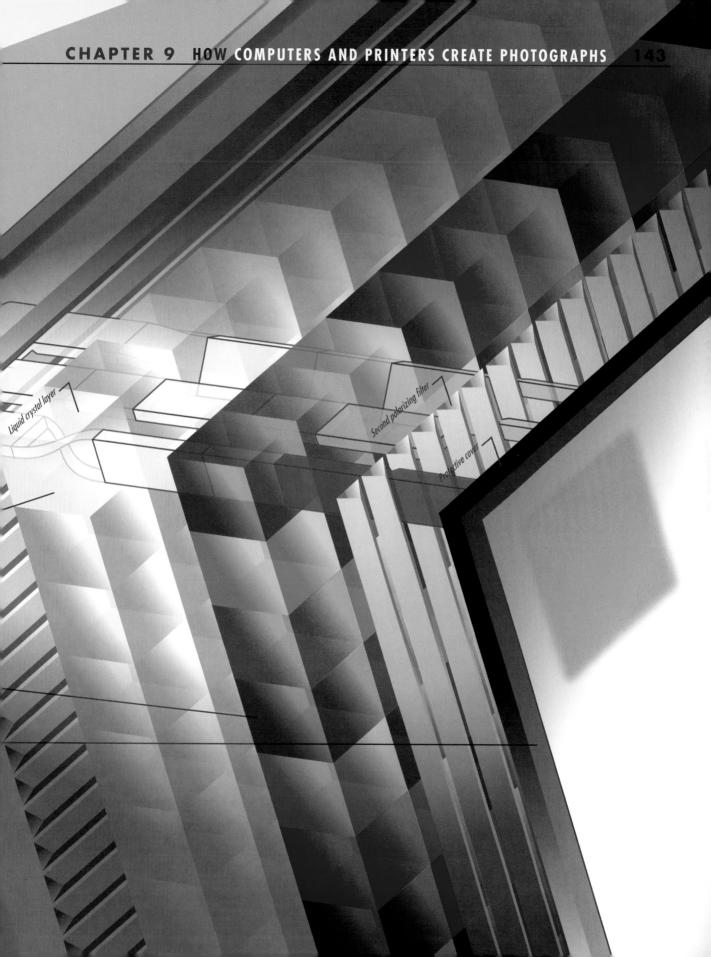

How Colors Are Created

In digital photography, two totally different ways of creating color blend into one another so seamlessly that it seems as if some master painter—and joker—must be at work. At one end of the spectrum, so to speak, the colors on your computer monitor, on your camera's LCD screen, on your TV, and in the movies are all created using light. At the other extreme, the colors in this book, on billboards, on cereal boxes, and in photograph prints are created with paints and dyes and pigments in an entirely opposite process. Yet, most of the time anyway, color moves from one medium to another with grace and beauty.

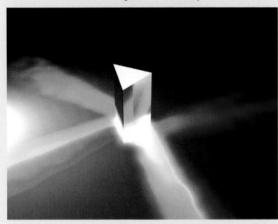

All the colors we perceive come to us through light, more specifically through various wavelengths we see as the different colors in the spectrum. The spectrum we see when a prism breaks up white light is a seamless infinity of hues. We can reproduce not all, but most, of those colors using only three of them. (The ones we cannot reproduce are never missed.)

Color created by the joining of differently colored lights is called **additive color**. The colors add to each other's capacity to produce light. If you shine a red light on a white surface and then shine a green light on the same area, the two colors join forces to create a third color: yellow. If you then shine a blue light on the intersection of red and green light, the three together produce a white light. Those three colors have added up to white, the total of all light in the visible spectrum. Red, green, and blue are the colors used in a monitor, a TV, or any device that *shines* light to create color and images, giving us the **RGB** (**red**, **g**reen, **b**lue) standard.

When two colors are mixed together in the form of an ink, a paint, a powder, or a pigment, they subtract from each other's ability to **reflect** light. They form **subtractive color** because each color absorbs (subtracts) a part of the spectrum found in white light. The more colors in the mix, the more colors deducted from the light reflecting from whatever the mixed colors are used on until the mixture becomes black and reflects no color at all.

In conventional color printing, four colors are used to produce the rainbow of the spectrum under a scheme called **CMYK**, for **cy**an (a blue-green), **m**agenta (a purplish red), **y**ellow, and blac**k** (*B* is already taken by blue). These are the colors used on all printers, although some printers designed especially for photo printing now have other colors, such as green and light shades of pink and blue to increase their **gamut**, or the range of colors they can produce.

Photo printers create images by one of two ways.

Some lay down tiny dots of ink thickly or thinly,
depending on how dark a shade they need to reproduce. The printers might employ different patterns of
dots called **dithering** to disguise the fact that a color
is changing from one shade to another. The newest
ink-jet printers are capable of varying the sizes and
shapes of the dots they produce to more effectively
produce gradations and shades of color. Other printers produce **continuous tone**, which more closely
resembles airbrush work in that there is no perceptibly
abrupt change from one color to another.

Diffusion dither

Pattern dither

Noise dither

To mix inks to create different colors, a continuous tone printer lays down its inks or dyes on top and overlapping one another. In conventional color printing (such as a printing press) and in most types of laser printing, CMYK inks and toners can't be varied continuously in an image. Instead, the printer usually simulates the color variations with **halftoning**. It prints CMYK ink dots of varied sizes in overlapping grids that are laid out at different angles so all the dots don't print directly on top of each other. The always accommodating human eye completes the job of blending the dots into a single perceived color.

Continuous tone

How Calibration Keeps Your Colors Your Colors

Because the human eye and perception are notoriously unreliable, most color calibration systems use a col**orimeter**, a device that measures the intensity and color of light. The colorimeter is placed on a computer screen while accompanying software displays specific shades of gray, blue, red, and green. (It can be used with TVs and other color sources, as well.)

It might be true that a rose is a rose is a rose. But a red rose is not a red rose is not a red rose. Although there are only seven basic colors in the spectrum, there are so many shades and tones that the number of colors the human eye perceives quickly jumps into the quadrillions. Needless to say, at least a few million of them are some variation of red. The trouble is that none of the hardware used in digital photography—cameras, scanners, LCD displays, CRT screens, printers, and projectors—can capture or display all those colors. At best, most equipment can work with four billion colors. The problem is that the billions of color your monitor can display are not necessarily the same billions of color your printer can produce. That's why a photograph that looks dead-on perfect on your screen comes out of your printer murky and offcolor. It's the job of color calibration and color profiles to ensure a red from your scanner is a red on your monitor is a red on a print.

MONITOR (RGB) GAMUT

FILM GAMUT

PRINTER GAMUT

Each device that produces or measures color has its own color space based on the inks, dyes, pigments, phosphors, lights, filters, and other colored materials that are intrinsic to how the device handles color. None of these color spaces matches the others' precisely, not even two identical monitors of the same model and maker. Over time a device's color space might not even match itself. Phosphors decay, inks fade, and even the changing temperature of the day can alter the color space of some hardware.

As a result, colors can change unpredictably as a graphic works its way through the production process. The solution is to calibrate all the graphics hardware so their results are consistent.

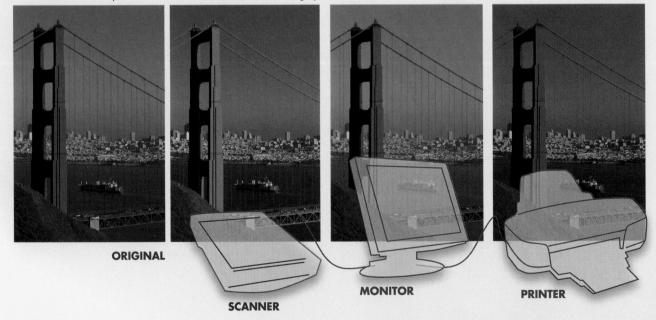

If the colorimeter is being used with an LCD display, light from the screen first passes through a filter that removes ultraviolet light. The photon counters would otherwise have added into their counts hits of infrared, inflating their readings. On a cathode ray tube (CRT) monitor, the thick glass at the front of the display absorbs the infrared.

A microprocessor in the colorimeter converts the counters' readings for red, green, and blue into digital values on the scale of the color space the meter uses. A color space lets any color be defined by a set of three numbers called the **tristimulus values**.

Finally, the software writes a file that contains the monitor's color profile. This is simply a short record of the color space values for a few key colors the monitor can produce. This information can be used by scanners, printers, cameras, and other devices to adjust their colors to match those of the monitor. Because the color values are different for different devices, color matching is not perfect.

On the side of the colorimeter facing the screen are three to seven **photon counters**, similar to light meters. The counters are set into walled cells to prevent them measuring ambient light from the sides.

After the light is evenly spread out by passing through a diffuser made of a material that could be mistaken for a plastic milk jug, it passes through the color filters mounted above each photo counter. The seven filters roughly correspond to the main divisions of the visible spectrum: red, orange, yellow, green, blue, indigo, and violet. The software switches the color on the screen among red, blue, and green to give the meter a chance to gauge each color.

The software uses this information to adjust the monitor's settings so it has the widest possible ranges for the three colors (RGB). If the monitor cannot be controlled by the software, the program turns to the video card, tweaking the controls that send color signals to the monitor.

Color Calibration on the Cheap

Color calibration systems that include a colorimeter cost at least \$100. You can take a software-only approach for free. PPTools provides a free printable color chart and software to calibrate a monitor. EasyRGB (http://www.easyrgb.com/calibrate.php) has an online Monitor Calibration Wizard that also installs a small icon that changes appearance later if your monitor comes out of calibration. Monitor Wizard 1.0 (no relation to the previous program) is freeware that also does the job (http://www.hex2bit.com/).

How well do they work? If they were perfect, they wouldn't be free. They all require your perceptions, which are subjective. In my opinion, the best software-only tool for monitor measurement and maintenance is Display Mate (http://www.displaymate.com/). It costs about \$70, but in addition to calibrating, it lets you test every aspect of your display.

How Printers Deliver Photoquality Prints

THIS is the main match! The battle for the technology that will claim the championship among photo-quality printers. In one corner, the long-standing and undisputed champ-peen in producing photos that most closely resemble prints you'd get from the drugstore! Weighing in at a pound or two and providing true continuous output...the Dye-Sublimation Printer!

And its opponent, the challenger, a longtime standard fixture in offices and homes, churning out everything from book reports to financial worksheets, and now shooting for the title of best photo printer! Weighing in at anything up to 34 pounds is...the Inkjet Printer!

That really pretty much says it. You get excellent results from either type of printer, but it's not at all clear which will wind up the champ. In case the fight goes the distance, you get to decide.

How a Printer Rains Ink to Create a Picture

Once considered little more than a toy for home PC users who wanted to play with graphics programs, the inkjet printer has come into its own as a serious tool for serious photographers. Where once photos from an inkjet were crude and quick to smear and fade, improvements have made some inkjet photos indistinguishable to the naked eye from a traditional print—and without the smears and fading.

Inkjet printers use one or more cartridges filled with different colors of ink in different reservoirs. The cartridges are locked into a print head. (Some printers combine cartridges and the print head as one unit.) The print head travels back and forth on a sturdy metal rod and spits colored inks onto a sheet of photo paper that the printer has grabbed from a stack and pushes beneath the print head.

Some printers strive to create larger **gamuts**—the total range of colors they can produce—by including additional color inks, such as green and lighter shades of blue and red. A few printers accept cartridges that contain nothing but black and shades of gray for photographers who specialize in black-and-white photography.

Inkjet printers produce dots of color so small we don't even call them drops of ink. They're **droplets**. Droplets are measured in **picoliters**—1/1,000,000,000,000 of a liter. That's smaller than the human eye can see. Droplets, such as those shown in this hugely magnified scan, range from 1 to 10 picoliters.

1200% aliased

1200% antialiased

Droplets are so small, in fact, that it is only when they are combined that we have something big enough to measure in **dots per inch (dpi)**. All current-model inkjet printers can create at least 300 dpi printed graphics, which is not fine enough to avoid such artifacts as the **jaggies**—also called **aliasing**—the stair-step edges you find along edges that should be smooth and straight.

The more dots that go into creating a photo, the sharper the details and the more it approaches the resolution of a good traditional photograph. The current state of the art is 9,600 dpi, although that's likely to be only for black. A more common top resolution for color is 4,800 dpi.

How Inkjets and Inks Differ

Inkjet printers vary the sizes of their droplets using one of two technologies to shoot ink out of their print heads. Hewlett-Packard, Lexmark, and Canon use thermal nozzles, whereas Epson uses proprietary piezoelectric nozzles. Both suck ink from the cartridges into their firing chambers New ink from reservoir and shoot the ink through scores of openings on the bottom of the print head that are too small to see.

Thermal Nozzle

When the printer sends an electrical current through a resistor built in to one of the walls of each of the nozzles, the resistor generates enough heat to boil the ink and create an air bubble.

As the bubble expands into the firing chamber, it creates pressure in the ink until the pressure is strong enough to overcome the surface tension holding the ink inside the nozzle. A droplet with a size between 6 and 10 picoliters bursts out of the nozzle to create a colored dot on the paper traveling beneath the print head.

At the same time, current to the resistor turns off, quickly cooling the resistor. A partial vacuum forms in the firing chamber, causing a new supply New ink from reserv of ink to rush in from the cartridge to arm the nozzle for

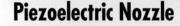

The walls of a piezoelectric nozzle are made of piezo, a crystalline substance that bends when electricity passes through it. When current passes through one way, the walls expand, drawing in ink from the cartridge's reservoir.

When the printer suddenly reverses the current's direction, the walls contract, squeezing out a droplet of ink.

By varying the intensity of the current, the printer changes how much the piezo wall flexes. That, in turn, changes the size of the droplet, which typically ranges from three to four picoliters. That is equal to about one-fourth the diameter of a hair and is at the boundary of resolution for the human eye. Generally, the droplets from piezoelectric ink-jet printers are smaller than those from thermal ink-jet printers.

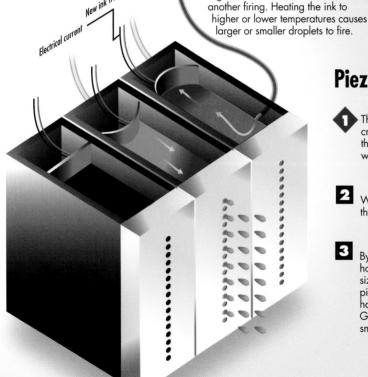

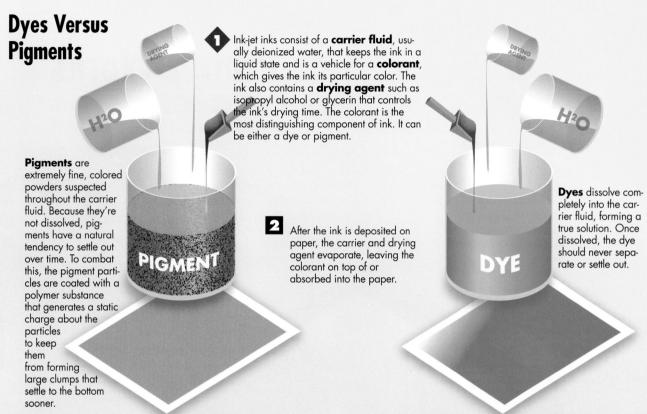

If the colorant is a pigment, the deposit consists of relatively large particles forming a rough layer of color lying on top of the paper. The thickness of the dried ink makes it less susceptible to bleeding and wicking on the paper fibers, which give fine details an unwanted fuzzy quality.

The dye dries to a smoother surface that is brighter and capable of a wider gamut of colors. The dyes are, however, still water soluble, and they easily smear or bleed. Dye inks also tend to fade unevenly, a failing that is overcome by applying an overcoating (or special laminent) that blocks ultraviolet rays, and by storing or displaying photos away from sunlight and heat.

Paper

· Fiber absorption

Uncoated paper—the type commonly used with laser printers and copiers—has an uneven surface that scatters the light, creating a duller finish. It also has no barrier to prevent the ink carrier or dye from being absorbed into the paper and spreading out through porous fibers, which can make the colors look muddy and the details fuzzy. A high-grade matte finish photo paper also dulls the photograph but is more resistant to absorption.

Coated paper—covered in a layer of fine varnish or wax—has a smooth surface on which ink lies more evenly, reflecting light so that ink takes on an added brilliance. The coating also stops the ink being absorbed into the paper, which helps to make the image look sharper. Ceramic-coated porous papers absorb inks quickly, but the ceramic coating leaves dyes exposed to light and gases, making them more prone to fading and discoloration. Plastic-coated, swellable paper encapsulates both pigments and dyes when they seep into the paper's fibers, helping protect them from light and air.

Wax or varnish -

Matched Sets

Printer manufacturers recommend specific papers for their printers. Although the recommendations suspiciously tend to favor papers they make, this is one time when you should believe them. Inks and papers that have been created to work well with each other usually do produce richer, more stable photographs than unrelated inks and papers forced into service with one another.

How a Dye Sub Photo Printer Works

Of all the types of photo printers, there's no argument: The printer that turns out pictures looking the most like they're hot off the automated printer at the drug store is a dye sublimation printer. You don't often hear it called that, of course, because it sounds like techno gobbledygook. It could be something one might do to suppress the urge to color one's hair. In fact, the name does reflect a process that people encounter so infrequently, it's no wonder so few people know what dye sublimation means. Well, now you have the opportunity to join the ranks of the photorati and to regale others at the next gathering with insights into the wonders of dye sublimation (dye sub).

Because the computer is so easily squeezed out of the entire process, the dye sub is likely to have a small LCD screen and controls that let the photographer see rough images of the photos and choose which ones to print. Although not as versatile as working with an application such as Photoshop on a computer, the controls usually allow rudimentary adjustments such as exposure, color correction, and cropping.

Although a few dye sub printers are capable of producing 8" × 10" photos, most of these printers are designed to turn out the 4" × 6" or 5" × 7" prints that are the standard size for nonprofessional photo fans. The printers themselves are smaller, usually no bigger than a thick hardcover book. Dye sublimation printers accept digital photos from a variety of sources—a USB cable from a PC, a built-in card reader where the photographer can insert a flash memory card filled with the latest shots, or from a cradle where the camera is inserted for minimum hassle.

The gases produce no dots of ink with clear demarcations. Each layer of dye blends evenly with the layer before it, producing **continuous tone** images that are otherwise found only in traditional photographs.

After all the paper has passed under the print head for one color of dye, the paper train reverses direction and takes the paper back to the start, where it moves in unison with a second coat. This repeats until the four printing colors have transferred to the paper.

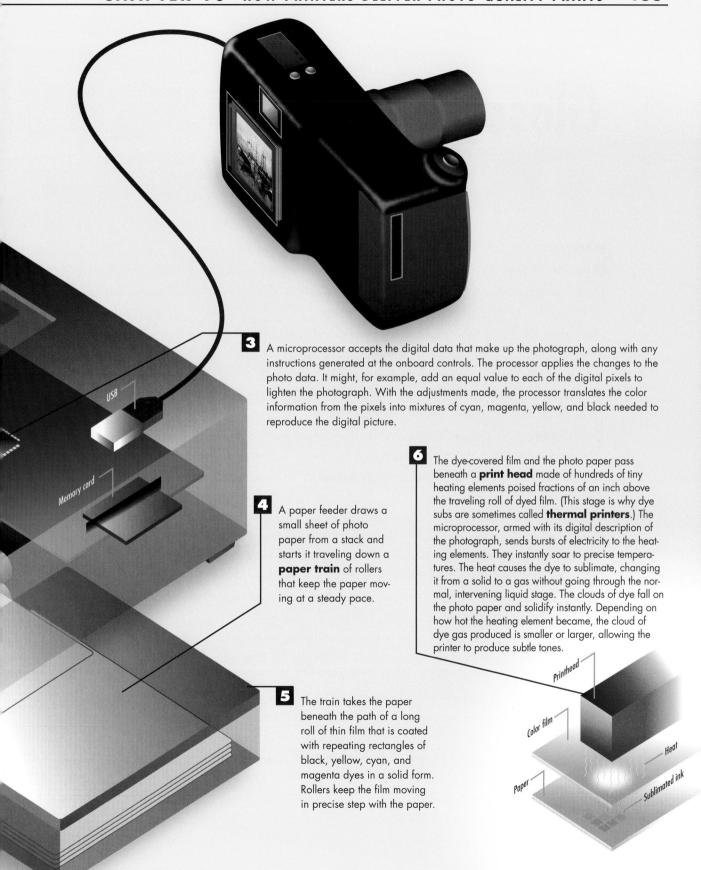

Glossary

A

aberration A distortion in an image caused by a flaw in a mirror or lens.

Acquire A software menu selection to scan from within the program (if it is TWAIN compliant).

ADC Analog-to-digital converter, a device that measures electrical voltages and assigns digital values to them.

Airy disc A disc of light caused when a pinpoint of light is diffused to form concentric halos about the original point.

aliasing The noticeable repeated patterns, lines, or textures in any photographed or scanned subject that conflict with the pattern of an electronic sensor's pixel arrangement. For example, diagonal lines represented by square pixels will produce jagged lines.

antialiasing A technique of blending variations in bits along a straight line to minimize the stair-step or jagged appearance of diagonal edges.

antishake One of several technologies to counteract the movement of a lens and the resulting blurring of a photo.

aperture The lens opening through which light passes, expressed by a number called *f-number* (or *f-stop*). Typically f-stops range from f/2 through f/32, although many lenses don't reach the extremes on either end. Each higher number represents an opening half the size of the previous number, with f/2 being the largest opening and f/32 the smallest. The aperture is one of the key factors in an exposure setting.

array A grouping of elements, such as the rectangular array of photodiodes that make up the digital film that captures an image.

artifact An unwanted pattern in an image caused by the interference of different frequencies of light, from data-compression methods used to reduce the file size, or from technical limitations in the image capturing process.

autofocus A lens mechanism that automatically focuses the lens by bouncing an infrared light beam or sound waves off the subject matter or by measuring the contrast in a scene. Some cameras use a combination of methods.

Automatic Exposure A camera mode that adjusts the aperture and shutter speed based on direct readings of a light meter.

automatic flash An electronic flash that measures the light reflected from a subject and varies the duration and intensity of the flash for each exposure.

B

back-lit A setting that illuminates the subject from behind.

banding Areas of color that show no differentiation except to change abruptly from one color intensity to another so that what should be a gradual change of color is marked by noticeable bands of color.

Bayer pattern A distribution of red, green, and blue filters on an image sensor that provides twice as many green filters as red and blue because of the eye's sensitivity to shades of green.

bit depth The number of bits—0s and 1s in computer code—used to record, in digital image situations, the information about the colors or shades of gray in a single pixel, which is the smallest amount of information in a graphic image. The smaller the bit depth number, the fewer tonal values that are possible. For example, a 4-bit image can contain 16 tonal values, but a 24-bit image can contain more than 16 million tonal values.

bitmap An image represented by specific values for every dot, or pixel, used to make up the image.

black noise Also known as dark current, it is the signal charge the pixel develops in the absence of light. This charge is temperature sensitive and is normal in electrical image sensing devices.

bleeding The color value of one pixel unintentionally appearing in the adjacent pixel or pixels.

blooming The bleeding of signal charge from extremely bright pixels to adjoining pixels, oversaturating those adjoining pixels. Masks or potential barriers and charge sinks are used to reduce blooming.

BMP file A Windows file type that contains a bitmapped image.

bracket A burst mode that, as a safety precaution, shoots extra exposures that are normally one f-stop above and below the exposure indicated by the light meter reading.

brightness One of the three dimensions of color—hue, saturation, and brightness. Brightness is the relative lightness or darkness of a color, ranging from 0% black to 100% pure color.

burst rate The capability of a camera to take several pictures one after another, as long as the shutter button is depressed or until the memory buffer is full. The size of the memory buffer and the speed that the camera writes the data to a memory card determine the burst rate.

calibrate To adjust the handling of light and colors by different equipment, such as cameras, scanners, monitors, and printers, so the images produced by each are consistent to a defined standard of brightness, hue, and contrast.

charge-coupled device (CCD) An image sensor made up of rows of photodiodes, which are transistors that convert light energy to electrical energy and transmit the electrical charges one row at a time.

chroma A quality of color combining hue and saturation.

circle of confusion Points of light focused by the lens into discs of light. The smaller the circles of confusion (the discs), the sharper the image appears.

clipping The loss of color information above or below certain cutoff values.

CMOS image sensor An image sensor similar to a CCD but created using CMOS technology. CMOS stands for complementary metal-oxide semiconductor.

color, additive The creation of colors in cameras, monitors, and scanners by combining the effects of pixels colored red, blue, and green, usually referred to as RGB. **See also color, subtractive.**

color balance The overall accuracy of the hues in a photograph, particularly with reference to white.

color depth The number of bits assigned to each pixel in the image and the number of colors that can be created from those bits. **See also bit depth.**

color, subtractive A system such as printing that creates colors by combining the absorption capabilities of four basic colors: cyan, magenta, yellow, and black. **See also color, additive.**

color temperature The "warmth" or "coolness" of light, measured in degrees Kelvin (K). Midday daylight is about 5,500K. Light bulbs are about 2,900K, meaning they're more orange or warm. Color temperature is important to color balance.

compression, lossless A file compression scheme that makes a file smaller without sacrificing quality when the image is later uncompressed. Zip and GIF files use lossless compression.

compression, lossy A file compression scheme that reduces the size of a file by permanently discarding some of the visual information. JPEG is the most common lossy compression format for graphics.

continuous tone An image, such as a film photo, that has a gradual range of tones without any noticeable demarcation from one to the other.

contrast The difference between the dark and light areas of an image.

D

demosaic An algorithm used to fill in missing color information from an image captured by a camera's mosaic sensor.

depth of field The area between the nearest and farthest points that are in focus through a camera lens. Depth of field increases at smaller lens apertures.

dithering The process of creating different colors by placing dots of ink coloring near each other in different combinations to create the illusion of other colors.

dots per inch (dpi) A measurement of resolution used for scanning and printing.

dynamic range The range of the lightest to the darkest areas in an image. **See also histogram.**

E-F

exposure The amount of light used in a photograph, based on the aperture and how long the shutter stays open.

exposure compensation The capability to automatically change exposure by one or two stops to lighten or darken the image.

fill flash Flash used to fill shadows caused by overall bright lighting.

fixed focus A lens made to permanently focus on the most common range, from a few feet to infinity. The focus is usually not as sharp as that obtained with a variable focus lens.

Flash memory card A card containing chips that store images using transistors instead of magnetic media.

focal length The distance, in millimeters, from the optical center of the lens to the image sensor when the lens is focused on infinity. Also defined as the distance along the optical axis from the lens to the focal point. The inverse of a lens's focal length is called its *power*. Long focal lengths work like telescopes to enlarge an image; short focal lengths produce wide-angle views.

focal point The point on the optical axis where light rays form a sharp image of a subject.

G-H

gamma A mathematical curve created by the combined contrast and brightness of an image, which affects the balance of the middle tones. Moving the curve in one direction makes the image darker and decreases the contrast. Moving the curve in the other direction makes the image lighter and increases the contrast. The blacks and whites of an image are not altered by adjusting the gamma.

gamut The range of colors a device captures or creates. A color outside a device's gamut is represented by another color that is within the gamut of that device.

grayscale At least 256 shades of gray from pure white to pure black that represent the light and dark portions of an image.

histogram A bar graph showing the distribution of light and dark values throughout a photograph, roughly equivalent to a photo's dynamic range.

hot shoe A clip on the top of the camera to which you can attach a flash unit; it includes an electrical link to synchronize the flash with the camera.

STATE STATES

IEEE 1394 A personal computer port capable of transferring large amounts of data at high speeds, often used to upload graphic and video files. It's known as i.Link on Sony systems and FireWire on Apple computers.

image sensor A microchip that records images by converting the scene's light values into an electrical current that travels to a memory chip to be recorded as digital values.

intensity The amount of light reflected or transmitted by an object, with black as the lowest intensity and white as the highest intensity.

interpolation A process used in digital zooms and digital darkrooms to enlarge images by creating the new pixels. This is done by guessing which light values they should have based on the values of the original pixels in the image that would be next to the new ones. **See also zoom, digital and zoom, optical.**

interpolation, bicubic Two-dimensional cubic interpolation of pixel values based on the 16 pixels in a 4×4-pixel neighborhood.

interpolation, bilinear An enlargement in output pixel values is calculated from a weighted average of pixels in the nearest 2×2 neighborhood.

interpolation, nearest neighbor A enlargement by copying pixels into the spaces created when the original pixels are spread apart to make a bigger image, just like film grains under an enlarger.

ISO Named after the organization that defined this standard, it's a number rating indicating the relative sensitivity to light of an image sensor or photographic film. A higher ISO number represents a greater sensitivity to light and requires less exposure than a lower ISO number does.

J-K-L

jaggies The stair-step effect in diagonal lines or curves that are reproduced digitally.

JPEG Also known as JPG and J-peg, it's a popular digital camera file format that uses lossy compression to reduce file sizes. It was developed by the Joint Photographic Experts Group.

lag time The time between pushing the shutter button and when the exposure is made by the camera.

long lens A telephoto lens.

lossless See compression, lossless.

lossy See compression, lossy.

M

Macro mode A lens mode that allows focusing on objects only inches away.

megapixel An image or image sensor with about one million pixels.

Memory Stick A flash memory storage device developed by Sony.

metering, center-weighted A light reading of the intensity with an emphasis on an area in the center of the viewfinder's frame.

metering, matrix A light meter reading produced by reading the light from several areas throughout the frame.

metering, spot A light reading taken from a narrow area, usually in the center of the frame.

midtones Light values in an image midway between the lightest and darkest tones.

MPEG A digital video format developed by the Motion Picture Expert Group.

N-0

noise A random distortion in an analog signal causing snow or dark flecks throughout the image. It can be caused by electronic noise in the light amplifiers, nearby electrical spikes, heat, or other random electrical fluctuations.

normal lens A lens with about the same angle of view of a scene as the human eye—about 45°. **optical character recognition (OCR)** A scanning technology that recognizes letters and translates them into text that can be edited onscreen.

P-Q

photodiode A semiconductor device that converts light into electrical current.

pixel A picture element, the smallest individual element in an image.

pixelation An effect caused when an image is enlarged so much that individual pixels are easily seen.

pixels per inch (PPI) A measurement of the resolution of an image based on the number of pixels that make up 1 inch.

preview screen A small LCD screen on the back of the camera used to compose or look at photographs.

R

RAW format The uninterpreted data collected directly from the image sensor before processing. **red-eye** An effect that causes eyes to look red in flash exposures; it's caused by light reflecting off the capillary-covered retina.

Red-eye Reduction mode A mechanism that fires a preliminary flash to close the iris of the eye before firing the main flash to take the picture.

resolution The sharpness of an image that's measured in dots per inch (dpi) for printers and pixels per inch (ppi) for scanners, digital cameras, and monitors. The higher the dpi or ppi, the greater the resolution.

resolution, interpolated A process that enlarges an image by adding extra pixels whose color values are calculated from the values of the surrounding pixels.

RGB The acronym for red, green, and blue, which are the primary colors of light and also the color model used for television, digital cameras, and computer monitors.

S

saturation The amount of color in a specific hue. More saturation makes the colors appear more vivid, whereas less saturation makes the colors appear muted.

sharpening A function in digital darkroom software, some cameras, and some scanners that increases the apparent sharpness of an image by increasing the contrast of pixels along the borders between light and dark areas in the image.

short lens A wide-angle lens that includes more of the subject area.

shutter The device in a camera that opens and closes to let light from the scene strike the image sensor and expose the image.

Shutter-priority mode An automatic exposure system in which you set the shutter speed and the camera selects the aperture (f-stop) used to make the exposure.

shutter speed The length of time during which the camera shutter remains open. These speeds are expressed in seconds or fractions of a second, such as 2, 1, 1/2, 1/4, 1/8, 1/15, 1/30, 1/60, 1/125, 1/250, 1/500, 1/1000, 1/2000, 1/4000, and 1/8000. Each increment is equal to one full f-stop. Increasing the speed of the shutter one increment, for example, reduces the amount of light let in during the exposure by half, so the lens aperture would need to be opened one f/stop to produce an exposure with the same tonal values as the exposure made with the original shutter speed setting.

SmartMedia Toshiba's form of RAM flash memory on a microchip.

T

Tagged Image File Format See TIFF.

threshold A color or light value of a pixel before software or a camera does anything with the pixel's information. For example, blue values might be substituted with red values, but only if the blue pixels have an intensity within a certain range of values. The higher the threshold, the fewer pixels affected.

thumbnail A small image that represents a bigger version of the same picture.

TIFF A popular lossless image format used by professional photographers and designers. It is also the most common format for scanned images.

TWAIN An industry-standard method for allowing a scanner to communicate directly with image-editing software or a word processor.

U-V

upload Sending files from a device, such as a digital camera or memory card, to a computer.
 variable-focus A lens whose range of focus can be changed from a close distance to infinity.
 viewfinder, optical A separate window that shows what would be included in a photograph, but only approximately.

viewfinder, single-lens reflex A viewfinder whose image comes directly through the same lens that will be used for taking the picture.

viewfinder, TTL (through-the-lens) A viewfinder that looks through the lens to use the same image produced by the lens to create a photograph.

W-X-Y-Z

white balance An automatic or manual control that adjusts the brightest part of the scene so it looks white.

white point The color that is made from values of 255, each for red, blue, or green in a camera's sensor image, a monitor, or a scanner. On paper, the white point is whatever color the paper is.

wide-angle lens A lens with an angle of view between 62° and 84°.

zoom, digital A way of emulating the telephoto capabilities of a zoom lens by enlarging the center of the image and inserting new pixels into the image using interpolation. **See also interpolation.**

zoom lens A lens that lets you change focal lengths on-the-fly.

zoom, optical A method that changes the focal length of a lens to change its angle of view from wide angle to telephoto. Optical zoom is preferable to digital zoom.

Index

angular velocity sensors, 63 **NUMBERS** antishake systems. See vibration reduction 4/3 System standard, 56-57 (VR) systems 35mm film, 56 apertures, 66 aperture priority/value, 77 A diffraction, 53 accumulative noise, 83 DOF, 53 achromatic doublet, 23 f-stops, 67 action scene mode, 76 array processors, 98 active autofocus, 28-31 autofocus actuators, 33. See also motors active, 30 additive color, 144 echo active autofocus, 28 afocal lens systems, 44 triangulation active autofocus, 29 Airbrush tool, 129 pros and cons, 31 Airy discs passive autofocus, 30-31 description of, 48 ultrasonic motor (USM), 32 focus, 49 automatic exposure, 77 least circle of confusion, 51 axis, 22 Raleigh limit, 49 algorithms (bilinear interpolation), 98 B aliasing, 151 backlit subjects, 116 amplified noise, 83 banding, 100 analog, 96 Bayer matrix, 94 angle of view, 52 bilinear interpolation, 98

bimorph, 32		C
bit sensors, 101		calibrating color, 146-147
bits, 100		cameras (traditional) versus digital, 5, 58
blooming, 91		image capture, 87-90
blur		lenses, 54-55
C	applying, 112	light sensors, 71
C	avoiding, 58	carrier fluids, 153
C	causes, 59	cartridges (print), 150
C	circle of confusion, 50	CCD (charged coupled device), 97
(Coriolis effect, 63	celluloid, 88
r	easons for using, 112	center-weighted meters, 73
r	educing	chromatic aberrations, 23
	electronic image stabilization, 60	circle of confusion, 50
	motion correction systems, 62	cloner tools, 124, 129
	piezoelectric supersonic linear actuator stabilization, 63	close-up scene mode, 76
	shift image stabilizers, 63	CMOS (complementary metal oxide semiconductor)
	vari-angle prism (VAP) systems, 61	description of, 35
	ibration reduction (VR) systems. See	function of, 97
vibration reduction (VR) systems		CMYK, 145
Bob Miller's Light Walk, 17		color calibration, 146-147
bokeh, 27		color filter matrix, 91
bracket exposures, 75		color filters, 147
bracketing, 78		color profiles, 147
built-in flash check, 75 burn tool, 128		color spaces, 146-147
		colorants, 153
		colorimeter, 146-147

colors	couplers, 89
additive color, 144	cross dissolving, 134
altering, 132	
CMYK printing, 145	D
colorimeter, 146	dark noise, 82
continuous tones, 145	Delete button, 13
dithering, 145	demosaicing, 98
gamut, 145, 150	depth of field (DOF), 50-51
origins of, 144	developers, 89
subtractive colors, 144	diaphragm, 17-19, 66-67. <i>See also</i> apertures
white balance, 80	diffraction, 53
compound lenses	diffusers, 147
function of, 24	digital versus analog, 96
multiple lenses, 25	digital cameras
simple lenses	4/3 System standard, 56-57
negative concave lenses, 25	light, 65
objective lenses, 24	optical physics, 37
positive convex lenses, 25	parts of, 8-10, 13, 59
compression, 100	versus traditional cameras, 5, 58
concave lenses, 22	image capture, 88-90
continuous tone, 145, 154	image storage, 87
control gate, 101	lenses, 54-55
converging lenses, 22	light sensors, 71
convex lenses, 22	digital images. See images
Copal square shutters, 68-69	digital multipliers, 55
copy/paste versus cloner and healing tools,	digital zoom, 46-47
Coriolis effect, 63	diopter eyepiece correction, 13

displays (LCD), 5	description of, 75
dithering, 145	exposure equivalences (EVs), 76
diverging lenses, 22	exposure modes, 77
Dodge tool, 128	ISO setting, 75
OOF, 52-53	overexposure, 91, 115
dpi (dots per inch), 151	programmed exposure, 77
droplets (picoleters), 150	pushing, 83
drying agents, 153	scene modes, 76
dust, removing, 124	shutter button lock check, 75
Dust & Scratches tool (Photoshop), 126	spatially varying pixel exposures, 93
dye sublimation printers, 149, 154	special programs, 75
dyes, 153-154 dynamic range, 92, 114	exposure compensation. <i>See also</i> histograms
	bracketing, 78
E	description of, 75
echo active autofocus, 28	Zone System, 79
ED glass, 56	exposure mode, 75
electronic image stabilization, 60	exposure systems
electronic viewfinders, 39	definition of, 19
elements, 23	diaphragm, 19
enlarging photos, 118-119	photodiodes, 70-71
EVs (exposure equivalences), 76	photovoltaic effect, 71
exposure	purpose of, 17
adjusting, 92	shutters, 19
automatic exposure, 77	external flashes, 11
bracket exposures, 75	extra-low dispersion (ED) glass, 56
built-in flash check, 75	eyepieces, 39

F	autofocus
f-stops, 67	echo active autofocus, 28
field of view, 55	eye-oriented focus, 34-35
file formats, 100	passive autofocus, 30-31
film,	pros and cons, 31
image capture methods, 88-89	triangulation active autofocus, 29
silver-halide grains, 56	ultrasonic motors (USMs), 32
versus 4/3 System standard digital, 56	circle of confusion, 50
versus digital image storage, 5, 87	depth of field (DOF), 50-51
versus photodiodes, 96	apertures, 53
fisheye lenses, 41	effects of distance, 52
fixed-focus, 27	focal lengths, 52
fixed-focus lenses, 19	utilizing, 52
fixing baths, 89	description of, 26
flash memory, 101	eyes (human), 34
flashes, 11, 75	fixed-focus, 27
floating gate, 101	focal length, 23
focal length, 23	focal plane, 25, 50
affecting angle of view, 52	focal points, 22
affecting DOF, 52	focusing screens, 34
digital multipliers, 55	focusing through glass, 31
effect on perspective, 42	lens elements, 23
versus perspective, 43	plane of critical focus, 50
focal plane, 25, 50	rear nodal point, 23
focal points, 22	reasons to blur, 112
focus	sharpen, 110-111
Airy discs, 48-51	tips for focusing, 31
angle of view, 52	unfocused images, 26. See also blur
	focus rings, 26

ocusing screens, 34	image capture methods
oveon X3 image sensors, 95	digital versus film, 88-91
Fujifilm Super CCD SR, 93	spatially varying pixel exposures, 93
ull-frame meters, 72	image circles, 55
	image sensors
G	Bayer matrix, 94
gamut, 145, 150	description of, 5
glass, photographing through, 31	Foveon X3, 95
Gradient tool, 129	functions of, 90-91
grain, 82, 88. <i>See also</i> noise	hot mirrors, 90
gray, 73	image circles, 55
grayscale range, 79	sizes of, 54, 57
ground glass, 38	variations, 92
gyroscopes	imager, 5
angular velocity sensors, 63	images. <i>See also</i> photos
definition of, 59	as data, 105
	blurs
H - I	avoiding, 58
Healing Brush tool, 128	Coriolis effect, 63
nealing tools, 124	electronic image actuator stabilization,
neirloom photographs, 123	60
nistograms	motion correction systems, 62
description of, 84	piezoelectric supersonic linear actuator
leveling, 85	stabilization, 63
software processes, 120-121	shift image stabilizers, 63
not mirrors, 90	vari-angle prism (VAP) systems, 61
not pixels, 82	combining to create light, 85
hues, changing, 132. <i>See also</i> colors	grainy, 88

latent, 89	landscape scene mode, 76
LCD screens, 142	latent image, 89
light into data, 87	Layers tool, 129
manipulating, 131	LCD read-out window, 10
noise versus grain, 88	LCD screens, 5
storing, 12	histogram, 84
unfocused, 26-27	how images display, 142
incoherent light, 10	least circle of confusion, 51
index of refraction, 21	LED (light emitting diode), 35
infrared light focus. See autofocus	lenses
inkjet inks, 153	afocal lens systems, 44
inkjet printers, 149-151. See also printers	angle of view, 43
gamuts, 145	axis, 22
history of, 139	cameras without, 17
interline CCD imagers, 97	concave lenses, 22
internal memory, 12	convex lenses, 22
International Order for Standardization (ISO) setting, 75	description of, 19
	diffraction, 53
interpolation, 98	digital versus traditional cameras, 54-55
iris shutters, 19 irises, 17. See also apertures ISO setting, 75	diopter eyepiece correction, 13
	ED glass, 56
	elements, 23
J - K - L	field of view, 55
jaggies, 151 JPEG files, 100	fisheye lenses, 41
	fixed-focus lenses, 19
	focal lengths, 42-43

function of, 19-20	behaviors of, 20-21
image circles, 55	capturing, 65
importance of, 17	controlling via diaphragm, 66-67
magnifying lenses, 22	correcting after photographing, 116
multiple lenses, 25	dynamic range, 92
negative lenses, 22	incoherent light, 10
normal lenses, 41	inconsistencies, 81
positive lenses, 22	off-center lighting, 73
purpose of, 17	outside light, 81
refraction, 21	temperature grades by source, 80
simple lenses, 24-25	temperature of, 80
telephoto, 40-41	transforming into data, 87
wide-angle, 40-41	white balance, 80-81
zoom lenses	light meters. See also histograms
description of, 44	averaging, 73
digital zoom, 46-47	center-weighted meters, 73
optical zoom, 46	definition of, 9
software versus lenses, 47	exposure compensation, 78
levels (histograms) tool, 128	full-frame, 72
light	point-and-shoot cameras, 72
Airy discs	shutter locks, 73
description of, 48	spot metering, 73
focus, 49	light sensors
least circle of confusion, 51	photodiodes, 70-71
Raleigh limit, 49	photovoltaic effect, 71
as data, 105	light sensors, 90. See also image sensors

M	optical zoom, 46
magnifying lenses, 22	oscillators, 69
megapixels, 100	outside light, 81
memory	overexposure, 91, 115
flash memory, 101 internal memory, 12 memory cards, 13 micro image sensors. See image sensors microchips, 5 microprocessors, 75 morphing, 134 motion correction systems, 62 motors rotors, 33 stators, 33 ultrasonic motors (USMs), 32 voice coil motors, 61 multiple lenses, 25 N - O negative lenses, 22 night portrait scene mode, 76 noise, 82-83, 88 noise-to-signal ration, 83	paper matching to printers, 153 paper trains, 155 parallax, 38 passive autofocus, 30-31 paste/copy versus cloner and healing tools, 124 perspective, 42-43 photodiodes blooming, 92 depletion layers, 70 functions of, 71 N-layers, 70 P-layers, 70 poison statistics, 83 versus film, 96 versus pixels, 90 wells, 91 photographic noise, 82-83, 88
objective (lenses), 24 optical physics, 37	photon, 89 photon counters, 147 photos. <i>See also</i> images displaying on LCD screens, 142 framing, 38

old photos, rescuing, 123	manipulating, 10/
overexposed, 115	versus photodiodes, 90
printing, 141	plane of critical focus, 50
restoring, 124	plotters, 139
retouching, 123, 126-128	plug for external flash, 11
sharpening, 110	point-and-shoot (POS) cameras, 72
software processes	poisson statistics, 83
enlargement, 118-119	polyester, 88
improving color, 120-121	portrait scene mode, 76
storing, 12	POS cameras, 72
Photoshop Dust & Scratches tool, 126	positive lenses, 22
photovoltaic cells. See photodiodes	pressure plate, 5
photovoltaic effect, 71	Preview button, 67
picoliters, 150	print heads, 150, 155
piezo, 152	printers
piezo bender, 32	CMYK printing, 145
piezo motors, 33. <i>See also</i> motors	continuous tones, 145
piezoelectric effect, 32	dithering, 145
piezoelectric nozzles, 152	dpi, 151
piezoelectric supersonic linear actuator	dye sublimation printers, 149, 154
stabilization, 63	firing chambers, 152
pigments, 153	gamut, 145, 150
oinhole cameras, 17	history of, 139
oitch, 58	inkjet printers, 149-150
pixels	jaggies, 151
blurring, 113	matching to paper, 153
definition of, 90	paper trains, 155
description of, 108	photos, printing, 141
effects, 108	

piezoelectric nozzles, 152	shift image stabilizers, 63
print heads, 155	shoe for external flash, 11
thermal nozzles, 152	shutters
programmed exposure, 75-77	Copal square shutters, 68-69
pulse coded modulation, 67	definition of, 19
pushing (exposure), 83	function of, 68-69
	iris shutters, 19
R	lock, 73-75
radius, 111	priority, 77
Raleigh limit, 49	purpose of, 17
random noise, 83	shutter priority, 77
range, 85	speeds, 58
RAW files, 100	signal noise, 83
read noise, 83	silver-halide grains, 56
read-out register, 97	simple lenses
rear nodal point, 23	negative concave lenses, 25
reducing agents, 89	objective lenses, 24
refraction, 21	positive convex lenses, 25
retouching, 123, 126-128	smooth impact drive mechanisms (SIDMs
RGB displays, 142-144	62
rotors, 33	software processes
S	copy/paste versus cloner and healing tools, 124
scene modes, 76	enlargement, 118-119
scratches, 124	improving color, 120-121
Selection tool, 128	pixels, manipulating, 107
sharpen, 110-111, 129	removing dust and scratches, 124

spatially varying pixel exposures, 93

spectral sensitizers, 88 sports scene mode, 76 spot metering, 73 stators, 33 stop baths, 89 storage, digital versus film, 87. See also memory subtractive colors, 144 Super CCD SR, 93 sympathetic vibration, 63 telephoto lenses, 40-41 temperatures of light, 80 thermal nozzles, 152 thermal printers, 155. See also dye sublimation printers threshold, 111 through-the-lens (TTL) viewfinders, 39 TIFF files, 100 time value, 77

tools (software), 128-129

tristimulus values, 147

twilight scene mode, 76

triangulation active autofocus, 29

transducers, 28

U - **V**

ultrasonic motors (USMs), 32 underexposure, 114 Unsharp Mask, 111 USB connection, 12

vanishing point, 42 vari-angle prism (VAP) systems, 61 Variations tool, 129 vibration reduction (VR) systems electronic image stabilization, 60 functions of, 58-59 motion correction systems, 62 piezoelectric supersonic linear actuator stabilization, 63 shift image stabilizers, 63 vari-angle prism (VAP) systems, 61 vibrations blurring, causes of, 59 side-to-side, 58 sympathetic vibration, 63 vertical, 58 viewfinders, 8 electronic, 39 eyepieces, 39

framing photographs, 38

history of, 38 inexpensive designs, 38 parallax erroror, 38 pros and cons, 39 through-the-lens (TTL), 39 voice coil motors, 61

W - X - Y - Z

warping (morph), 134 wavelengths, 23 weighted average, 113 wells, 91 white balance, 80-81 wide-angle lenses, 40-41

yaw, 58

Zone System, 79
zoom lenses
afocal lens systems, 44
description of, 44
digital zoom, 46-47
optical zoom, 46